THE GRID BOOK

THE GRID BOOK

HANNAH B HIGGINS

THE MIT PRESS
CAMBRIDGE, MASSACHUSETTS
LONDON, ENGLAND

MIT Press books may be purchased at special
quantity discounts for business or sales
promotional use. For information, please email
special_sales@mitpress.mit.edu or write to
Special Sales Department, The MIT Press,
55 Hayward Street, Cambridge, MA 02142.

This book was set in Adobe Garamond,
Corporate SBQ, and Univers by
Graphic Composition, Inc., Bogart, Georgia,
and was printed and bound in Spain.

Library of Congress Cataloging-in-Publication Data
Higgins, Hannah, 1964–.
The grid book / Hannah B Higgins.
 p. cm.
Includes bibliographical references.
ISBN 978-0-262-51240-4 (pbk.)
1. Grids (Crisscross patterns). 2. Design. I. Title.
NK1570.H54 2009
701'.8—dc22

 2008029430

10 9 8 7 6 5 4 3 2 1

For Tom Mitchell

INTRODUCING GRIDS
A MEDITATION ON MRS. O'LEARY

One dark night—when people were in bed,
Old Mrs. O'Leary lit a lantern in her shed;
The cow kicked it over, winked its eye and said,
There'll be a hot time in the old town tonight.[1]

SOON AFTER THE GREAT CHICAGO FIRE BURNED FROM OCTOBER 8 TO 10, 1871, this anonymous poem appeared in the *Chicago Evening Post.* It distills in one stanza, complete with mischievous bovine protagonist, one of our most enduring modern myths. As the story goes, in an unnumbered shed behind the cottage at 137 De Koven Street in Chicago, a hitherto unremarkable cow kicked the lantern lighting her milking. One of five cows in this informal dairy, she normally yielded easily to the patient caress of her udder by practiced hands. But it was hot and dry; there'd only been five inches of rain since July. Maybe Catherine O'Leary's cowshed was sweltering. Maybe there were too many biting flies in the air. Maybe the normally compliant cow just didn't want to give it away that day. Whatever the cause, she kicked. Hard. Over went the lamp, sparking a few odd pieces of hay. Mrs. O'Leary stomped them with a worn boot and uttered a few profanities—or so we would imagine. To no avail: more hay caught. Then the floorboards. Outside, the ground itself was tinder. Scraps of leaves ignited. The elevated wooden sidewalk and roadway. Ships along the Chicago River loaded with wood and coal. Buildings. City Hall. The opera. Theaters. The thirteen-day-old Palmer House Hotel. More buildings. In the end, a third of the city, about 2,000 acres including the entire

0.1
View from the southwest corner of Dearborn and Monroe, 1871. Jex Bardwell. Reproduction of photograph; ICHI-26579. Chicago History Museum.

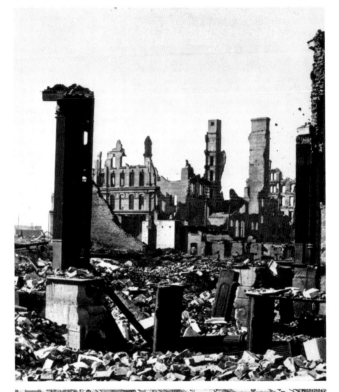

0.2
Illustration depicting buildings from Adams Street, North on Dearborn, Chicago, Illinois, 1893. Publisher: Rand McNally and Co. Reproduction of illustration; ICHI-51542. Chicago History Museum.

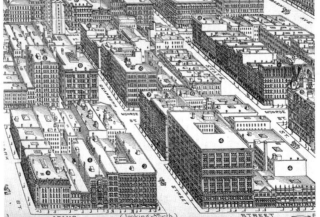

business district, had burned to the ground. Nearly one-third of the city's population of three hundred thousand were homeless.

By this account, history was made in a single animal's rebellion, rendering mass destruction while also clearing the staging area for a phantasmagoric theater of the future. As the story goes, old Chicago burned to the ground and modern Chicago rose, phoenix-like, from the ashes. The transformation—or at least the impulse for it—was immediate. Two days after the fire, on October 12, Joseph Medill proclaimed in a *Chicago Tribune* editorial: "Chicago Shall Rise Again." Within weeks, Potter Palmer secured funding for a new Palmer House Hotel across the street from the first and advertised it as the "World's First Fireproof Building."

Called *shikaakwa* by the Miami-Illinois tribe for the skunky smell of the wild-onion that grew on the banks of Lake Michigan, "Chicago" is a French transcription of the earlier name for the area. Founded in 1833, with an initial population of 350, before the fire, it is said, Chicago's streets curved around the Lake Michigan waterfront and followed the course of the Chicago River and a network of cattle paths lain over Native American migration routes. In contrast to the organic form of the city associated with the early settlers, modern Chicago would be organized as a grid, with address numbers that could tell any pedestrian where they were in relationship to the central point (0,0) of State and Washington streets. According to plan, the modules of this new grid, great skyscrapers, grew up from the rubble like gigantic, up-stretched skeletons of cast iron and, later, steel. The grid, "a framework of spaced parallel bars" according to the Oxford American Dictionary, appears here as the image of an emerging modernity.

Embedded in this enormous gridded lattice were uniform apartments and office spaces carefully divided into smaller modules of uniform height, width, and length. The offices were filled with supplies delivered in stackable boxes that could be unloaded into standardized desks with little drawers designed to hold gridlike organizers filled with more standardized supplies. A harbinger of long-distance commerce to

3

come, Sears, Roebuck and Co., the mail-order company that shipped goods to the world, was born here. A 1906 picture of Sears' order-processing room shows how the industrial grid echoes itself at smaller scales that link the city's gridiron to the office building, then to the manufacturing and distribution process, and finally to the desktop of each worker. Inside this modern factory space, uniformed female office workers labored in a carefully organized grid of identical desks on which stood legions of clipboards—always to the left—with printed order forms snapped to them. The modern work environment is made of such modules, each module the same as the next, each made up of smaller modules adapted to an incorporated whole. Applied with such authority by designers, it comes as no surprise that the modern grid has been at times reviled as a mechanism of dehumanization and at others celebrated as uniquely efficient.

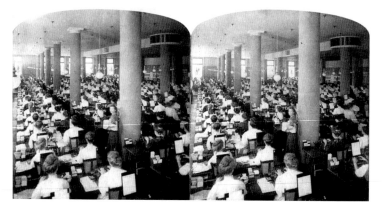

0.3
Making a record of the customer's order, Sears, Roebuck and Co., Chicago, Illinois, 1904. Chicago Public Library, Special Collections and Preservation Division, CCW 20.23.

Even today, Chicago sees herself as the quintessentially modern city of industry arisen from an Indian settlement-turned-cowtown-turned-rubble-turned-honeycomb-and-cubical. Most Chicagoans and tourists never learn that Mrs. O'Leary was later acquitted of the dastardly deed, that Daniel "Pegleg" O'Sullivan or another neighbor stepping out from a nearby party possibly started the fire while trying to pilfer some milk, long after Patrick and Catherine O'Leary had gone to sleep. It doesn't matter that the fire department sounded an alarm that sent the wagons to the wrong neighborhood as the O'Leary fire spread, that several other fires started simultaneously in Chicago on the fateful night perhaps as the result of a meteor shower caused by the breakup of Biela's Comet, or that the fires spread because the system was already exhausted from a sweep of fires the night before. We certainly don't learn (or can't remember) that the city was already laid out on a grid *before* the fire, though, fatefully, in the flammable materials used during that first wave of development.

Our oversights are easy enough to explain. The O'Leary story is simply better than these corrective facts. It resonates with an emergence into modernism that is foundational both for Chicago and for American expansion in general. As history, this story offers an emissary of a simpler life, the dairy farmer Catherine O'Leary, whose accident symbolizes the predestined exchange of an agrarian life for one of efficiency and industry. This fiction held sway well before time eroded the facts. Chicago papers published the poetic and factual accounts side by side, as if to suggest their equal merit. The *Chicago Evening Journal* said as much at the time: "Even if it were an absurd rumor, forty miles wide of the truth, it would be useless to attempt to alter 'the verdict of history.' Mrs. O'Leary has made a sworn statement in refutation of the charge, and it is backed by other affidavits; but to little purpose. She is in for it and no mistake. Fame has seized her and appropriated her, name, barn, cows and all."[2]

The fundamental elements of Mrs. O'Leary's story, in which nature-fated destruction virtually necessitates emergence into the grids of industrial life, is repeated in the genealogy of many cities.

The destruction occurs by warfare with the Dutch in New York, by earthquake in San Francisco, and by revolutionary agitation in Paris. In each of these instances, the grid plan takes over in apparent opposition to nature, including human nature, whose form is irregular and inefficient. Ever since these early, apparently wholesale transformations, the interconnected, nature-subsuming grids of the emerging modern metropolis have proven themselves infinitely appealing and adaptable, guiding the creations of not only city planners and architects but artists and designers throughout the twentieth century and into the twenty-first. Coupling this application of grids with the O'Leary story and stories like it, one could even argue that the grid is the dominant mythological form of modern life—a visualization of modernity's faith in rational thought and industrial progress comprising everything from the urban landscape to the power grid, from modernist painting to the forms of modern physics.

In 1979 art historian Rosalind Krauss wrote "Grids," an essay that neatly distills this mythology and its limits. She describes the grid of modernist painting as "flattened, geometricized, ordered … antinatural, antimimetic, antireal. It is what art looks like when it turns its back on nature."[3] Following Krauss's account, the modernist grid is an emblem of industry. It reflects standardization, mass production, and the newly smooth mechanics of transportation. In the modern imagination, in other words, the grid pits culture against nature and the body: it "turns its back on nature." Equally importantly, it reflects an evolutionary, even unavoidable, allegiance toward these efficiencies. After criticizing the separation of the grid from nature, Krauss goes on: In the modern era, "The grid is the means of crowding out the dimensions of the real and replacing them with … aesthetic decree."[4]

The grid, however, has a history that long predates modernity, and the living material excluded by the process of "crowding out" by modernist painters is precisely what the grid frames in its many nonmodern forms and indeed in many of its modern expressions, as we shall see. The urban grid was operational long before the Chicago fire,

long before it was conventionalized as a symbol and product of the modern metropolis and its attendant industrial progress. A return to Mrs. O'Leary demonstrates the persistence of these premodern grids. At the outset of the fire, our much maligned beast stood in a cow-shed, the simplest of buildings, a single module in an irregular grid that included other buildings. The grid existed in the long, skinny plot that housed Mrs. O'Leary's cottage and shed and in the maps that brought Irish Catholic immigrants like her to America. The grid was there in every hymnal with musical notation, in the ledger books in every shop she entered, every printed sign she encountered, every newspaper she read or didn't read. The grid existed in the surface of every brick wall and every building facade dotted with regularly spaced windows and their panes.

The persistence of grids demonstrates that once a grid is invented, it never disappears. At least not yet. This book tells the story of the evolution of each grid from the handmade brick through the ethereal Internet in the language of a generalist so that the provisional history laid out here is accessible across many fields. In this narrative, the Paleolithic brick of ancient Mesopotamia, the first grid module, is rolled into a slab and stacked to make buildings and cities. These city grids in turn are projected onto the landscape as maps and coordinate systems whose measure suggests the measure of time that is founda-tional for musical composition. The "looking through" of map pro-jections suggests, by various turns, moveable type and, when peeled up as a screen, the rudiments of Renaissance space and photography and the evolution of the Newtonian universe. With the invention of moveable type and modern mechanics, grids could be mass produced, effectively becoming a universal space. This universal space takes the form of the modernist boxes of architecture and painting alike, which then melt away into the ether of the Internet's World Wide Web.

As I am an art historian of the post-1945 period, this list of grids clearly falls beyond the scope of my specialization. I am well aware that certain debates, positions, and connections suggested by this list would be rendered more complex or subtle in the hands of an expert

in each field. Such subtlety would have doubled the length of this project, however, bogging it down with technical details relished by the specialist but largely beside the point for the overall thrust of this interdisciplinary adventure tale. Equally important, this project was born of personal necessity. Three years ago I was working on a book about transdisciplinary art programs in post-1945 America. Looking at the geometric abstraction, musical notation, choreography, and performance formats of the 1950s and 1960s, I saw grids everywhere. What's more, they had premodern histories that converged in interesting ways. I began looking for a transdisciplinary theory of artistic form. None existed. This book describes my journey through the grids of other disciplines as described by an art historian deeply humbled by the complexity of each. I am not a linguist or a cartographer, or an economist, musicologist, or technical historian. Nevertheless, I hope to be a welcome guest in each field, and not a mere trespasser. It is fitting that this interdisciplinary time traveler would hail from art history, which (broadly speaking) studies the social evolution of visual forms.

How amazing it is that grids evolve as they do! They do not, however, evolve in isolation. Rather, the quality of each grid progressing to the next ties them to political, social, economic, and religious histories, each grid aligning with a different universalizing scheme. Large-scale urban planning follows on the invention of the grid plan and reflects the expanding scope of the Egyptian bureaucracy. Vast territorial conquest requires maps, which appear during the reign of Alexander the Great and signify expanded imperial power. Orchestral performance is inextricably bound up with the invention of musical notation and the spread of Roman Catholicism. Mass literacy is unimaginable without moveable type and reflects the literacy required by a newly emergent merchant class in the early modern period. Each of these grids scales information, whether domestic, geographic, musical, or textual, and on behalf of its user, by turns a bureaucracy, an empire, a church, and the emerging merchant class.

A view of the grid as a framework for large-scale socialization is consistent with French anthropologist Claude Lévi-Strauss's description of myths as social glue that structure real data in the simplest way, while remaining adaptive to specific contexts and detail. (While grids are present in virtually all societies, it should be clear by now that the subject matter of *The Grid Book* focuses on the West, in which individual grids have proliferated and persisted most of all—for better and for worse.) Myths, it is important to note, are not lies by this account, but rather tools used to efficiently structure information on behalf of society. Lévi-Strauss writes, "mythical thought always progresses from the awareness of oppositions toward their resolution," a description that goes some way toward explaining how myths organize a seemingly chaotic natural and social world.[5] Following Lévi-Strauss, grids would be said to state the opposition between the detail and the totality, the chaotic and the ordered, and the individual and society geometrically, as a relationship between the square module (or what it contains) and the grid. This opposition is resolved by the homogenizing power of the gridded field. The modernist version of the ancient grid-myth, in other words, serves a vision of historic progress that mediates between the capriciousness of nature and the order of industry. Following the homogenizing function of the grid to its logical conclusion, the grid-myth of Western civilization could be described as a dehumanizing mechanism of social control—but we will not buy that.

Schematic value notwithstanding, the preceding account fails to explain the wide variety of grids throughout history, their continued use long after their function on behalf of one group has dissipated, and the changing use of each grid within and beyond its original context. Sigmund Freud, for example, conceived of the human mind as a grid, by which account the grid would be intrinsic to the human drives and not a mere expression of social control.[6] Whatever the origin of each grid in establishing a social standard, the recurrent transformations of grids, the ways in which they break down, shatter, bend, and adapt to unanticipated purposes, suggest that the homogenizing

9

dimension of the grid-myth begs for reversal. One could even argue that the life of each grid is defined by such reversals.

In one of his famous critiques of power, French philosopher Michel Foucault writes, "In order for there to be movement from above to below there has to be capillarity from below to above at the same time."[7] The implication for a biography of grids is clear. As much as they produce opportunities for organization, communication, and control, they also offer occasions for analysis and, where the grid is broken, cultural upheaval and change. Abandoned brick buildings on the urban grid, for example, might become squatter settlements or artists' studios. Left uninhabited, or subject to destruction by force, these abandoned spaces further degrade into rubble. The potent symbol of hearth and home, the brick, has become in this state almost synonymous with revolution and warfare, in the form of collapsed or thrown bricks, as in the frequent images emanating from the American war in Iraq. It is important, in other words, not to mistake the regularity of the grid and its attendant connection to social, political, or economic power as a permanent state. If grids are gods according to the grid-myth, the pleasure (the devil?) is in comparing their details.

Grids and the material they contain are in a constant state of variation. Their evolution gives them some of the animating features of living things, and suggests the possibility of seeing them as individuals caught in their own life cycles. The French art historian Henri Focillon anthropomorphized forms along these lines in his 1934 book *The Life of Forms in Art*.[8] His nonuniversalizing, even anarchic chronicle of the life of a form traces the dynamic transformation of the stubby pointed arch to the leaping and impossibly attenuated forms of high Gothic architecture. For Focillon it was crucial that art develop in response to changes in materials and techniques. Political, social, and economic facts might be interesting, but they were not enough to explain appearances: "The most attentive study of the most homogenous milieu, of the most closely woven concatenation of circumstances, will not serve to give us the design of the towers of

Laon."[9] Rather than following a predetermined thrust forward, forms by his account are in a constant state of becoming; unstable and perpetually changing course, they are discontinuous by definition. The manifold variety and inexorable evolution of grids in this study are consistent with his view, albeit tempered by a sense that social developments and individual interest are aspects of the change.

Following Focillon, it is *use* that brings each grid to life. In his essay "In Praise of Hands," he imbues hands with the ability to exert use and bring life to forms, describing them as thinking tools, as makers with a peculiar sense of independence: "Through his hands man establishes contact with the austerity of thought.... Hands are almost living beings. Only servants? Possibly. Servants, then, endowed with a vigorous free spirit, with a physiognomy. Eyeless and voiceless faces that nonetheless see and speak."[10] The history of the grid is a living history of crafted things—from the handmade object to the World Wide Web. Made by human hands, grids are endowed with a most human contradiction: a vigorous free spirit and a propensity to control. And what of the habitual hands of Mrs. O'Leary? Her servants pulled the udder, which riled the cow, which kicked the lantern, which started the fire, which nearly sealed the fate of the grid. But merely nearly. That mythical creature, the grid, was ready with the aid of builders to leap from the ashes, phoenix-like, leaner, meaner, and stronger than ever before. But not everlasting. The few scraps that remained of Mrs. O'Leary's farm were torn down in 1956 to make space for the new Chicago Fire Academy. Here, fires are forever set and doused by aspiring firemen and women, a fitting reminder of the grid's constant making and unmaking. There'll be a hot time in the old town—tonight and *every* night.

1 BRICK 9000 BCE

IMAGINE YOU ARE HOLDING AN EVERYDAY BRICK. You have probably pictured it in one hand. With few exceptions, since the brick was invented, it has been easily grasped this way. You might almost say that in order to be a brick, the object *must* be handheld. Of course the brick begins in the flesh of the hand; the hand is the agent of its incarnation, the instrument of its personality. Routinely shaped to a ratio of approximately 4:2:1, the handmade brick is clapped on each side into a roughly rectangular form and capped at each end by the slap of a palm. Do this enough to some malleable material and you get a nice, handmade brick. In addition to this manual imperative, the dimensions of bricks are pre-set by the human hand and their drying needs: whether mud or clay, parched by air or by fire, they must dry all the way through—too thin and they crack, too thick and the core stays forever moist. In other words, the form of the brick is a product of harmonious intrinsic and extrinsic demands. The grid character of the brick, however, is revealed in its use. Bricks are lined up end-to-end in rows staggered one on top of another, with mortar in between. The builder holds the brick in one hand and a mortaring tool in the other, producing a grid that is equal parts mortar and module.

1.1

Daily life and trade along the Nile. Making bricks from mud and chopped straw, Nile River, Egypt. Photo: Erich Lessing/Art Resource, New York.

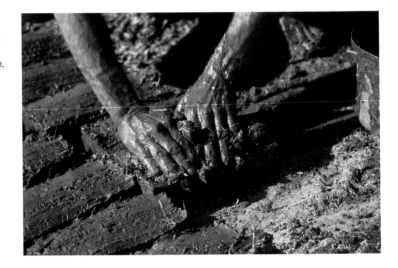

In the Babylonian creation myth, God turned men out like bricks from clay molds. It was men who built bricks into walls. The first grid, the brick wall, easily evokes associations with the human body. The wall of handmade or hand-molded clay bricks, which is any clay wall made before the nineteenth century, has a rich and varied surface texture, like skin. The bricks seem to swagger up and down in undulating zigzag patterns; the wall pulses with dents, furrows, and bulges. In time, a brick wall will seem to breathe as the brick cells cohere in a unified field of vertical and horizontal, shifting like a tectonic plate. The much vaunted "warmth" of brick walls comes from their relationship to their makers—a human warmth that is added to the real warmth of fired bricks. In the words of one writer: "Brick and the building techniques of bricklaying … betray an alternative order of the flesh—not raw but purple and made of identical cells. We create everything in our own image. The brick is the elemental self-portrait of the human species."[1]

All this said, there are bricks that do not originate in the hand. There have been flatter brick forms, particularly in ancient Rome, where large, square, flat bricks based on the size of the Emperor's

feet predominated. These slab-style bricks, when stacked up to make walls, created striated rather than gridded patterns. In modern architecture, this striated patterning would make a famous return in the double-length "Roman" bricks Frank Lloyd Wright used. There are other varieties as well. To make curved, angled, domed, towered, and lateral architectures, bricks have been formed in various nonquadrilateral shapes—wedges for keystones and arches, arced bricks for columns, and inverted pyramids for plazas, for example. Bricks with one ornamental face have been arranged to create both abstract patterns and representational images that obscure the staggered grid of the simple brick wall. Such variations notwithstanding, the standard brick and the wall it forms when stacked have remained largely unchanged since the birth of the grid some 11,000 years ago.

Beginning in about 9000 BCE (just prior to the waning of the last Ice Age), Neolithic humans in the Middle East discovered that rather than following the migratory paths of animals or the seasonal cycles of plant life, they might just stay put. Hence began the process of domesticating animals, cultivating crops, and making bricks. These early settlers of the Middle East discovered that mud, and later clay, could be formed by hand or squeezed between boards and sun-dried into the stackable form of a staggered grid still used to form brick walls.[2] The staggering, where the module is shifted regularly to one side of the one above it, is structurally necessary for brick walls since the long side of each brick supports the breaks between two bricks above. The staggered grid can be seen as small-scale versions of the force grid of familiar post and lintel architecture: two posts supporting a beam becoming two bricks supporting a third across the vertical and horizontal spread of a brick wall. Joined or placed just so, walls would become houses, irrigation canals, and security walls, the latter of which would make towns possible. A revolution in human life had occurred, one that would move civilization, and with it the brick, from the Fertile Crescent of the Tigris and Euphrates River Valley (Syria, Iran, and Iraq) along two paths: west across the Mediterranean to Greece, Italy, Spain, and the rest of Europe, and

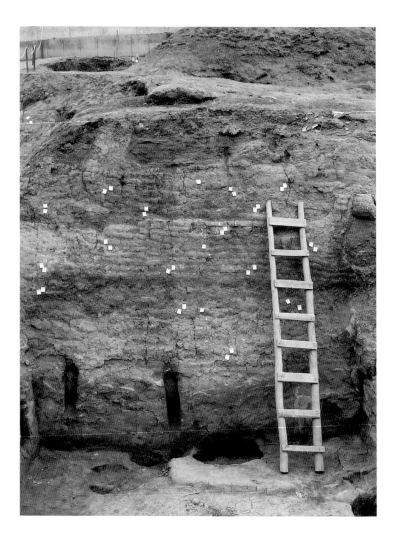

1.2
Çatalhöyük, south wall sequence
of walls in Shrine 10 with ladder
showing modern archeologists'
sole point of entry into the room.
Photographer SHL, 2005. Location:
Stanford University Çatalhöyük
Image Database.

northeast into Central Europe and Asia, with the brick reaching England and Scandinavia last, in around 3000 BCE.

Archaeologists have dated the launch of this migration to the settlement in about 9000 BCE of Neolithic Jericho in modern Jordan, where the first bricks of sun-dried mud were produced sometime between 8300 and 7600 BCE. These archetypal bricks, the bricks that established the brick for posterity, were hand-formed like loaves of bread and mortared together with more mud. During the next millennium, they would become more regular in size and shape and take on thumb indentations, concave pocks that made them more receptive to the mud mortar. Though we certainly couldn't call this a signature in the modern sense, it nevertheless imprints the brick with the mark of its maker. One imagines a field of concealed thumbprints, elemental self-portraits, tucked away inside these ancient walls.

By about 6000 BCE, wooden molds that produced standardized bricks supplemented the hand-formed method. In an era before mechanical wood planes, the hand-hewn boards of these early molds would have taken inordinate amounts of time to produce. But the effort was worth it. These bricks were more uniform in size and more squared in form and could therefore be more reliably stacked into rectilinear walls. Still, the handmade brick was not replaced by the molded brick. Far from it. (Technological evolution seldom results in full replacement of the existing technology—you're reading this book, after all, on the age-old page.) Rather, those who could afford the new technology had more options from this time forward.

Jericho gives us the earliest examples of brick, but Çatalhöyük in modern Turkey tells more of its use in these ancient brick towns. Çatalhöyük, a Neolithic trading city of 10,000 inhabitants dating to 6500 BCE, had no streets or alleyways. Each mud-brick-walled structure of Çatalhöyük was added to another to form a continuous mass, like a propagating crystal cluster. The knot of buildings was navigated over rooftops and entered exclusively by ladder. Communal life was carried out on these rooftops, as were trade and religious rites. Though windows and doors were thus not particularly relevant

17

to the function of brick for the earliest bricklayers, the homes in this ancient Turkish metropolis were no mere rudimentary structures. The builders at Çatalhöyük used many kinds of brick of varying texture, density, and rectilinearity; one building often consisted of some four different types of brick, produced both with molds and by hand and then plastered meticulously to a smooth surface. A first course of mud bricks was laid out to establish the floor plan of the building, including storage area, kitchen hearth, and benches in which the dried bones of dead family members were entombed. Above this, rougher and recycled bricks could be laid and filled in with mud mortar, ending with a finished, flat roof.[3] The variety of bricks made each part of the building, including built-in furniture, appropriately responsive to time, gravity, weather, and environmental change. When a building nonetheless collapsed, the rubble contributed to the elevation of Çatalhöyük, which grew to roughly sixty feet high during its thousand years of habitation.

Between 5000 and 3000 BCE the farming villages of the Fertile Crescent developed the religious, mathematic, and intelligible cultures we now associate with ancient Mesopotamia, the so-called cradle of civilization. In about 3000 BCE fired brick would appear in the region, making possible the large-scale permanent architectures of great kings and gods. (The technique then followed trade routes to the great cities of Ancient India, such as Harrappa and Mohenjo Daro, where fired bricks appear in the third millennium BCE.) Firing or cooking the brick greatly increased its life span and strength. Perhaps equally importantly, fire imparted symbolic warmth to the brick, an association that remains to this day in the image of the hearth. While the method was widespread, firing clay into brick was no small task, as clay must be brought to 950 to 1150 degrees Celsius before it vitrifies. This of course required kilns and fuel, which was scarce in the region. Recent explanations for why civilizations diminished dramatically in size in this area after this period speculate that destruction of the ecosystem stimulated by the need for burnable fuel used in brick

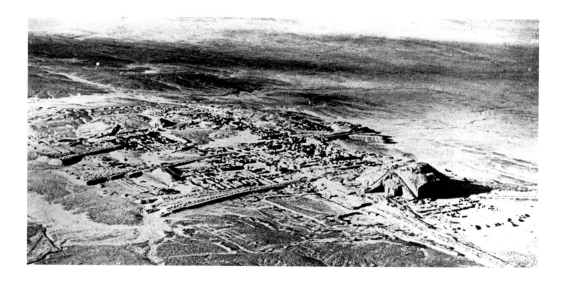

manufacture was a contributing factor. In ancient Ur, which became a powerful city-state between 4000 and 3000 BCE, and where the first brick arch was built, fired brick was nearly thirty times as expensive as its more common mud counterpart. Savvy ancient builders found ways to economize, for instance by filling the core of their ziggurats with mud brick and saving the high-end fired bricks for the exterior. The famous Ziggurat of Ur was originally made with air-dried mud bricks, which were later replaced with more durable, fired clay bricks. A stepped pyramid, the ziggurat demonstrates that the rectilinear composite of bricks need not necessarily result in an overall rectilinear form.

The ziggurats of ancient Mesopotamia—enormous, stepped pyramidal bases for temples—stood at the center of ritual renewal, linking the prosperity of the state to the pantheon of gods and to their kings. The Sumerian word for brick, *sig,* also means building, city, and the god of the building. Like today, the laying of the first brick of a building could be ceremonial. In some places, for example, the laying of the first brick was accompanied by offerings of food and drink to the brick god. To initiate public buildings including ziggurats, the king

1.3
Aerial view of Ur, Mesopotamia, including "White Ziggurat," excavation area. Photo: Foto Marbur/Art Resource, New York.

himself would produce and lay the first brick. This brick was called the *asada,* or "invincible one"; its making was highly ritualistic and attended by divinity, as the following account attests: "[The king] put the blessed water in the frame of the brick mold…. He set up the appropriate brick stamp so that [the inscribed side] was upwards; he brushed on honey, butter, and cream; he mixed ambergris and essences from all kinds of trees into a paste. He … acted precisely as prescribed, and behold he succeeded in producing a most beautiful brick…. He struck the brick mould; the brick emerged into daylight…. The sun god rejoiced over [his] brick, which he had put in the mold, which rose up like a swelling river."[4] Clearly the brick was an object of not only functional but great ceremonial and aesthetic significance.

Perhaps the greatest (and most famous) ziggurat of all was built in Babylon some two thousand years later. Made of as many as thirty-six million bricks, it was about sixty yards, or roughly seventeen stories, high. Between 604 and 562 BCE Babylon reached the peak of its political power under the rule of King Nebuchadnezzar. At this time, the city was enormous by ancient standards, boasting a brick palace of hundreds of rooms that featured a great, glazed (waterproof) brick processional and molded ornamental bricks in the throne room, attesting to significant technical and decorative advances. There was also a complex urban fabric and a double ring of high-walled defenses, with the external ring wide enough for a four-horse-drawn chariot to circumnavigate the city. Imagine the effect in an era before highway overpasses—it would have resembled flight itself!

The grandeur of this accomplishment has suggested to many that the ziggurat at Babylon is the inspiration for the Tower of Babel, which appears in the Old Testament as a symbol of hubris, the crime of equating oneself with the very power of the divine. It is noteworthy, too, that here is where bricks first appear prominently in the biblical literature, albeit reduced to rubble, the anarchic rebuttal to the secu-

rity and order represented by the seemingly permanent brick walls and towers of the ancient megalopolis. Babel appears in Genesis 11:

> Now the whole earth had one language and few words. And as men migrated from the east, they found a plain in the land of Shinar and settled there. And they said to one another, "Come, let us make bricks, and burn them thoroughly." And they had brick for stone, and bitumen for mortar. Then they said, "Come, let us build ourselves a city, and a tower with its top in the heavens, and let us make a name for ourselves, lest we be scattered abroad upon the face of the whole earth."
>
> And the Lord came down to see the city and the tower, which the sons of men had built. And the Lord said, "Behold, they are one people, and they have all one language; and this is only the beginning of what they will do; and nothing that they propose to do will now be impossible for them. Come, let us go down, and there confuse their language, that they may not understand one another's speech." So the Lord scattered them abroad from there over the face of the earth, and they left off building the city. Therefore its name was called Babel, because there the Lord confused the language of all the earth; and from there the Lord scattered them abroad over the face of the earth.

Indeed the Tower of Babel was quite likely the *bab-ilu,* the "Gate of God," of the Babylonian tower temple, which translates to *bavel* in ancient Hebrew. That the punishment should be the infliction of *balal,* or "the confusion of language," represents a biblical etymological pun linking botched communication to the destruction of the brick tower.[5]

The association of the Tower of Babylon (the ziggurat) with the fragmentation of an original universal language suggests a simultaneous disintegration of culture and the body. This association in fact had its origin in the Babylonian creation myth, where, by some accounts, God created human beings as bricks in molds. In Genesis 2:7 the spirit of the divine gives life to the human being as he likewise mingles with the mud. "And the Lord God formed man of the dust

of the ground, and breathed into his nostrils the breath of life; and man became a living soul." In the Old Testament spoken language (breath) predates death itself, as it was given before the betrayal in the Garden of Eden that made human beings mortal. Human beings, then, represent God's mixing of the Earth and the word: a kind of speaking brick. When Yahweh destroyed the Tower of Babel, in other words, he both denied its builders the powers of universal communication bestowed on human beings since Creation and symbolically separated once again the formed clay (the brick/the human being) from the word, returning both to the soil when he scattered them over the face of the Earth. If the brick is the elemental self-portrait of the human species in this account, rubble is the unofficial portrait of a shattered civilization.

Ancient cities like Babylon slowly disappeared as the mud bricks, and later the fired bricks, broke down into great rubble mounds, called tells, upon which subsequent structures were built. Archeologists measure the passage of millennia by studying the strata, or levels, of these tells, which are now compressed one atop the other. Tells could be quite high; for example, the tell of Çatalhöyük was over sixty feet high, Megiddo in Palestine stood over seventy feet high, and Lachish, also in Palestine, was over one hundred feet high and eighteen acres in area. Ancient writers mentioned these tells. The description in Joshua 8:28 of the taking of the Canaanite city of Ai by the Israelites shows us that tells could form quickly by the hand of man, not just slowly as a course of nature: "So Joshua burned Ai, and made it into a tell, which it is to this day."

Joshua's plundering was not limited to Ai. His Israelite army reputedly decimated the fired brick wall of Jericho, which in about 1900 BCE replaced the earliest known wall—a mud-brick fortification that had protected this desert oasis since about 9000 BCE. Joshua's legendary Jericho battle is forecasted in Joshua 3:6: "And when ye' hear the sound of the trumpet, all the people shall shout with a great shout; and the wall of the city shall fall down flat, and the people shall ascend up every man straight before him." The actual outcome is debatable:

a tell has been found on the site, but no irrefutable evidence of Joshua leading the Israelites into Canaan after crossing the River Jordan. What happened was more likely a slow infiltration and transformation of the Canaanite civilization by the Israelites over the course of generations. The story's symbolism is nonetheless consistent with the association of the brick wall with the human body in the form of physical analogue. Both are upright, the wall functioning as body armor, until it falls down flat and the Israelites ascend up every unarmored man. Like the wall of Jericho, the Great Wall of China, the Berlin Wall, and the security fence between the United States and Mexico, walls function as prophylactics between human beings. Whether once wall or building, in its "down flat" state, pulverized brick signifies cultural collapse. To wit, throughout history, imagery of rubble accompanies virtually every story of the destruction of a civilization.

Albeit vulnerable to ruin like the rest of the ancient world, the structures of ancient Greece displayed a key difference: fired bricks were largely unknown there. This prompts a brief material detour:

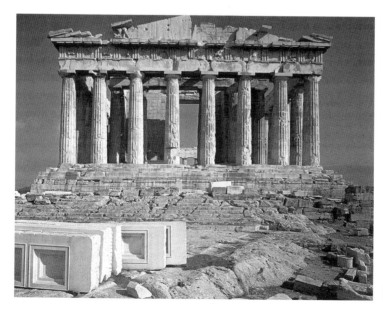

1.4
West facade of the Parthenon Temple, Acropolis, Athens, Greece. Photo: Scala/Art Resource, New York.

the primary building blocks of Greece's ceremonial architecture were made of stone—which is plentiful there—large blocks of uniform color and much larger than bricks. Despite this disparity, the proportions of Greek architecture involve harmonious geometrical relationships that, though not displaying the graphically gridded surface created by mortared brick, express a precisely proportioned rectangle that is reminiscent of the brick itself. Another way to put this is that in ancient Greece, the object of the brick is effectively eclipsed by its idea as the brick became explicitly theorized in its ideal form as a rectangle.

Take, for instance, a rectangle drawn around the façade and pediment of the Parthenon in Athens, a classic example of Doric architecture and by many accounts an embodiment of the golden ratio, a proportion of 1.6180339887 that is commonly represented by the Greek letter Φ (or Phi). Phi is used to explain the harmonic patterns of simple musical tones and also reflects the proportions of the golden rectangle, which is formed such that when a square is drawn inside it using the length of the short side, the remainder on the long side forms another rectangle of equal proportion to the original, so that it too can be cut down into a square, and so on, to infinity. This proportion occurs repeatedly not only in architecture, art, and geometry, including contemporary fractal geometry, but in geometric forms in nature, such as the spiral of conch shells and rotating galaxies. Phi's ubiquity in both nature and culture inspired the medieval mathematician Johannes Kepler to call it "the divine proportion."

Modern mathematician H. E. Huntley extrapolated from the golden section (a single line demonstrating the ratio Phi) a three-dimensional golden cuboid that is shaped quite like a brick.[6] As Phi would have it, when three vertical lines bisect this horizontal form equally, the three sections each have the same ratios as the original rectangle, and their relationship to the original is a function of Phi. In other words, the geometry of the most ancient brick partakes of the so-called divine or golden proportion. Pythagoras, the first great

mathematician in the West, developed a mystical philosophy of numbers as the common substance of all things, theorizing a world unified through numerical relationships. He is famous for figuring the area of the triangle as a function of the relative lengths of the sides of the right triangle ($a^2 + b^2 = c^2$), but patterns in his Pythagorean Theorem correspond to Phi. His mathematical mysticism would have taken quite a liking to the elementally geometric brick.

The Romans took a hybrid approach in their ceremonial buildings, using stone blocks, like the Greeks, for the facade, and bricks, like the Mesopotamians, for the substructure. This concealment might explain why Marcus Vitruvius Pollio wrote only a few words about bricks in his influential *Ten Books on Architecture.* Or perhaps the technology of the brick was still relatively new in Rome when Vitruvius wrote, between 30 and 20 BCE. In any case, bricks were central to the structural innovations of Roman architecture. The Romans preferred mud brick for domestic architecture, but fired brick was introduced by way of the Etruscans, and both paved the way for the great examples of Roman public architecture and early Christian buildings.

Although Roman bricks differ in proportion from the handheld standard of their predecessors in ancient Mesopotamia, the Romans maintained a strong link between the proportions of an ideal physical body and those of the brick. According to Vitruvius, the smallest brick was the *bessalis,* which was about eight inches (200 mm) square, or roughly the length of a hand. Another common brick was the *pedalis,* which was about one foot (295 mm) in length and based on the human foot, as dictated by Emperor Diocletian. The two largest, and least common, forms of brick Vitruvius mentions would more properly be called slabs. The *sesquipedalis* measures one-and-a-half Roman feet (450 mm) and the *bipedalis* two Roman feet (600 mm)—with both sizes again determined by the proportional ideal represented by the body. These had decorative functions when cut down, but also made significant appearances in brick and slab floors.

The peak of Roman brickwork dates to the end of the first and second centuries CE, nearly a century after Vitruvius wrote his historic books. Roman brick architecture is famous for the great leaps in space traversed by the bowed forms of enormous arches that made up the aqueducts and coliseums of classical renown, not to mention the unprecedented structural support of the concrete dome of the Pantheon. The coastal town of Ostia was built using elaborately carved and molded bricks that lay nearly flush thanks to the invention of a new, faster drying lime mortar. Bricks would find themselves at the center of Roman imperial grandstanding, whether by being spurned or extolled. Where Emperor Augustus boasted famously that he had "found a Rome of brick and replaced it with stone," Cicero would associate the brick architecture of the Forum with the glory of Rome itself.

Another Roman brick innovation is the increased use of identifying stamps, which enable the bricks to be dated and linked to specific manufacturers and landowners. This evolution occurred under Emperor Trajan, who reigned from 98 to 117 CE, when the Roman brick industry was rapidly expanding and Roman decorative brickwork coming into its own. The ruins of the famed Trajan's Market, with its arch-inlaid facade and multifloored corridors of shops, can still be seen within the Forum. Not only the decorative, but the engineering achievements of Roman brickwork reached a fever pitch at about this time. The earliest aqueduct, the Aqua Appia, was built in 312 BCE, and by Trajan's era ten of the eleven celebrated aqueducts of ancient Rome were complete. These brick wonders of civic infrastructure piped water into the capital from as far as fifty-six miles away—by gravity alone. They supplied not only drinking water, but the Roman baths of which the populace was so fond. Complex brick hydraulic systems in the bath buildings took advantage of the insulating qualities of brick, serving both to warm the water over hot gas pipes, and also, through evaporation, to cool the water for the customary final cold plunge.

The Roman Forum, domes, baths, and aqueducts would be followed by brickwork masterpieces such as Hagia Sophia (537 CE), the Byzantine masterpiece in Istanbul, and exquisite, patterned brick-laying like the basket-weave pattern of the Tomb of the Samanids (900 CE) in Bukhara, Uzbekistan, whose patterned beauty is said to have spared it from the 1220 Mongol invasion. This small building (about thirty-five feet square) presents a wide range of grids and checkerboard-like patterning. The resulting surface, softened by the earthy colors of the bricks yet dynamic in its starkly contrasting forms, represented both the actual bodies in the tomb as well as symbols of the "afterlife."[7] Likewise, Islamic brickwork in the Middle East would favor patterns of many kinds—stripes, grids, and more—that function as a kind of superrhythmic overlay to the brick walls that support them. Indeed, if the eye zigzags at a measured pace over the brickwork of a standard brick wall, it positively flies across the visually energetic surfaces of dark and bright squares found in Islamic architecture.

In medieval Europe as well as China, soaring churches and pagodas would use brick to link Earth to sky. In Poland and northern Germany, for example, *Backsteingotik* ("baked-stone Gothic") churches dominated from 1200–1600 CE. But medieval brickwork was as important for its place in the social evolution of complex craftsmen guilds across Europe as for any stylistic innovations. By association with the earth, given its clay origins, as well as for its handmade manufacture, brick came to represent both piety and poverty, labor and virtue. Whether because of the rejection of ornament by the Protestant Reformation in the north, or simple cost efficiency, a simple form of brick wall—straight layers carefully placed one on top of the next—came to dominate the Western world.

This style and double association made its way across the Atlantic. Beginning in 1768, Thomas Jefferson would famously use bricks in building his Monticello estate and later the University of Virginia. The millions of bricks that comprise Monticello were made on site, by slaves, but nevertheless reflect Jefferson's appreciation of

local craft traditions. For him, the material was economical as well as democratic—appropriate qualities for a burgeoning democracy.

Come the nineteenth century, with the start of the Industrial Revolution, the brick's mode of production, and thus its appearance and perceived character, would change dramatically. Since 9000 BCE, bricks had been made by hand. Bricks could now be mass-produced with mechanical molds and wire cutters. Cheap in large numbers and flame-retardant, industrial brick was efficient and safe for building large factories and ever-expanding urban architecture and worker housing. In a century when cities doubled and tripled in size in the industrial world, bricks also made up the aqueducts, sewers, canals, and tunnels that carried the products of the people. The new bricks were very uniform, which must have sped construction. Not surprisingly, many architects "liked the uniformity of the product," while "others complained that the bricks lacked the texture and character of handmade ones." Thus an early example of faux finishing came to be, as "a number of devices were thus added to extrusion and pressing machines to produce surface variations artificially."[8]

Nineteenth-century English socialist writer and designer William Morris would make much of the new distinction in brick manufacture and appearance. Starting from the assumption that the democratically run medieval guilds were "the progressive part of the society of the time,"[9] Morris praised the medieval-type, handmade, or "good brick" (his term), for its unique ability to preserve "its own outlines right away to the end," and added, "I should like to see places built of good bricks and entirely of brick."[10] For Morris, the democratic nature of the guild that produced medieval brick bespeaks a homely materialism that appends to the brick wall itself. He continues: "This organic life of a building is so interesting, so beautiful even, that it is a distinct and definite pleasure to see a large blank wall without any ordinary architectural features, if it is really properly built and properly placed together. In point of fact this seems to me almost the beginning of architecture, that you can raise a wall which impresses

you at once with its usefulness; its size, if it is big; its delicacy if it is small; and in short by its actual life; that is the beginning of building altogether."[11] In sum, the wall of "good brick" stands in the modern era as a symbol of the origins of architecture, valued not so much for its religious or political associations, but for its being properly built and socially progressive by virtue of its association with the seemingly egalitarian guild method of manufacture. By contrast, Morris cited industrial London and its worker slums as "the center and the token of the slavery of commercialism," wrought, one might conjecture, of "bad brick" (my term).[12]

Morris's acquaintance, critic John Ruskin, would likewise bemoan industrial brick as a symbol of the rapacious nature of industrial capitalism, "feeding the demands of the rows of similar brick houses, which branch in devouring cancer around every manufacturing town."[13] Charles Dickens, in his epic *Bleak House,* would devote a chapter to a London brick maker's family who lived in a "cluster of wretched hovels in a brickfield."[14] Industrial bricks, in other words, came to symbolize the negative consequences of the Industrial Revolution in terms of their manufacture, the quality of the end product, and the miserable social conditions they housed.

These double senses of brick—good and bad, crafted and mass-produced—remain with us to this day. In its day, the Soviet Union was routinely associated with the image of the utilitarian "red brick"—the color symbolizing "red" communism and the brick its emphasis on industrial labor. By contrast, the Mexican artist Gabriel Orozco describes handmade bricks used in Mexican architecture glowingly: "It's amazing how much physical effort and how much working class labor is behind each brick."[15]

Both images of the brick—the insidiously industrial and the rustic—are sufficiently established as to have found their way into popular fiction. J. R. R. Tolkien, for example, utilized this dual brick imagery in his novel, *The Lord of the Rings.* In the book the natural archaism of the original shire of "hobbit holes in the bank of the

29

North side of the pool" has been replaced by a poorly crafted "tall chimney of brick in the distance." Civic buildings, in this case a gate-house, worker housing, and the "Shirriff-house" were "built of ugly, pale bricks badly laid." The new, industrialized mills of the modern-izing shire, which are "full o' outlandish wheels and contraptions," pollute the pure earth of the shire, since "they pour out filth a purpose; they've fouled all the lower water." When the good Hobbits Frodo and Sam crush the leader Sharkey's corrupt and oppressive regime in a grassroots campaign, its symbols (the brick buildings) are also crushed: "Before Yule not a brick was left standing of the new Shirriff-houses or of anything that had been built by 'Sharkey's Men.'" Once reduced to rubble, the bricks take on a surprising new function: "the bricks were used to repair many an old hole, to make it snugger and drier."[16] The image is deceptively simple, for in it the brick returns to the earth from which it originated while also retaining its social utility. It is as if nature herself had plucked the brick from the industrial-socialist order and used it to plug a wound.

Among the modern architects most associated with the brick is Louis Kahn, who described himself as practicing a "religion of the brickwork" whose gospel clearly spoke to the elemental aspect of the material.[17] The son of an immigrant bricklayer, Kahn would extrap-olate from the handwork of his father a modern brick architecture sensitive to the natural qualities of the material at hand. His most fa-mous brick buildings include the Exeter Library (1969–1971) in Exeter, New Hampshire; the Institute of Management (1963) in Ahmedabad, India; and the National Assembly (1962–1974) in Dacca, Bangladesh, an agglomeration of pristine brick volumes, including curved volumes, that form enormous interior volumes punctured by deep window cuts. These cuts allow for precise direction of the natural light, causing the slow movement of lit geometric shapes over hand-formed bricks over the course of the day.

Speaking to a Master Class at the University of Pennsylvania in 1971, Kahn proposed the following imaginary conversation: "And when you want to give something presence, you have to consult

nature, and that is where design comes in…. If you think of a brick, for instance, you say to brick 'What do you want brick?' And the brick says to you, 'I like an arch.' And if you say to brick, 'Look, arches are expensive and I can use a concrete lintel over you. What do you think of that, brick?' Brick says, 'I like an arch.' And it's important, you see, that you honor the material that you use."[18]

In his recent book, *What Do Pictures Want? The Lives and Loves of Images,* W. J. T. Mitchell, made the remarkable observation that as we interact with images, they seem to have many of the same qualities as living things.[19] The logic can be extended to virtually any man-made object, since the things we make embody our aspirations, the ways we would use them. When asked in an interview, "What do pictures want?" Mitchell responded in terms that reflect pithily back to Kahn, "ask yourself what the word *want* means. I attribute two meanings to it: One is desire, the other one is lack."[20] "I like an arch," said the brick, because it isn't one, but would like to be. Alone, the brick is just a lump of mud or clay. As a brick, however, it embodies aspirations like social grouping, reaching, stretching, expanding, securing, and breaking—an elemental portrait of a human being.

2 TABLET 3000 BCE

PAT, ROLL, OR PRESS A WET CLAY BRICK SO THAT IT IS THINNER, broader, and longer, and you have a tablet. With the addition of one key ingredient, that is: text. The tablet, a flat rectangle of clay, stone, wood, or wax whose primary function was to be inscribed with pictographs, words, or numbers, first appeared in Sumer some six thousand years after the first brick, in about 3000 BCE. The first known writing—cuneiform script—was engraved within drawn grids on clay and stone tablets that originated, like the brick, in the city-states of the Fertile Crescent of ancient Mesopotamia. (Although there may be earlier scripts on less permanent materials as well as independent inventions of writing in Mayan Mexico and China, Sumerian texts came to be known as "the first" because they survived and formed the bases of European and Middle Eastern languages.) It is here, in other words, that humans in this part of the world first learned to build two kinds of gridded forms essential to Western civilization as we know it: brick walls and recorded narration.

Like the staggered grids of the early brick wall, the grid-buttressing early cuneiform script was not made up of clearly delineated cells resting one atop another. Rather, pictographs (conventionalized linear images that stand in for words, normally nouns) went from being

34

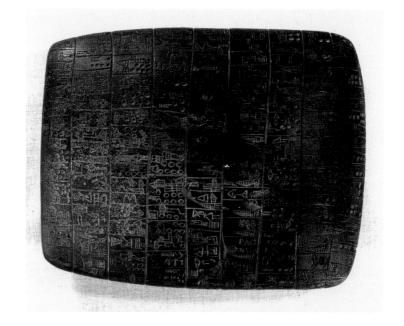

randomly scattered over the surface of the tablet to being enclosed in a system of irregular rectangles inscribed around them. The resulting compound images created clustered associations, but did not form what we would call grammatical sentences. Rather, they functioned more like lists. Throughout the evolution of tablet-based texts—from Sumerian pictographs to Babylonian cuneiform to standard biblical Hebrew and Greek and Latin scripts—this grid becomes more and more regular. By the time later ancient scripts arrive, their letters are consistently spaced and squared, a progression that stems from how they were incised, but relates equally compellingly to the subject matter of the majority of these tablets.

Most cuneiform tablets concerned financial arrangements and legal agreements, and the simultaneous development of an organized letter grid to communicate this concrete content makes intuitive sense. The organization of script into a grid, with its visually regulated pacing of the document as scanned by the eye, suggests that an

analogy might be drawn to the regulative nature of the contract as such. One might adapt a phrase from modern architecture: pictographic form follows legal function.

If the brick expresses the first form of the grid, which serves to provide protection and security by physical means, then the grid of the tablet provides security by another means: the social contract. That is, the ancient tablet expresses how human groups of various interests and political persuasions organized themselves through clearly communicated, behavioral consensus, ensuring stability via written language. From this point of view, the tablets of the ancient and classical world might be treated as portraits of the societies that made them—from them we can read how people communicated, what they valued and, perhaps most importantly, how their values were organized, expressed, and displayed permanently.

Despite its lyrical appearance to modern eyes, cuneiform script was used to document the legal and cultural activity of several highly complex cultures. Indeed, by the middle of the second millennium cuneiform script was used to write not only in Sumerian, but in Akkadian, Babylonian, and Assyrian—the languages of societies whose knowledge included astronomy, astrology, magic, medicine, law, and literature. The tablets presenting these cuneiform languages were not necessarily intended to last for millennia; they were active, functioning documents. Take, for example, the production of duplicates: in the ancient world, an original and duplicate were made in clay and signed by both parties before being placed into identical, signed clay envelopes. If a dispute arose, a judge could break the clay envelope and check the terms inside. Practical matters also dictated the orientation of the tablet, or what we might today call its layout. At first, the writing moved from top to bottom in vertical columns and starting from the right, like Chinese. Perhaps to accommodate the horizontal movement natural to the wrist of a scribe, in about 2700 BCE all characters were flipped ninety degrees. All objects in the early pictographs now faced up on the tablet, which is another way of saying that the texts now read from right to left. Later, writing was adjusted

35

to read from left to right, to avoid erasure, one imagines, on those occasions when the right-handed scribe's hand passed over freshly imprinted text in clay.

A prime example of this transition can be found in the Chicago Stone, which hails from Mesopotamia, dates to 2600–2500 BCE, and shows both orientations. The tablet details the exchange of a parcel of land for silver, sheep, fat, wool, and bread. *She* (grain) is represented by grains on a stalk and appears vertically as it had since 3000 BCE. In contrast, *Hi* (man) is illustrated by a papoose-like form lying on its back, or horizontally. *Dingir* (god) or *an* (heaven) is represented by a star, and thus has no discernible orientation.

This brings us to the pictographs themselves—ancient symbols with a comparatively unambiguous quality of relating to the visual world. Instead of the totally arbitrary connection between, for example, the letters *h-e-a-v-e-n* and the idea of the cosmos, the pictograph offers a conventional sign based on a characteristic view of the object in perceived reality. The star stands for heaven since it is seen there. Grain is even more direct: it "is" a stalk with kernels growing from it. The early cuneiform pictograph, while highly conventional, suggests that the origin of written language is fundamentally representational: this (drawn) star resembles/is like that one (out there in the sky), this (drawn) man is like that man (on the road). All the more urgent, then, to have clear symbols and a clear organizational system in which to arrange them. Were the pictographs highly individualized by each artist or the tablet less schematic in its design, the task of documenting an unambiguous contractual agreement between two parties would be compromised. (Imagine, for instance, mistakenly trading one's house for a loaf of bread instead of a field of grain!)

The advanced nature of ancient tablets as both legal contracts and visual objects contradicts the commonplace perception that a culture using pictographs is primitive, preinstitutional, or even preeconomic in its development. No less a philosopher than Jean-Jacques Rousseau made such an assumption when he wrote that "the depicting of objects is appropriate to a savage people; signs of words and

of propositions to a barbaric people, and the alphabet to civilized peoples."[1] While clearly motivated by an overdetermined sense of the (questionable) civility of his own age, eighteenth-century France, Rousseau is correct insofar as he recognized that shifts in culture can be detected in how writing looks at a given place and time. In *Of Grammatology* (1967), for example, French philosopher Jacques Derrida described the close relation between the emergences of standardized written languages and of the social contract: "The place of writing is linked, as Rousseau had intuited, to the nature of social space, to the perceptive and dynamic organization of the technical, religious, economic, and other such spaces."[2]

One example of this link between writing and social space of the technical sort occurred in about 2500 BCE, when scribes switched from the pointed stylus used to inscribe objects like the Chicago Stone to a triangular wedge. (*Cuneus* is Latin for "wedge," hence the word *cuneiform*.) Whereas the stylus point allowed for the comparatively freehand marks unique to each subjective scribe, the triangular stylus of mature cuneiform script was pressed into the clay like a stamp, with each character wrought of a particular arrangement of wedges, and thus produced lines of uniform length and thickness and characters of more or less uniform size. This regularity, born of mechanical efficiency, had a significant side effect: it led to the disappearance of the incised grid lines, which were no longer necessary. The individual letters themselves, now consistent, could be hand-pressed into self-organizing sequences of regular shapes on horizontal lines. Economies of means would therefore profoundly affect how text would look, and how it would be read. Instead of columns of grouped pictographs, horizontal rows of forms would create a jagged but regular linear letter grid, organized like the one in use today.

The shift to wedge-shaped marks had profound effects not only on how text was arranged on the tablet, but on how it made meaning, since it moved the pictograph away from its basis in representational drawing and toward the abstract representation of ideas. The mature cuneiform script that emerged in the middle of the second

Codex Hammurabi. Babylonian
inscription, 1790 BCE. This set of
laws often appeared on a vertical
pillar in public places with an
image of the king bestowing
the laws on the reverse. Photo:
Erich Lessing/Art Resource,
New York. Museum of Oriental
Antiquities, Istanbul, Turkey.

38

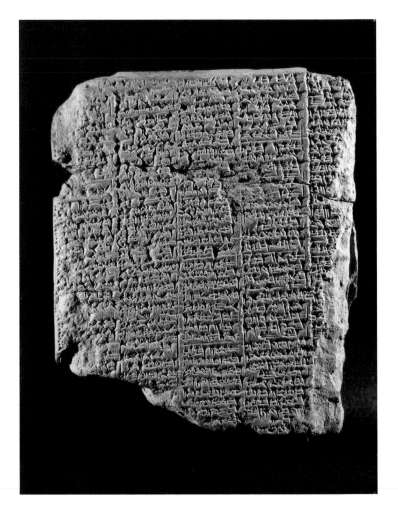

millennium BCE was widely used in many Near Eastern languages, including Akkadian (the ancient Semitic language that replaced Sumerian and absorbed many of its words), Elamite, and Hurian. The Greek alphabet has roots in Akkadian cuneiform writing, which also lent its form to ancient Hebrew.[3] It was logo-syllabic, consisting of a combination of pictographs and syllables. The cuneiform symbol for house illustrates one way in which this synthesis might occur. It resembles a floor plan, an overview of a rectangle with an opening at the bottom right of the long side. "The spoken word for house," according to linguistic historian Clarisse Herrenschmidt, "sounded something like *bayt,* therefore this symbol was used to write the sound "*b.*" In the course of the evolution of writing, the shape of the symbol lost its realistic character, but the name of the letter, *bayt,* remained concretely anchored to the value of the sign."[4]

Compounds of these characters could be used to compose new words or to spell names, and this adaptability was crucial to the formation of a new ancient world order—one dominated by trade. It was just at the time of the transformation from pictograph to ideogram that ancient Sumer, with its ancient, pictographic text, was on the decline. Ancient Babylon, on the other hand, with its ideograms, was on the ascendancy—engaging increasingly in manufacturing and international trade, not to mention the production of poetic and literary cultures. It is no accident that Babylon is described as the first city-state with a bourgeoisie and a middle class. Here, literate people who spoke different languages could all read Akkadian, which was effectively the lingua franca, or universal language, of the region. Contracts were required for virtually every business transaction, so this familiarity was mandatory for many. Notary publics wrote the contracts. Judges expert in their languages and standards interpreted them.

Cuneiform writing, in other words, was the basis for the West's first standardized writing system sufficient for the contractual regulation of a global economy. As that economy grew in size and complexity, the script became increasingly standardized and legible. Thus the evolution toward a standardized script is equated explicitly with

39

the growth of a regulated, systematic trade culture. Again, Derrida is instructive: "The trader invents a system of graphic signs, which in its principle is no longer attached to a particular language. This writing may in principle inscribe all languages in general. It gains in universality, it favors trade…. That is why the alphabet is commercial, a trader. It must be understood within the monetary moment of rationality."[5] In other words, the standardization of language enabled trade. He goes one step further. This universality is part of a larger, homogenizing cultural development that includes "the monetary moment of rationality," a mutually supportive monetary and legal system. The facts bear out the association.

Though not written on clay tablets, the Code of Hammurabi (1792–1750 BCE) is, for modern audiences, the most famous example of cuneiform writing. Hammurabi was the first king of the Babylonian Empire; he established the city's legendary greatness and unified the entire region under a common government and shared language. His Code—commonly called the first set of written laws despite the fact that others, like those of Eshnunna (1930 BCE), preceded his—have the advantage of citations in ancient sources as well as being the most widespread of the known ancient codes of law. The Code, which appeared on pillars and stone tablets in a formally regular, Akkadian cuneiform script, can be described as a covenant between kings and vassals in that it prescribed the promises of loyalty. Its 282 case laws detail criminal and civic law, economic regulation of tariffs, prices, and commerce, and marriage and divorce, rendering in permanent form the legal order of society. With its comprehensive, systematic approach, and written in the Akkadian language familiar to a range of Semitic peoples, the Code trumped the individual contracts typical of Sumerian governance and brought order and efficiency to the newly triumphant Babylonian society. Reading it, even distant subjects would know what behavior was expected of them and what the grave consequences of transgression would be.

The authority of the Code of Hammurabi stemmed not only from its content and tone, but also from its physical presence in

the form of a gridded stone tablet of cuneiform text. Indeed the durability of stone makes it a logical material for such an enduring object, a point made implicitly by Hammurabi himself in the Code's epilogue. "In future time," he commanded, "through all coming generations, let the king, who may be in the land, observe the words of righteousness which I have written on my monument; let him not alter the law of the land which I have given, the edicts which I have enacted; my monument let him not mar."[6] That the law should not be changed, was literally set in stone, speaks to its public status as well. It was intended, after all, "to further the well-being of mankind" for all time. The durability of stone also had immediate benefits, as the Code's laws were spread by carrying or installing the stone from town to town. Among other places, the great tablet was set up in the Babylonian Temple of Marduk, where it served simultaneous religious and civic functions—paying homage to the benevolence of Marduk, the national god of Babylonia, as well as suggesting his endorsement of the king's laws.

Both the enduring and public nature of Hammurabi's laws set them apart from the complex of tribal and religious customs that preceded them. As long as law was generated tribally, according to individual contracts, marital affiliations, and blood feuds, then that law was mutable and biased. Indeed, before Hammurabi the law could change at the whim of a king, or in the transition to another king an entirely new set of allegiances could fall into place. Even if the divine right of kings might supersede the law, the existence of the Code itself suggested an objective, timeless, and universal standard. These qualities are evidenced in the very form of material remains: the Code was duplicated and sent around the empire, spreading the king's voice far and wide. Fragments of the stele have been found in over forty locations across Mesopotamia.

Given this blanket dispersal of the laws, it is tempting for the modern reader to see them as dictatorial regulations imposed by an authoritarian ruler, as *logos* in the negative sense. Although laws no doubt function in the service of social authority, if we overdetermine

their commanding aspect, we miss the equalizing effect of Hammurabi's Code. For when laws are written down, they can be appealed. Rendered legible and public, the laws lent recourse to even the lowest ranked citizen under Hammurabi. Indeed, the king described their mission thus: "so that the strong should not harm the weak." Toward this end, Hammurabi's laws went far to protect the rights of women and orphans in particular, as well as those of slaves who bore children to their masters. Hammurabi was explicit in this as well. In his prologue, Hammurabi constructs an image of himself as "the shepherd of the oppressed and of the slaves … who recognizes the right, who rules by law."[7]

In addition to protecting the weak, Hammurabi's laws aimed at rationalizing the relationship between crimes and their punishment. No longer was the goal of the law to punish in excess of the deed (as in "you kill my brother, I wipe out your entire village"); rather, the punishment was designed to fit the crime. Adapted from other ancient codes, the concept of *lex talonis,* or "law of retaliation," appears in the Code as numbers 196 and 197: "If a man put out the eye of another man, his eye shall be put out. If he break another man's bone, his bone shall be broken." Perjury, or false testimony, was also punished on the basis of equivalence; the perjurer would be charged with the very crime to which he had falsely testified, as stated in Law number 3: "If anyone bring an accusation of any crime before the elders, and does not prove what he has charged, he shall, if it be a capital offense charged, be put to death."[8] Such high-stakes standards would surely have preempted many an idle accusation.

The perjury clause appears famously in the Ten Commandments as "Thou shalt not bear false witness," where other parts of the *lex talonis* appear in Exodus 21, including regulations concerning unintentional injury, injury to a third party, striking a parent, and goring by someone else's ox. Other parts of the first five books of the Bible, the Pentateuch, share with Hammurabi's Code dialogue expounding the great accomplishments of kings as well as epilogues detailing the blessings and curses that would follow adherence to or divergence from

the laws. These include large sections of Exodus, Leviticus, Numbers, and Deuteronomy and demonstrate a strong desire for consistency in the applications of law to the nation. Furthermore, when in Exodus we learn that Moses had tired himself out as a personal legal advisor to his people and was thus grateful for the Commandments bestowed by God, we might imagine Hammurabi felt the same way, relieved of the burden of enforcing uncodified law. The distinctly similar Hammurabi's Code and Ten Commandments, it could be said, represent a codification of Sumerian laws in the former case, and Semitic laws in the latter, with each progressively unifying an inherited patchwork and moving it toward greater standardization.

Perhaps the writers of the Old Testament associated the standardization of writing with the advent of codified law, as I have, since writing appears for the first time in the Old Testament in the first stone tablets containing the first version of the Ten Commandments: "The writing was the writing of God, graven upon the tables." Moses smashed these divine inscriptions on stone in dismay over the idolatry of the Israelites. Then, in Exodus 34–35, he returned to Mount Sinai with "two tables of stone," and the Lord commanded him: "Write *thou* these words: for after the tenor of these words I have made a covenant with thee and with Israel." Moses (the first literate man in the Bible) would then write ten laws—the "thou shalts"—whose repetitive format renders them as uniform conceptual modules or idea units that could be described as a language-grid. Even accounting for some differences in the numbering and phrasing of the commandments among Jewish, Christian, and Muslim adherents, when the laws are represented in painted or carved form, they often appear simply in squared Roman type as numbers I through X. No text is necessary.

Significantly, at the time when Exodus was written down, the entire Hebrew scripture was being transcribed, transformed from a cluster of primarily oral traditions with significant regional differences into the written form of standard biblical Hebrew in which the Pentateuch, the five books of the Torah, which include Genesis and Exodus, was canonized by at least the first century CE. Moses' life

43

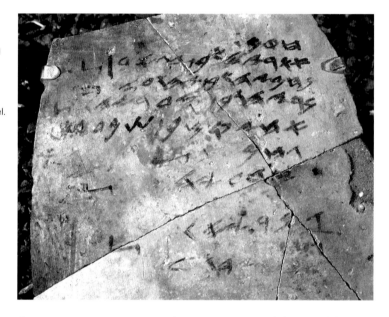

dates to 1290–1235 BCE, yet the transcription of these oral legends into the written text of Exodus by the so-called Yahwist source dates between the reign of David in about 1000 BCE and the fall of Samaria and the North in 722 BCE.[9] The collection of oral evidence that makes up the totality of the Pentateuch finally reached its "finished" form three hundred years later, in about 450 BCE, when the period of exile of the Jews had drawn to a close. We know that from the postexilic period (after 539 BCE), Jews held that Moses himself was the author of these books. Beginning in the seventeenth century, however, scholars began to identify first two, then three, and finally whole groups of "priestly" authors.

Even though there is no way to know what God's writing or that of His translator might have looked like for believers, we can always speculate based on contemporaneous models. Significant for the life of the grid in general and the tablet in particular, at precisely the time of Exodus, Hebrew changed from a cuneiform script (associated with calendars of agriculture and the Akkadian languages) to the

squared script of standard biblical Hebrew. The newly squared form, so called because its signs can each be inscribed within a square, has been explicitly connected to the canonization of the biblical stories and, with them, its commandments. According to Hebrew language historian Angel Sáenz-Badillos, this process was an interactive one: "After a long period of formation in which the various texts were expanded, modified, and, after exile, adjusted in a variety of ways, the paleo-Hebrew script gradually gave way to Aramaic square characters, and the text of each book began to stabilize."[10]

This account demonstrates that standardized writing, squared letters in the form of a grid, and the advent of scripted laws occurred relationally: as the languages merged, stories were canonized, and the appearance of letters was rendered more regular. We should not infer from this, however, that regularity would render the language "dead" for those who read it. To the contrary, this scripted grid consisted only of consonants; vowel sounds were provided by the breath of the reader. Remember that grids are brought to life in their use. Thus breath brought the Torah to life, engaging the reader in its meaning. Live reading enabled the reader to imprint the legal code, now set in stone, with the breath of the reader's life, linking the code to its first reader, Moses, as well as to the divine breath given to the mud-brick that was Adam's origin in Genesis.

Performativity is exactly what's missing from phonetic alphabets, according to critics of written language who associate the emergence of phonetic alphabets with a tendency to restrict the meaning of words to *literal* content, effectively limiting discussion and mystical encounter alike. The foremost proponent of this view was Socrates, who argued in Plato's *Phaedrus* that the written word was inferior to speech because it did not promote discussion.[11] His misgivings are supported in the modern era by Jacques Derrida, who argued in his watershed *Writing and Difference,* that "linear consecution, moving from present point to present point, could only tend to repress. In particular in so-called phonetic writing."[12] Where picture-writing, however abstracted, inspires an imaginary relationship between text

and things in the world, one could argue that the phonetic alphabet, in which words are sounded in lockstep, diminishes the magical, imaginary, or psychological content of words. The history of typography, however, which tells of thousands of years of the fashioning of individual letters to communicate specific literary content, mitigates against such an appraisal, as does the experience of reading through the spoken voice. Even a phonetic alphabet can't completely squelch performative expression.

Within two centuries of the Babylonian exile of the Hebrews in the sixth century BCE, the Greeks were likewise writing in squared capital letters without spaces. This comes as no surprise, perhaps, since both languages have Phoenician roots. For example, after famously describing the origins of language in *Cratylus,* his last work, Plato describes a legal code in terms that suggest the permanence of a tablet as a point of reference. In "Laws" he writes: "They shall compare these institutions and amend them in the light of their personal experience until they judge them to be all sufficiently perfected; then only will they take the last step, *stamp them as wholly immutable, and put them into practice for all time to come.*"[13] In other words, the discursive and spoken laws of the tribunal are rendered permanent through the action of the square stamp on a tablet. Whether Plato is referring to actual stamps on actual clay tablets, to any symbolic marker of legal authority, or to a figurative permanence of legal code that would be written metaphorically "for all time," his fourth-century BCE symbolism resonates both with Hammurabi's Code of fourteen hundred years earlier and the Ten Commandments, which were codified at about the same time.

This association of tablets and tablet-like squared letters with the law *as such* has made periodic appearances in how tablets operate culturally in the West into the present. The most famous example would be the Magna Carta (1215), which limited the authority of the ministers of the British Crown, governed the Crown's subjects, and introduced the principle of *habeas corpus* against imprisonment without charge. Written on parchment, these laws were carefully copied and widely distributed so as to assure a single legal standard. Later,

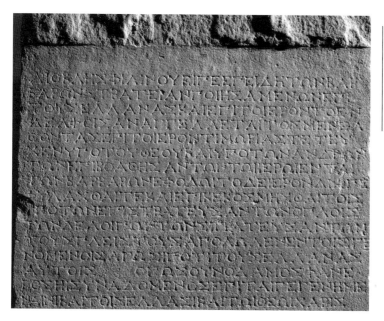

2.4
Decree of the town of Cos, Greece,
March 278 BCE. Inscription on stone
about the conquest of Delphi by
the Gauls under Brennus in March
278 BCE, followed by the news of the
expulsion of the Gauls from Delphi.
Photo: Erich Lessing/Art Resource,
New York. Archaeological Museum,
Istanbul, Turkey.

47

images of constitutional law on tablets appeared in paintings during
the French Revolution.[14] Sayings like Gilbert Romme's 1791 "law is
the religion of the state" were central to the way in which the French
Revolution saw itself. Representations of the Rights of Man and the
Constitution on mosaic—curve-topped tablets with squared Roman
numbers—were worn as insignia of the French National Legislative
Assembly in 1792. And like Hammurabi's laws and the laws of the
Hebrew covenant, the French Declaration of the Rights of Man and
Citizen were placed in public spaces for general consumption during
the French Revolution and beyond. Finally, in our own time, Moses
and the Ten Commandments appear three times in the architectural
symbolism of the Supreme Court of the United States. When a case is
argued in front of the court, in other words, the Ten Commandments
is never far away. Thus, although laws are not themselves a grid in the
simple sense, the political and religious authority of the tablet grid
endures as a symbol of a universal standard of justice.

3 GRIDIRON 2670 BCE

IN MY ACCOUNT OF THE BRICK, the brick module overshadowed the matter that held one to the next. Mortar was incidental, a mere connecting agent or negative space that glued together brick walls. It is to such tracery that we now turn our attention, though not in an exploration of the space between bricks, but the space between brick structures— the alleyways, streets, marketplaces, and piazzas that traverse and pepper many cities. In cities, buildings can be organized in a wealth of ways relative to one another. For example, they can be laid out for the sake of military defense, as in the concentric rings of Florence, or to reflect topography, as in Lima, Peru, which is rife with hillsides and rivers, or in ways that frame civic symbols, as in Baroque Rome, or in clustered groups without any streets at all, as in Neolithic Jericho and Çatalhöyük. The organization of most modern cities like New York and Chicago, however, is not responsive to unique functions and features of the landscape. Rather, modern cities are designed on a fixed, gridded field that allows for easy navigation via mapped coordinates (see fig. 0.2). This is the gridiron, a plan whose name is adapted from the metal grid used in the middle ages to grill meat, fish, and even human flesh as an instrument of torture. The gridiron is the tool by which we orient ourselves by saying, for example in New York City,

"The Metropolitan Museum? You can find that on Fifth Avenue at Eighty-Second Street."

Although one might imagine that the grid plan of the modern metropolis is the inevitable outcome of bricks being fashioned into straight walls, and these into rectangular houses, then into rows of houses, then streets, then blocks, and so on, this is not so. Rather, the grid plan can be described as a reversal of emphasis on the module. The gridiron is line-based (like mortar) as opposed to module-based (like brick), even as both make up a grid field.[1] The gridiron begins with the plan, which is then filled in; it is the tracery, the spaces *between* the buildings. This tracery, in turn, organizes proprioception, literally tracing the human sense of where we are in space. It systematizes the relationship between the individual body and the acculturated spaces of our towns and cities, not in terms of the organic forms dictated by nature, but in terms of organized social systems.

Despite its widespread association with modern urbanism, the gridiron form did in fact appear in ancient times. In the Old Kingdom of Egypt (2695–2160 BCE) some towns were built within walls to which the streets were aligned. In the Egyptian town of Hierakonopolis the streets were aligned not only with the exterior walls, but with interior, quadrilateral temple forms. A grid plan resulted, but it was not a true gridiron, the distinction being that Hierakonopolis did not "pursue *predetermined* alignments, which ignore topography."[2] In other words, even though parts of the city suggest that Hierakonopolis was planned on a grid, its aligned streets were merely reactive to preexisting forms.

Although we can't ascribe to this town the intent of a grid plan, we can say that a foreshadowing of the urban grid appeared here as a by-product of the form of its security wall. A similar process of internal accretion would occur at the Giza tomb of Queen Khentkawes and the Valley Temple of Menkaura, where the organized layout of a courtyard, necropolis, and temple, and a string of worker and administrative quarters were in time gradually filled in with a cluster of rectangular forms that mirrored the right angles of the exterior walls

3.1
Plan of the Valley Temple of King
Menkaure (Mycerinus). From
George A. Reisner, *Mycerinus:
The Temple of the Third Pyramid
at Giza* (Cambridge, Mass.: Harvard
University Press, 1931), plan VIII.
Photograph © 2008 Museum
of Fine Arts, Boston.

51

and temple structures. Given the presence of these accreted quadrilaterals, it comes as no surprise that a more regular expression of the urban grid would be taken up by planners in the provincial pyramid towns of the Middle Kingdom (1991–1785 BCE), where the kings and queens were buried. To understand this evolution toward greater regularity—which led to a radically new form of line-based field design of many, many walls at right angles to each other and parallel to identical blocks across highly regular streets—one must consider not so much the physical aspects of the evolving grid, but the cultural framework that necessitated this evolution. Above all, the gridiron is an expression of a highly regulated, tightly administered culture.

In constructing its massive pyramids and temple complexes, building its elaborate literary culture, and creating its sculpture and painting, Egypt developed a highly sophisticated system for administering natural and human resources. In this administrative system, the scribe was a mighty person indeed. Not only could he read and write, he had the task of transforming actions into routines for measuring, constructing, inspecting, and controlling all manner of human activity. He generated the massive bureaucracy behind ancient Egypt's achievements not only on the day-to-day level but by recording innovations for posterity. Imagine if each achievement had to be reinvented anew with each generation—the accomplishments of ancient Egypt would have been impossible. This is to say that they would also have been impossible without the development of papyrus, an Egyptian invention and extension of the tablet.

Papyrus was essential to civilization in many ways, of course, not least for serving as a model for the very "ground" on which the first gridirons were built. Describing how the mechanisms of bureaucracy translated into urban form in Egypt, archaeologist Barry Kemp writes, "Ropes and pegs and simple sighting instruments took the place of scribal equipment, whilst the ground served as the papyrus sheet."[3] Indeed, the Middle Kingdom pyramid town of Kahun (2670 BCE) exemplifies this gridiron cityscape inscribed on the model of written papyrus. Here, scribes planned the design and construction

of two types of housing units, each intended for a separate social stratum, and each virtually identical to others of its kind. The regularity of these homes carried over to the gridiron of the streets, suggesting a highly regulated relationship between the members of each stratum. In other words, the housing module and the linear grid of the street were coordinated to promote class-based human behavior originating in administration.

3.2
Plan of Kahun. From Sir W. M. Flinders Petrie, *Illahun, Kahun and Gurob* (London: David Nutt, 1891), plate XIV. Location: The University of Chicago Library.

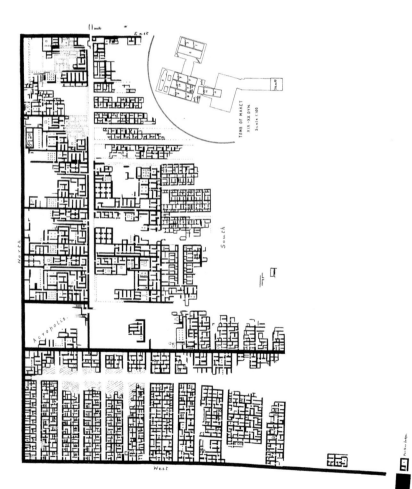

The administrative complexity of Kahun is suggested by the place-
ment of its granaries, whose capacities directly reflect the city's esti-
mated population of 9,000 people. These granaries were located
within Kahun's large residences, which were inhabited by wealthy
officials and located in the northern part of town. Everyone else was
housed in the south, in small housing units built for laboring serfs as
well as state-appointed soldiers and entertainers—many of whom
would be paid in grain. The officials responsible for distributing grain
payments thus held the very banks in their homes, given that the gra-
naries served as the foundation of Kahun's economy. Clearly, urban
administration—rooted in formal planning—wove the social fabric
of Egyptian society.

There was a glitch though, in Kahun's plan: it permitted only
large and small households, dividing the rich from the poor and
middle-class and reflecting an oversimplification of the complex social
order of the day, as Kemp describes: "The simple two-fold division
represented a social myth held by the elite. It made no serious attempt
to cope with the social and economic differentials within the numerous
bodies of people."[4] It would fall to the New Kingdom Egyptian plan-
ners to both entrench and retreat from the totalizing gridiron born
in the Middle Kingdom temple towns.

The Egyptian New Kingdom city of el-Amarna (1353 BCE) dem-
onstrated both trends. Its worker village was designed on the gridiron
plan, a clear forbear of modernist public housing and one that like-
wise reflects the bureaucratization of poverty. The city itself consisted
primarily of clusters of smaller and larger houses, without the rigid
separation of types found in Kahun. El-Amarna's daily operations
were linked to the state, in that official labor was given over to the
maintenance of the city, but it also displayed a complex trade econ-
omy involving both the sale of farm produce for profit and the ex-
change of goods, many of them stolen, with Thebes. This diversified
economy and comparatively liberal distribution of trading practices
among all classes, along with less intrusive bureaucratic organization,
enabled the growth of diverse residential constellations of villages,

neighborhoods, and storehouses. The complexity of el-Amarna's economic, social, and political activity is reflected in its very streets.

Significantly, this adaptive design corresponds to the kingship of Akhenaten and Nefertiti, who stripped away the formalities of the institutionalized religion of Egypt and replaced it with a generalized demagoguery. The relationships between the Pharaoh and his representatives in the neighbor states of Canaan and Amurru is illuminated by a famous cache of over three hundred letters, called the Amarna Letters, which were written in Akkadian cuneiform, the diplomatic language of the era. Whether the grid plan came to the West from Kahun or the worker camps of el-Amarna has long been a matter of debate, and a third account, in fact, has emerged.

Many historians contend that the grid plan proper was invented in about 2154 BCE, in the Indus Valley city of Mohenjo-daro, and was subsequently imported to Greece by an anonymous traveler from India.[5] Since all of the Indus River city sites share this basic plan, it has been hypothesized that this civilization of a million people enjoyed a centralized political or administrative authority. Even more advanced than its sister city and the seat of the dynasty, Harrappa,

55

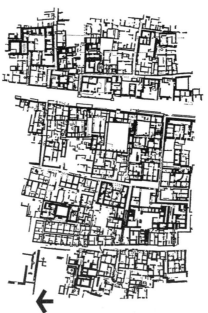

3.3
Plan of Mohenjo-daro. From A. E. J. Morris, *History of Urban Form: Before the Industrial Revolutions,* 2nd ed. (New York: Wiley, 1979). Location: The University of Chicago Library.

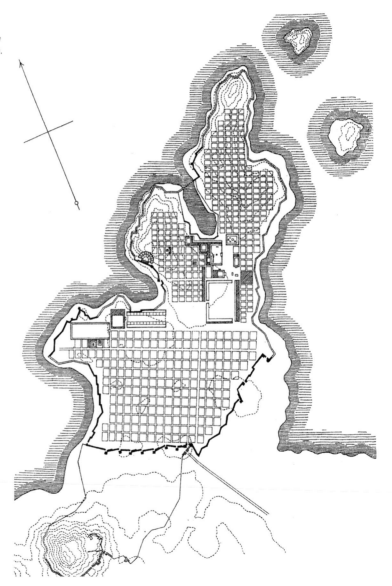

3.4
Plan of Miletus. From Armin von
Gerkan, *Griechische Städteanlagen*
(Berlin, Leipzig: W. de Gruyter, 1924).
Location: The University of Chicago
Library.

56

Mohenjo-daro was remarkable for its perfectly patterned gridiron, as precise as modern New York City, and for its organized water supply and trade serving about 35,000 inhabitants. In addition to grain stores that included underlying air ducts and bays for carts arriving from the countryside, this gridiron contained a plumbing substructure that drew wastewater under the major streets in covered drains—a feat of planning that places a premium on hygiene. Equally remarkably, the diverted underground sewage system moved waste downstream of the city on the Indus River, which would have protected the city's drinking water supply. Mohenjo-daro is famous for the advanced indoor plumbing systems that this carefully articulated plan permitted, with lavatories on the upper stories of multistory dwellings. The city was destroyed by flood and rebuilt at least seven times—a testament to its being highly valued in its own time.

Whatever the source, the grid plan came into widespread use in the West following the rebuilding of the Greek city of Miletus. Sacked by Persians in 494 BCE and liberated by Athens in 479 BCE, Miletus was rebuilt over the course of three centuries. The new city followed the axes of the old city, but the plan was strictly orthogonal, set in a square grid relative to the extant orientation lines. Its 10,000 inhabitants lived in three residential neighborhoods whose blocks were surrounded by public facilities and a central marketplace, in a clear rationalization of social space.

At least the plan seems rational according to the modern associations of grids with the Age of Reason. Although Miletus's Hellenistic gridiron apparently anticipates the functionalism of the modern era, for the Greeks geometric order reflected religious and spiritual principles and motivations. Architectural historian Alan Waterhouse describes Hellenistic planners' taste for the orthogonal urban grid this way: "The Hellenistic mind never equated the practical life just with technical things: function and geometry were admired by Pythagoras as part of the character of nature, and were therefore imbued with mythic significance."[6] In a landscape peopled with gods and goddesses, where human lives were intimately entwined with

those of the deities, coordinated axes that allowed for views through a city and into the landscape beyond were anything but strictly rational and functional in the modern sense. Nor were they expressions of a strict bureaucracy. Rather, they encouraged commune with nature, which is to say spirit.

A spiritual understanding of pure geometric form perhaps explains the Hellenistic use of the orthogonal plan even where it was totally impractical. The city of Priene, for example, built in the fourth century BCE, had hillsides so steep that the imposition of the grid meant that much of the city was navigated by steps set at 45-degree inclines. Although it could be argued that the planners of Priene were inept from a functionalist perspective, it makes more sense to view this city as harmoniously linked to the globe through the orientation of its urban grid to the cardinal directions of north, south, east, and west. Like the grids of the Greek cities of Miletus, Rhodes, Paestum, and Heraclea, Priene's was also attuned to the natural surroundings, "flexed over the terrain … and aligned toward divine features of the mountain and the river plain."[7]

Thanks to the writings of Aristotle, we can put a name to these simultaneously divine and mathematical grid plans of Hellenistic Greece: Hippodamus of Miletus, whom Aristotle praised, perhaps excessively, as he who "invented the art of planning cities."[8] According to Aristotle, his friend Hippodamus was simultaneously "adept in the knowledge of nature" and also "the first person not a statesman who made inquiries about the best form of government." Indeed, in his town plans Hippodamus was quite explicit that social form be reflected in design, as Aristotle describes: "The city of Hippodamus was composed of 10,000 citizens divided into three parts—one of artisans, one of husbandmen [farmers], and a third of armed defenders of the state. He also divided the land into three parts, one sacred, one public, the third private: the first was set apart to maintain the customary worship of the gods, the second was to support the warriors; the third was the property of the husbandmen."[9] According to Lewis

Mumford's classic book, *The City in History*, Miletus was "the first historic example of a deliberately fabricated neighborhood unit."[10]

Although Miletus did indeed have three distinct neighborhoods, Aristotle's description is perhaps more important in its conveying the symbolic power that he associated with the plans of Hippodamus. Far from merely pragmatic, as our modern minds might imagine the "inventor" of the grid plan, this "strange man, whose fondness for distinction led him into a general eccentricity of life … (for he would wear flowing hair and expensive ornaments)," is presented as a visionary, capable of combining abstract social, political, philosophical, religious, and natural principles in the form of a single plan.[11]

In a *polis* where "everywhere the grid boundaries confirmed the sense of being embraced by the landscape, carrying the eye beyond the confines of the street to the revered forests, outcrops, and hills shaped in the image of the deities," it is not surprising that social boundaries were as fluid as the physical frontiers.[12] Greek civilization was organized into collegial groups, called *philoi,* who shared in the events of both festival life and daily life within the city's collective sphere, called *koinos.* Here, religious and civic behaviors were united through these social groups, who "knew no separation between the sacred and the profane."[13] Furthermore, although women were largely absent from the official political process, they ruled large sections of the house, a domain protected by Hermes, god of the threshold; the courtyard and meeting room (*andron*), for instance, could be accessed by those who entered through the women's network or the men's. In other words, urban surrounds penetrated domestic space.

Reading the interpenetrated gridiron as symbolic of a broader Hellenistic zeitgeist, Waterhouse sees in it the capacity to unify symbolic opposites more generally. As he points out, the myths of ancient Greece bring to life gods who take the shape of mortals and animals. Greek mythology is rife with hermaphrodites and children of human and divine couplings, as well as gods and human beings whose complex personalities render them both servile and free. From this

perspective, the Hellenistic grid plan can be described as an expression of Greek paradox and inversion: the Hellenistic gridiron expressed both rational and irrational ideas, or perhaps an irrational belief in rational form.

The same would not be said of the Roman gridiron. In 332 BCE the planner for Alexander the Great would apply the gridiron to Alexandria as well as to the military outposts and cities north and east of Egypt established during his campaigns—a pragmatic function that would continue into the Roman era, when the gridiron would dominate military encampments. Unlike the ages-long agglomeration of organic growth characteristic of ancient Rome at its peak in the few centuries before and after the start of the Common Era, Roman fortified camps, known as *castra,* were rapidly assembled offensive military centers. In stark contrast to the Greek hillside grids affording visual continuity with the natural environment and some variability by neighborhood, *castra* were built on flat land, often near river crossings and trade route intersections, and surrounded by a square wall usually 2,150 feet on each side. The plan was essentially identical from one to the next location; groups of soldiers engaged in the expansion and governance of Rome would be housed at the same address as they moved from *castra* to *castra.* Many of these became permanent cities and towns, playing a significant role in the resuscitation of trade during the medieval period. Permanent settlements built in new parts of the empire, whether for trade or administration, were likewise given simple gridiron forms (so simple they are thought to have inspired the chessboard pattern). Eventually, the checkerboard made its way to Europe via Moorish Spain during the Crusades.

The best-preserved example of Roman town planning on the gridiron is the city of Pompeii, which owes its pristine state to an eruption of Mount Vesuvius in 79 CE. A cultural and leisure center, Pompeii featured one of the first known pedestrian districts as well as a uniform housing design consisting of single-entrance homes with interior central courtyards, some as many as six stories high. Originally settled by Greeks in the sixth century BCE, Pompeii was absorbed

late in the third century by the Roman Republic. Like most Roman towns, it is laid out along two main roads that meet at right angles at the Forum, the center of public life. Expressing its roots in Greek sight-line gridirons, the axis of Pompeii's Forum centers on Mount Vesuvius. It contains architecture from the Greek through Roman periods—legal and administrative buildings, a basilica, temples to many deities, and a market—and amenities like elevated tiles at the crosswalks, which kept feet dry during the rains.

Though Pompeii was untouched after the eruption, many other Roman cities were adapted to the needs of later civilizations, blurring or obliterating their original plans. Among these later civilizations were those of the Islamic empire, which began its expansion in the seventh century CE, as Islam extended from its origins on the Arabian Penninsula to India, China, Spain, and Morocco. In the process, many cities and towns that started as Greek or Roman settlements designed on the gridiron were transformed to suit a very different belief system and lifestyle. Whether set around central medallions or on fractured remnants of the Roman grid, Islamic cities are defined by a central mosque, a palace or citadel signifying political authority, and a *maiydan,* a public square often used as a market. Where planned cities were started from scratch, as at Baghdad, the design was centripetal, with the maiydan and mosque set at the center of the city in an expression of the total rule and legitimacy of the caliph. The social solidarity of various religious and ethnic groups, as well as extended families, was expressed in self-contained, inward-oriented groups of dwellings called *harahs.* These domestic enclaves formed secluded units in the interstitial spaces of ideal Muslim cities.

In contrast to the particular gridiron features typical of planned cities before theirs—Egyptian bureaucracy, Greek sight flows, and Roman predictability—beyond the constants described here, Islamic cities take many forms. Despite this pluralism, they are always recognizable, as sociologist Janet Abu-Lughod has noted with a degree of sensitivity well worth quoting at length:

While the diversity is striking and defies simplification to a single "genre" of either architecture or urban form, it is equally remarkable that one always "knows" when one is in the presence of an Islamic civilization. Is it merely the superficial decoration, the insistently repetitive arches, the geometry of tiny spaces aggregating to vast designs that signal the Code? Is it the basic architectonic concept of square-horizontal and rounded vertical space that announces the unity underlying external diversity in shape? Is it the overall emphasis upon enclosing, enfolding, involuting, protecting, and covering that one finds alike in single structures, in quarters, indeed entire cities? There appear to be certain basic "deep structures" to the language of Islamic expression in space.[14]

Not surprisingly, the "deep structures" of Muslim urban life required substantial alterations to the Greek and Roman grids, transformations that would have a practical and symbolic significance. In order to form the secluded and protected enclaves of harahs, for instance, Islamic planners filled in ancient Greek and Roman traffic thoroughfares. One typical example of widespread superimposition can be found at the Syrian capital of Damascus, first mentioned as an Aramaic city in 1100 BCE, which was taken over by the Assyrians, the Babylonians, the Greeks under Alexander the Great, and the Romans under Hadrian, during whose rule it became a metropolis by the second century CE. In 395 CE Damascus became part of the Byzantine Empire and, finally, became an Islamic city during the period of expansion in 670 CE, effectively ending a millennium of Western domination.

With each new conquest, the gridiron changed. Following the conquest by Alexander, for example, a Hellenistic gridiron with standardized lots was built; the Romans added a *castrum,* and the Byzantines a palace. Soon, the grid began to fracture in a socialization process: marketplaces were filled in, streets were truncated; indeed, "the decomposition of the Damascus grid had begun as early as the second century AD, and the gradual forsaking of the geometric block structure was consummated under the Arabs."[15] Early changes

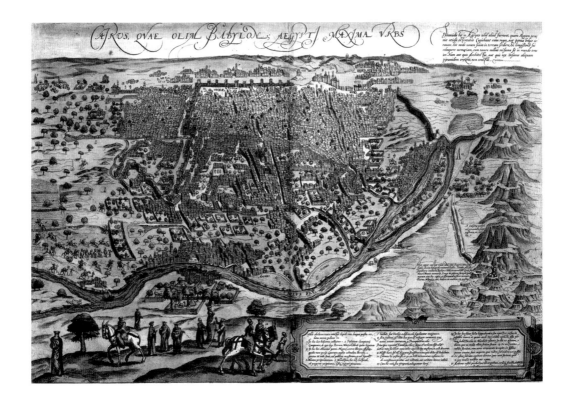

to Damascus following its conversion to Islam were rather modest, a mere continuation of what had begun under Byzantine occupation. However, under the caliphs Abul Malek (685–705 CE) and his son al Walid (705–715), the church of Saint John the Baptist, once a temple to Jupiter, was apparently demolished and replaced with a great mosque. Alongside other transformations, for example the replacement of the Christian government workforce with an entirely Muslim one, the destruction of the church would have symbolized for the people of Damascus a final conversion from Byzantium to Islam. This pattern of advancing renovation can be seen also in other Islamic cities, such as Aleppo, whose Greco-Roman grid was likewise fractured under Byzantine and then Islamic rule.

3.5
Braun and Hogenberg, map of Cairo (showing fortified walls), from *Civitates Orbis Terrarum* (first Latin edition of volume I was published in 1572). Woodcut: admitted to Matteo Pagano, 1549, or after a Venetian engraving derived from it. The Jewish National and University Library, Shapell Family Digitization Project, Era Laor Cartographic Collection, and the Hebrew University of Jerusalem, Department of Geography, Historic Cities Project.

In the context of these fractured grids and the centripetal design of other Muslim cities, the design of Cairo (al-Qahirah) in 969 CE is remarkable. Here, after leading forces in a successful campaign on Egypt, caliph Jawhar al-Siqeli laid out a plan that bore a strong resemblance to a Roman *castrum,* though it resulted in a rectangle with a proportion of 2:3, indicating an intentional adaptation from the original square format. As in Baghdad, the *harahs* were built near the outside edge of the town. Twenty such quarters were built, each assigned to one of the twenty tribes of the Fatimid army. In short, the design of Cairo "conforms to a regular grid with wide streets and wide open squares, [and is] very much different from the stereotypical Muslim City."[16]

Like their Islamic contemporaries, medieval towns across Europe tended to be organized around a market and a place of worship; the largest were cathedral towns, which were often circled by fortified rings and organic in their growth patterns. In contrast to this irregularity, *bastides,* thoroughly preplanned towns in France, England, and Wales, took the form of the gridiron toward vastly different ends than had the Greco-Roman plans that preceded them. Based on Roman *castras* in their midst, *bastides* were primarily agricultural communities established by a central royal authority, which granted regular house plots including farmable land at the outskirts of the town in order to impose order on dissident areas. In exchange for the land, the freemen inhabitants promised militia service and loyalty to the crown in a typically feudal manner. In other words, counter to the Greek association of cities with democracy or the Roman model of military and administrative homogeneity, the *bastide* was a means of granting individual privilege and guaranteeing military cooperation.

Among the towns that followed the lead of the *bastides* were New Brandenburg in Eastern Germany—founded in 1248 by Teutonic Knights spreading Christianity—whose success stemmed from the granting of land and house lots both inside and outside the city. But perhaps the most extensive network of newly planned towns dates to the period following 1310 in the Florentine Republic. Twelve towns near Florence were settled strategically along the river Arno and its

64

tributaries. Like the French *bastides,* their walled enclaves were laid out in regular blocks, and their granted land allowed the republic to assert centralized control and keep the feudal lords of the region in check, "an important step towards the unification of the city and the surrounding country."[17]

Unification in turn lent the stability and wealth that ushered in the Renaissance, which was born, of course, in Florence. From here, the ideals of Renaissance humanism spread across Europe, finally reaching England in the late 1600s. This was a period marked by dramatic urbanization of the rural population, with, for example, Rome growing sixfold, from about 17,000 in the 1370s to about 124,000 by 1650. Since this was a mere 10 percent of what classical Rome could hold, however, very few new towns were necessary. Instead, urbanization meant the evolution of existing urban fabrics: the laying out of straight streets, the building of fortifications and new gridiron districts linked to economic and population growth, and, finally, the making of enclosed space—the public square or the piazza.

The piazza was a hallmark of Renaissance city planning. During this period, piazzas would be built into the renewal programs of Rome as well as the other major cities of Italy, France, and England. Between the late thirteenth and fourteenth century, for example, the walls of Florence were expanded three times while a network of piazzas was built. This suggests that the reshaping of the inner city was a direct response to a growing periphery, as architectural historian Marvin Trachtenberg has argued.[18] It also marks a fundamental shift in how urban life was understood at the time. Rather than a destination for dispossessed peasants fleeing agricultural catastrophe and war, Florence, like many Italian cities, had become a destination of choice for an educated and burgeoning middle class looking for business opportunities. Winding streets that foster crimes against individuals (assault, robbery and rape) were replaced by piazzas offering open space with wide sightlines and ample opportunity for guilds, the political elite, and the newly wealthy to advertise their benevolence in the form of opulent sculptures, fountains, and buildings.

Filippo Brunelleschi's Hospital of the Innocents, a foundling hospital (probably the world's first) commissioned in 1419 by the Silk Guild of Florence, is a prime example of the era's urban philanthropic endeavors. Loosely inspired by Roman architecture, with portico bays of equal length, width, and height, the building reflected a Renaissance predilection for regular geometry and human scale. From 1450 until the mid-sixteenth century, two buildings set in front of the hospital were adapted to its style, forming a coherent piazza at the crossroads of pedestrian streets. The Renaissance floor work on the piazza, with its gridded surface, likewise recalls early Roman influences. Similarly, representations of the piazza in works like Perugino's *The Remission of the Keys to Saint Peter* (1491) suggest an orthogonal, grid-formed conceptualization that locates it firmly within a gridiron typology—even as the established nature of Florence made applying the harmonious and balanced form of the gridiron largely an imaginary enterprise. Perugino's painting can be seen as an illustration of the Renaissance architect Leon Battista Alberti's Ideal City; a temple

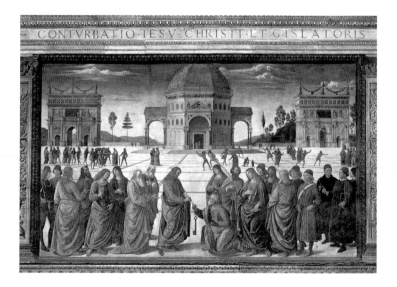

(church) is shown at the center of a great open space in full view and in total geometric harmony with the gridiron plaza, as if to unite the business of merchants with the church and the needs of the general population.[19] Ideal or imaginary, perhaps, but the gridiron shown here portends greater ambitions since, by Lewis Mumford's account, "the grid plan answered, as no other plans did, the shifting values, the accelerated expansion, the multiplying population, required by the capitalist regime."[20]

The principles of Renaissance planning reached London when the Covent Garden piazza was built in 1630. This, however, was an isolated incident that would not, as fate had it, take root. After a flight-inducing plague in 1665 and the devastating London fire of the following year, architect and inventor Sir Christopher Wren proposed a new design that combined the continental gridiron and the radial, hub-and-spoke forms of the Renaissance fortified town. Wren's design had its proponents, but it was rejected, and it has become mythical in the lore of modern urbanism. In the end, London was rebuilt largely according to its preexisting plan, though with more standardized house types and street widths—a concession to the prevailing wisdom that the plague had festered in the grimy alleyways of a congested and loosely planned city.

Another by-product of the London plague was the settlement of the outlying countryside by wealthy families who had fled the city. Here, they built estates that eventually included residential squares, for example, Lord Russell, Duke of Bedford's Bedford Square in Bloomsbury. Houses faced prestigious streets, with mews—alleyways for horses—and stables and coach houses behind them. This innovation on the gridiron was widespread in England, and can also be seen in middle-class Edinburgh. It takes the form of urban alleys and garages today, which signal planners' attempts to address the traffic-flow issues endemic to large-scale modern cities.

Such practical issues are the basis of the modern gridiron, which has dominated overwhelmingly in the United States since the first

planning code, the 1753 Laws of the Indies. The Laws specified that city land be dry, healthy, arable, preferably near a river or other body of water for the transport of goods, and that the hundreds of settlement towns established by the Spanish be laid out in a manner that implies a gridiron: "[T]he plan of the place, with its squares, streets, and building lots, was to be outlined by means of measuring by chord and ruler, beginning with the main square from which streets were to run to the gates and principal roads and leaving sufficient open space so that even if the town grew it could always spread in a symmetrical manner."[21] Although it is true that many New England towns were, like Boston, characterized by organic, unplanned growth in their original city centers, most major cities were designed on the gridiron in the colonial period. This plan would be applied to Santa Fe in 1609, Albuquerque in 1706, San Diego in 1769, San Francisco in 1776, and Los Angeles in 1781. Following the Federal Land Ordinance of 1785, the grid plan was effectively law for every American city. A famous plan of Chicago published by real estate speculator John S. Wright in 1834 shows the tightly planned city of rectangular grids that would burn to the ground in the famous fire of 1871. Among the most notable of these grid plans was for Philadelphia, which was founded by William Penn in 1682.[22]

Penn's instructions as to the town plan are explicit even in his first official remarks to his Surveyor-General, Captain Thomas Holme. In July 1681, on receiving the regional charter from Charles II in payment for a loan, Penn wrote: "settle the figure of the town so that the streets hereafter may be uniform down to the water from the country bounds … only let the houses be built in a line, or upon a line."[23] A combined Penn–Holme plan for Philadelphia was completed in 1683 and served as promotional material for advertising this new city to Londoners looking for a new life. Penn himself had witnessed the devastation of London during the plague and fires of the 1660s, and his design was intended to prevent such catastrophes in the future. The reference is explicit when he suggests that "every house be placed, if the person pleases, in the middle of the plot, as to the breadth way

3.7
Joel Shawn, midtown Manhattan from the air, n.d. With permission of www.shutterstock.com.

of it, so that there may be ground on each side for gardens, or orchards or fields, that it may be a green country town, which will never be burnt and always be wholesome."[24] Philadelphia eventually grew into the busiest commercial port in America. Like Chicago almost two hundred years later, its gridded plan was inspired by fire.

New Amsterdam, founded by the Dutch in 1624, was, unlike most American cities, *not* built on the gridiron—at least initially. It began as an urban center without a plan, like a typical colonial town on the organic growth model. The British captured the city in 1664, renamed it New York, and a century later it had begun to grow north in haphazard fashion. In 1807 the State of New York authorized a planning commission, which imposed a uniform grid over the entire island. Twelve one-hundred-foot-wide avenues would run north–south.

Sixty-foot-wide streets—155 of them—would run east–west, their grid broken by the great public land offering and respite to nature that is Central Park.

By 1857 Los Angeles would begin to grow inland from the Pacific Ocean, eventually plowing massive freeways through desert and mountain range alike, its open-ended gridiron reflecting the American expansionist ethos. This was the ultimate, modern, totalizing scheme. Indeed, it seemed virtually anyone could use the system, from anywhere in the world—an attractive quality for a melting-pot culture. By contrast, travel accounts written throughout the period by Americans on the Grand Tour of Europe remark with dismay and wonder on the topographic specificity and centripetal layout of medieval European cities, with their squirrelly little corners and rings of defenses reflecting archaic technologies of war.[25]

Even a modern European city like Paris, which was redesigned beginning in 1852 by Baron Georges-Eugéne Haussmann for Napoleon III, forsook the grid plan in favor of standardizing building heights and broadening boulevards that would center on new monuments and newly built railway stations. Radiating circles surrounding these features were bisected by streets that formed like spider webs. Air and light, offered not least by introduction of gas lamps, made this a healthier, safer city, a "city of light." The project was not strictly benevolent, however, as the wider boulevards were designed with the distinctly undemocratic intention of delivering soldiers to the city center in times of social strife, as they did during the Paris Commune of 1871.

Like Paris with its circular grids, the United States employed urban design principles to meet its own particular national ideals. One might say that for a country founded on the conjoined principles of individual freedom and social responsibility, the democratic form of the grid (each cell is the same size) and the interconnectedness of its parts (each cell is part of the total fabric) make the perfect symbolic and practical match. Another read: the gridiron in the United States of the Industrial Revolution embodies the mechanical

efficiency and rational organization of the mass-production enter-
prise, a description that suggests the gridiron might be, as one author
has described, "an all-embracing super-organism, leaving human be-
ings with an epiphenomenal and purposeless existence as floating
cells" devoid of a sense of community and personal privacy.[26] Beyond
the effect on individual human beings, many writers have attacked
the industrial grid as exploitive, a violation of nature. In *Design with
Nature,* for example, Ian McHarg famously described the modern
industrial city as "a memorial to an inordinate capacity to create ugli-
ness, a sandstone excretion cemented with smoke and grime."[27]

For better and for worse, the gridiron prevailed; by 1785 the en-
tire country was conceptualized on the grid. The Land Ordinance of
1785 addressed the thorny issue of who owned the land to the west of
the Ohio River—whether the government should be allowed to sell
these "uninhabited" areas, or whether the American people should re-
ceive free land grants for farms. The land grant would serve the dual
function of seizing the land from its Native American inhabitants and
feeding the growing urban population as those new farmers devel-
oped markets for their goods. Six-mile square townships were laid out,
each subdivided into thirty-six one-mile-square plots of 640 acres
each. Such regularity meant that homesteaders could locate their land
and avoid property disputes. It also made for efficient planning: in
each town, the same section was set aside for schools; placement of
roads, boundaries, and intersections were equally uniform. In other
words, one giant grid was projected across the land, then easily sub-
divided to form towns, blocks, intersections, and so on.

By the mid-nineteenth century, a new sort of American grid ap-
peared, as federal land grants were awarded to railroad companies
eager to profit from Western expansion. Beginning with an act of
Congress in September 1850, the Illinois Central Railway and later
other rail companies were encouraged to support the expansion
with incentive donations of unproductive federal land. Thus on
mile-square plots totaling 150 million acres by 1872, many railway
towns sprouted up, many on the gridiron, including thirty-three

identical plans used by the Illinois Central Associates. Clearly, the production-based economy had become a major force in constructing the meaning of the gridiron in the modern era. By the twentieth century, as interstate and state highways appeared, the system for cross-country transportation of physical bodies on a grid matrix was essentially complete.

Perversely, perhaps, this highway and rail system linking cities would lead to the demise, or partial demise, of the densely populated core of the urban gridiron—one gridiron leaching the contents of another. Smooth transportation by commuter rail and highway encouraged separations of business and home for those eager for peace, quiet, lower crime rates, and closer proximity to nature. The twentieth century would see an explosion in scale of these suburban communities, a continuing trend with long-term implications. "New Urbanism" is a term applied since the 1980s to pedestrian neighborhoods designed for a diverse range of jobs and housing. Whereas a shopping or business district or corporate campus may be a gridiron or not, the residential parts of these neighborhoods routinely reject the strict grid, opting instead for a more seemingly natural design. These designs place homes on curved streets that evoke a sense of connection to natural features of the landscape. In actuality, at higher population densities these streets form curved grids of regular-size modules, indicating a warped but not a fractured grid.

Another name for new urbanism is "traditional neighborhood design," a term that suggests a nostalgic sentimentalizing of a past that was never quite as simple as the romantic version suggests. Indeed, nostalgia seems to be fundamental to the movement as curved streets and paths of new urbanism often respond to manufactured features in a landscape design, not nature, and show a propensity for nonmodern architectural styles. Such a view is oversimplified, however, since some of these new neighborhoods include corporate campuses and business districts and therefore behave as self-sufficient sites, whereas others have defined themselves as conservation communities, establishing nature preserves, promoting energy conservation, and being

situated near transportation hubs. Although automobile traffic remains an environmental concern, it should be noted that pedestrian neighborhoods located near corporate centers, and in particular those that place conservation at the core of their mission, arguably promote mass transit and foot traffic instead of automobile traffic. Among the most successful of these is Prairie Crossing in Grayslake, Illinois.[28]

Joel Garreau's *Edge City* lists the terms used for this new urbanism, the variety of terms indicating their widespread appearance: in addition to edge city, he offers "urban villages, technoburbs, suburban downtowns, suburban activity centers, major diversified centers, urban cores, galactic city, pepperoni-pizza cities, a city of realms, superburbia, disurb, service cities, perimeter cities, and even peripheral centers."[29] Garreau describes a world that has left the urban gridiron core behind.

> Americans are creating the biggest change in a hundred years in how we build cities. Every single American city that *is* growing, is growing in the fashion of Los Angeles, with multiple urban cores. These new hearths of our civilization—in which the majority of metropolitan Americans now work and around which we live—look not at all like our old downtowns. Buildings rarely rise shoulder to shoulder, as in the Chicago Loop. Instead their broad, low outlines dot the landscape like mushrooms, separated by greensward and parking lots.... The hallmarks of these urban centers are not the sidewalks of New York of song and fable, for usually there are few sidewalks. There are jogging trails around the hills and ponds of their characteristic corporate campuses.[30]

Though it is premature to relegate the gridiron to the dustbin as a relic of "song and fable," it is nevertheless possible to speculate that this progress from urban gridiron to edge city suggests a return in the cycle of deterioration, warping, and fragmentation of the gridiron, as typified the shift from the Classical to the Medieval and Muslim cities. This return, however, is largely local. Global development is

74

uneven, and needs and tastes differ by region. Instant cities that are
leaping up in the industrial sectors in China and the Arab world, for
example, are planned on the gridiron and designed for maximum
efficiency.

There is one more gridiron, however, left to address—the invis-
ible grid of electricity, the seemingly disembodied energy that trans-
formed domestic and industrial life by providing power and
around-the-clock light. On May 16, 1888, Nicola Tesla delivered a
lecture entitled "A New System of Alternating Current Motors and
Transformers." This lecture described the equipment that could
generate alternating electrical current efficiently. The patents for
these were owned by General Electric, which gave them a steady
advantage in the deployment of the new technology. In 1891 at an
exhibition of electricity in Frankfurt, Germany, the first transmission
of a three-phase alternating current using high voltage was performed.
This transmission moved alternating current along a 175-kilometer-
long transmission line linking Frankfurt on the Main River to Lauffen
on the Neckar River. By 1907, Harold W. Buck and Edward M.
Hewlett of Niagara Falls Power Corporation and General Electric had

devised the technology that allowed for the transmission of power at high voltages for virtually any distance.

Since this event, electricity has spread across every industrialized country. Colloquially referred to as the "power grid," the electricity network is seldom a true grid, even though large parts of it run parallel to established roads and train lines. Rather, the power grid contains a lateral form of duplicated access points associated with the grid form generally: paths and lines are redundant, allowing for power to be routed from any power plant to any load center along a variety of routes, as a guard against disruption. Not long after the invention of the telephone exchange (routing center) was invented in 1878, permanent telephone networks were put in place. By the 1920s, they, too, used the grid system, often sharing poles with the electric lines. Both systems, electric and telecommunications, relied on some degree of redundancy.

Or rather they *did:* in 1996 the power grid was partially deregulated in the United States and particularly in California, resulting in a separation of transmission and generation functions and a reduction in protective redundancy of routes. Arguably hoping for the same increases in efficiency that deregulation had brought to telecommunications and transportation, in the energy sector the effect was quite the opposite. The 2000–2001 California electricity crisis has been blamed on mismanagement of this deregulation as the infamous Enron Corporation and others manipulated the market for profit. Months of rolling blackouts across the entire Western United States resulted and power companies lost credibility with their customers.

Albeit unforeseen, one result of deregulation and the ensuing crisis was the empowerment of consumers within the same power distribution system that had failed them. In 2002, following the crisis, California offered 60 percent rebates on solar power systems to homeowners in addition to tax credits. Homeowners paid less than 30 percent of the retail cost associated with solar energy equipment. Because of the California climate, residents are able to direct their solar energy into the grid during daylight hours, while at work or

school, effectively easing peak demand and running their electric meters in reverse. This contribution into the system is reversed at night, when the sun is down. Electric bills have been driven down toward zero for some rebate participants. New York, Massachusetts, Illinois, New Jersey, and Rhode Island also have rebate programs. Recent advances in the technologies of other renewables, such as geothermal and wind energy, suggest that the reversal of direction of power in the grid is here to stay and that, with sufficient investment in these new technologies, homeowners and industry can function simultaneously as producers and consumers (now called prosumers) in this increasingly decentralized electrical grid.

The same technology has allowed some people to break with the power grid altogether. Independence can likewise be achieved with telephones and satellites; whereas land lines require being physically tied into a network of physical wires, cell phones and satellites require almost no ground-based physical infrastructure. At the same time, rain water retrieval and river and well technology has advanced to take these people out of municipal water systems in some areas, allowing them to live "off-grid." With these developments it is now possible to have electricity, phone, and water without the coordinating spatial system associated with wires overhead and pipes below, be they carriers of telephone calls, digital information, electricity, or water. Users often refer to living off-grid as a mark of independence from the distribution system and its ties to energy markets, a way to "get out from under Big Brother," by one account.[31] Though this sort of lifestyle was long marginalized as an extremist wing of the counterculture (remember media characterizations of Unabomber Ted Kaczynski), in 2006 *USA Today* reported that "180,000 families living off-grid, a figure that has jumped 33% a year for a decade."[32] At this rate, over three million households could be off grid by 2016.

Many proponents of living off-grid note that most citizens in developing countries have never been on the grid, so to speak. By one estimate, two billion people live off-grid worldwide. Even though recent industrialization in many countries has replicated the disastrous

environmental consequences of the industrial gridiron described by McHarg as "cemented with smoke and grime," advances in solar energy, satellite, and cell phone technology suggest other options. These technologies mean that the environmentally destructive gridirons of industrial cities and distribution centers, the energy and phone grids so characteristic of development in the first world, are not necessary components of future economic development worldwide.

Clearly, we are in the midst of a large-scale transformation of how the gridiron and its ethereal offshoots, the power grid and telecommunications network, are used. Prosumer activity, with users feeding into and pulling out of the power grid, with the option of signing off permanently, suggests at turns more and less interdependence among these grids. This shift is widespread. The kind of data sharing characterized by Facebook, MySpace, and YouTube, where content is put into the telecommunications network by one user and pulled off by another, indicates the same sort of shift. Energy and information now move as easily from the producer to the consumer as they do back again. These examples suggest more than the simple fragmentation or degradation of the gridiron associated with its many historic cycles. Rather, we have entered the era of its awakening. In addition to organizing space, the gridiron warps, bends, fragments, renders itself in ether, pulls material from other gridirons, and, perhaps most importantly, is made and unmade at will by its many users.

4 MAP 120 CE

THE PEOPLE OF THE MARSHALL ISLANDS, a network of thirty low-lying atolls and islands spread over eighteen hundred square miles on the Pacific Ocean, make waterproof maps of the waves from the ribs of palm fronds. Woven into a loose grid, the intersecting patterns of these "stick charts" reflect the interference between primary waves produced by trade winds and offshore, reflected waves.[1] When the status of a given wave formation is unclear, the natives lie down in their canoes to feel the pattern of major and minor waves, compare it to their map and the horizon, and orient their canoes accordingly. Their maps, together with these spatial-tactile indicators, are highly effective navigation tools. The Marshall Islands stick chart represents a world that appears and disappears before our very eyes, and thus points to an essential quality of *all* maps, whether of water or of land. Maps are not records of some objective physical reality, but of human intervention and perception. They are more like the graphemes of early writing than a simple translation of the gridiron to two dimensions.

Like the gridiron, the map—that ancient gridded method of picturing our world at a perceptible scale—organizes space, but *its* space lacks the materiality of the built environment. Indeed, the space of the

map is symbolic and immaterial, an expanded projection of the built grid of the gridiron onto the greater world that contains it, an imaginary latticework placed over natural or cultivated terrain in order to show people where they are in relative terms and beyond their immediate sensory perceptions.[2] We might like to think that maps are a pure translation of the three-dimensional world into a small-scale two-dimensional form; however, in fact, map format says little of the nature of the land, and nothing of its balance of natural resources, or its peoples. And of course no map can pretend to be a complete representation of the world in all its detail. For that, it would have to be as large as the world it represents. Given the necessary and necessarily subjective editing process, all maps reproduce the worldviews, which is to say the value systems, of their makers. A quick look at a contemporary map tells us what is a road, a tourist attraction, or a border, for instance, and these symbols reflect a set of values regarding movement, entertainment value, and the geographic reach of a political entity. It is this last quality that is most loaded with regard to maps. Indeed, many modern critics experience maps as a record of a world laid bare for exploitation over a long history of voyage through and conquest of the complex spaces of the human habitat.[3]

Notwithstanding such critical appraisals, in everyday use maps provide us with a genuine sense of the physical world. Anyone who has navigated a road trip, successfully connecting map symbol to landscape feature, knows this. Transferring our eyes from the symbolic form of the gridded map to the actual environment charted by the grid, we connect the image to the real. This *naturalization* of the map, its apparent self-evidence, demonstrates that, when it is being used, the map is equal parts symbol and index, meaning it portrays both a symbolic version of the world and also seems to relate directly to that world as a scaled model, the index. If we get lost, the map reasserts itself as we bury ourselves in its symbolic-indexical logic, only to leave it behind again when it connects to some marker outside the window. This action—the looking at and looking away from the map—expresses the uniquely comparative and interactive character

of the map grid, which suggests a counterbalance to the strictly deter-
ministic view of the politicized map. The grid form of the modern map
thus represents at its most benign engaged exploration, and at its most
venal imposed exploitation. The outcome depends on the user.

Perhaps it comes as no surprise, then, that the map's format—
grids of orthogonal lines peppered with indications of rivers, capi-
tals, and such—should have originated in the Greco-Roman culture
of inquiry, exploration, and conquest. Latitude—the bands that
run around the Earth parallel to the equator—would come first, in
fourth-century BCE Greece. Longitude—the meridian lines that run
from North to South Pole and divide the Earth into something like
orange segments—would come two centuries later in Alexandria.
Together, latitude and longitude would form the cartographic grid.

North–south orientations for conceptualizing the globe were
common in ancient Greece, as evidenced by the writings of the
Pythagoreans, Plato and Aristotle. In his *Meteorology* (350 BCE), for
example, Aristotle divided the world into climata, climate bands that
represented the temperature zones of the Earth. Aristotle understood
the Earth as spherical and symmetrical, and therefore postulated a
northerly and southerly expression of each climate. There were two
frigid zones at the far north and south of the globe (where the Earth
was thought to be too cold for habitation); inside these there were
two protoarctic circles, which in turn bounded two temperate zones
inhabited by the majority of human beings. These temperate zones
were separated from each other, according to Aristotle, by uninhab-
itable "torrid" regions just south and north of the equator. The four
regions—arctic, protoarctic, temperate, and torrid—could be in-
scribed by equidistant parallel lines running horizontally around the
globe. Of course these parallel lines remain a feature of constructed
globes today.

But it was Eratosthenes (276–196 BCE), the head of the most re-
nowned library of the ancient world at Alexandria, who would develop
the hard science around the Greek philosophers' cartographic model.
(Not incidentally, the library was founded, or so the legend goes, by

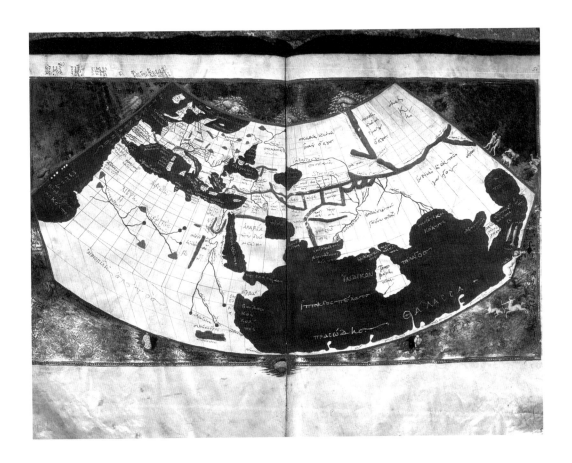

Demetrius of Phaelon, a student of Aristotle, whose collection of books is said to have served as the library's foundation.) Eratosthenes observed at noon on the longest day of the year that the shadows cast on a sundial were different lengths in the ancient Egyptian cities of Syene (modern Aswan) and Alexandria, which lay in a north–south relationship to each other. This suggested to him a way to measure the rate of curvature of the Earth between these locations. Calculating the distance between the cities at 5,000 stadia (just under 500 miles) and using the differing shadow lengths to gauge the arc as one fiftieth of a circle, Eratosthenes was able to calculate the circumference of the globe at 250,000 stadia (24,509 miles).[4] The actual circumference of the globe is 24,888 miles, which means that Eratosthenes performed a remarkable feat: measuring the Earth with less than 1 percent error. His accuracy was long in question, however. After the geographer Posidonius raised doubts about the measurement in 100 BCE, subsequent geographers and explorers reduced Eratosthenes' globe by over 25 percent.

In addition to theorizing the size of the Earth, Eratosthenes formed it into rectangles based on north–south and east–west axes. Because he also wanted to be consistent with existing national boundaries, and countries come in different shapes and sizes, his rectangles were irregular in form. Here was the emerging prototype for the gridded map, though the world would wait almost another century to see the first strict example. It came courtesy of Hipparchus of Nicea (190–125 BCE), inventor of the astrolabe, an instrument made up of rotating, concentric circles that map the locations of stars to generate a regular and geometric view of the heavens. Projecting these regular forms back to the Earth, Hipparchus forged a system of imaginary grid lines uniting the Earth and the heavens, replacing Eratosthenes's irregular rectangles with regularly spaced horizontal parallels and vertical meridians based on astronomy.

This new system would be systematized to form a detailed map of Europe, Africa, and Asia in the cartographic descriptions of Ptolemy (90–168 CE). Like Eratosthenes four centuries earlier, Ptolemy, the

4.1
Map of the known world, from *Geographia* (after Ptolemy), fifteenth century, vellum. Photo: Erich Lessing/Art Resource, New York. Biblioteca Marciana, Venice, Italy.

most important geographer and astronomer of his age, was chief librarian at Alexandria. Ironically, his famous *Geography* did not consist of a single drawn map. The subtitle to his book is "guide to drawing a world map," and indeed Ptolemy provided instructions for drawing the entire known world at his time, but not the map itself. His instructions were based on reports by travelers, who would send word after journeying for a given number of days in a given direction to a landmark. From this data, Ptolemy would calculate the average speed of travel over a certain terrain and devise an approximate distance to the site. Forgotten during the Middle Ages, the reappearance in 1477 of Ptolemy's descriptions in print inspired generations of exploration and conquest. In fact the smaller scale of the globe that Ptolemy inherited from Posidonius would inspire Christopher Columbus's attempt to sail west to India in 1492.

Determining individual locations relative to others is of course quite different from understanding the mathematics of drawing a three-dimensional globe in two dimensions. If one simply stretches the globe to flatten it out, distortions of distance occur where there is lateral spread. Starting with an easily replicable three-dimensional grid produced using a sundial to determine longitude and longest-day values to fix latitude, Ptolemy produced three flattening mechanisms for solving this problem. The first pictured a conical world that unfurled into a third of a circle, like an unrolled ice cream cone. This cone projection allowed for the relative closure of the globe at the North Pole, where the stars were thought to rotate around the fixed top of the Earth. The second projection offered a solution to the everextending girth of the southern hemisphere that would result from this conical form. The cone closed at the South Pole as well. The third projection, which most closely resembles the logic of modern maps, is an imagined view of a ringed earth as seen by a fixed eye from a distant celestial point. Here, three-dimensional space is measured and transferred onto a two-dimensional surface using a system of lines, orthogonals, that converge on this single viewing point, which would be produced while standing directly in front of two converging arcs (one running north–south and one east–west) where they would

appear to form two straight lines. (At greater distances, the arcs bend more.) If this sounds familiar, it is because Ptolemy's third method of flat mapmaking has been described as the first instance of the rationalized, linear perspective that is famously associated with the Italian Renaissance.

The arrival of the Ptolemaic system did not come about by accident; indeed, it fulfilled a fundamental need. Ptolemy served as librarian at Alexandria under the Roman emperor Trajan, who presided over the empire at its largest. During his reign (98–117 CE), Rome was essentially unencumbered by internal and external threats and extended its area to 2.5 million square miles—moving across the Mediterranean sea from Spain to Syria, north through greater Britain and south through Egypt. In an empire this vast, record keeping in general and mapmaking in particular were essential to effective governance. Mapmaking also became that much more complicated. As the Roman Empire extended beyond the scope of regional cartography, it required world cartography, which is to say maps of the unknown. For each of these types of maps, Ptolemy conceived a distinct standard.

In producing regional maps, he offered coordinates for over 8,000 known locations on a series of "handy tables," each setting out "the individual localities, each one independently and by itself, registering practically everything to the least thing therein."[5] World cartography, on the other hand, would forgo such detail in favor of a homogeneous and encompassing view of the globe. "The essence of world cartography is to show the known world as a single and continuous entity, its nature and how it is situated, only of the things that are associated with it in its broader, general outlines (such as gulf, great cities, the more notable peoples and rivers, and the more noteworthy things of each kind)."[6] Revealing an astute sense of the managerial scale of the world superpower of his own era, Ptolemy wrote that world maps "exhibit to human understanding … the earth through a portrait (since the real earth, being enormous and not surrounding us, cannot be inspected by any one person either as a whole or part by part)."[7]

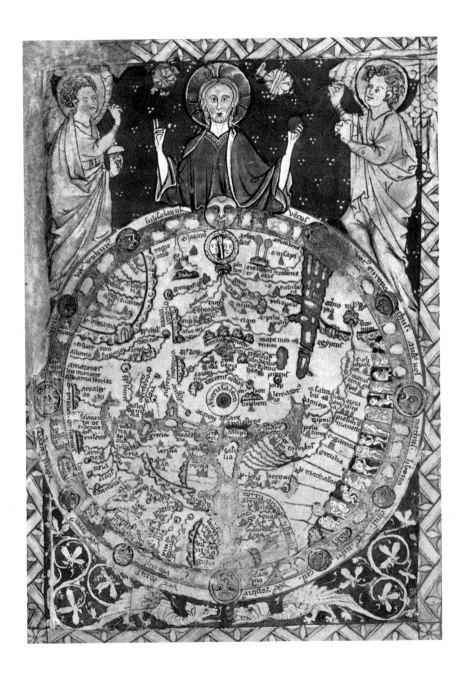

Just as Ptolemy's systems were required and wrought by the growth of the Roman Empire, so they were replaced on its decline. After 200 CE, the Roman Empire destabilized (with the notable exception of the rule of Constantine in 306–337 CE). For hundreds of years, Western Europe was characterized by low literacy rates and widespread petty warfare. The social and political fracture of the times was widely blamed on the decadence of ancient Rome, which was finally sacked by Visigoth invaders in 410. Responding to this shocking state of affairs, Saint Augustine wrote *The City of God* (413–426 CE), in which he attempts to explain how the Christian god could allow such a rout. Augustine theorized an earthly city (with pagan Rome as the archetype) characterized by "love of self" and a heavenly city characterized by "love of God," arguing that the latter must ultimately prevail. And indeed it did. The Roman Catholic Church became the unifying cultural force and governing body of the West—so much so that Jerusalem, the biblical workshop of Christ, was conceived as not only the religious but the geographic center of the world.

With the censure of the earthly city and the rise of the Church came the inevitable replacement of Ptolemy's earthly (which is to say secular) map in favor of one that reflected emerging Christian ideals. The T-O map, first described by the theologian Isidore of Seville in 600 CE, is schematic in the extreme: a *T* form encircled by an *O*. (Although it bears a strong resemblance to some Babylonian and ancient Chinese maps, there is no evidence that Isidore knew of these predecessors.) Isidore showed a circular world surrounded by a circumfluent (*O*-shaped) ocean with a *T*-shaped body of water in the middle and Jerusalem at the center as a kind of navel. The vertical leg of the *T* represents the Mediterranean, with the Don River making the left arm of the T and the Nile the right. Asia fills the resulting top section, with Europe below to the left and Africa to the right. This T-O form became the basis of the great tradition of large, hand-painted maps of the Middle Ages. In a Psalter map from 1250, so called because it is found in a book of psalms, the winds are shown at the perimeter, the "monstrous races" of Africa are shown on the

4.2
Psalter map, circa 1250. Jerusalem is in the center of a squared axis (T,O) surrounded by a zone of winds. Photo: Erich Lessing/Art Resource, New York. By permission of the British Library Board. London, Great Britain. All rights reserved.

87

right side, and Moses is shown crossing the Red Sea in a large, red rectangular wedge at the upper right. These placements are strategic: Asia, the origin of civilization, is placed appropriately at the top, while Jerusalem falls at the very center of the world. In other words, the T-O map was constructed to tell a particular story—in this case about the natural centrality of the Christian world.

Isidore's T-O map (like all maps) simultaneously expresses a symbolic physical world and a belief system. Unlike other maps, it also expresses another feature: time. This is an image of the world of things and the world of the divine unfolding together. The locations of the continents in the T-O maps, though not wholly inaccurate from a modern geographic perspective, are based on the principle that the biblical history of the world and the human experience of that world were in fact inseparable. In *De natura rerum,* Isidore describes mankind as a "minor mundus," or a miniature world. "The human being experiences space in terms of the material body and time in terms of the annual cycle of the seasons, as well as his own passage from birth to death. These are the coordinates of human existence."[8] Maps in the T-O tradition express the temporal and physical dimensions of human experience through biblical narrative. The scattering of people after the fall of the Tower of Babel and the redistribution of people and land among the sons of Noah after the great flood are linked to the continents of Asia, Europe, and Africa directly on the map. As Isidore writes of Asia, for instance: "After the confusion of languages and the dispersal of people throughout the whole world, the sons of Shem lived in Asia and from his posterity descended twenty-seven peoples. And it is called Asia from Asia the queen, and is the third part of the world."[9]

As biblically narrative as it was, the T-O map was also strictly gridlike, its circumfluent ocean (which appeared as well in several ancient clay tablet maps of Mesopotamia) divided into quadrants by an axis. These lines had a source other than topographical bodies of water: they were associated with the four primary and eight subsidiary winds responsible not only for the cardinal directions, but for the attributes

of the seasons, which are shown at the edge of the map. (In *De natura rerum,* Isidore writes that the west wind Zephyrus kindly says, "I adorn the earth with flowers," whereas the cantankerous Vulturnus, or northeast wind, boasts, "I dry up everything."[10]) The cardinal directions, of course, likewise form a right-angled intersection, which would have been seen as a representation of the Christian cross. In sum, the remarkably simple form of the *T* inside the *O* of Isidore's map contains a wealth of symbolic material linking classical mythology and cartography to Christian symbolism as associated with the (crucified) body of Christ and the spatiotemporal "coordinates" of humanity.

The arrangements of cathedral towns across Europe in the Middle Ages show that the cross and circle of the T-O maps also took form in city plans. By this practice, extant Roman grids, if they existed, would be fractured or filled in, or the city would grow organically as infill, adjusted to the contours of the geography. The grid, in other words, is not there in plan, even though the space is conceptualized on the axial model of the cross. Around the bodily remnants of saints (relics) held in the cathedrals, great ringed walls were built for protection. This centripetal organization also linked the surrounding populace conceptually and physically to Christ, who was symbolized by the cross-bearing cathedral at the center of both town and consciousness. The worldview expressed by this plan is summarized neatly in the thirteenth-century Hereford Map. Named for England's Hereford Cathedral where it was found, the map combines detailed geographic information organized on the T-O model with Christian and political narrative material derived from tradition and traveler accounts. Long dismissed as merely symbolic in form, this map and others like it have recently been reappraised and found to demonstrate a high level of geographic accuracy about the edges of navigated landmasses, waterways, and pilgrimage itineraries. As these particular map features suggest, travel and mapmaking persisted during the medieval period. Indeed they picked up pace. Pilgrims visiting religious sites to worship relics, the traders who worked along these routes, and finally the Crusades to win Jerusalem back from the Ottoman Turks (1096–1292) all required maps.

By about 1270, a new kind of map came along, this time by virtue of a new technology. The magnetized needle was first introduced to the Mediterranean probably by way of the silk trade with China through the Middle East, where it was used to generate orthogonal maps beginning in the eleventh century. At Amalfi, Italy, in the late thirteenth century, this magnetized needle was satisfactorily mounted to a card illustrated with a sixteen-pointed star showing wind direction. Thus the portable compass was born—a remarkable invention that made possible highly detailed navigation charts, called portolans. The most famous of these, the Carte Pisane, is found in Genoa, Italy, and dates to 1290–1410. Unlike maps in the T-O tradition, these charts, usually drawn on sheepskin, were oriented toward magnetic North. They also contained the crossing lines of the wind rose, called rhumb lines, which could be used to orient ships according to a network of interconnected wind patterns.

The compass represented a great navigational gain, and it would soon be usefully combined with a new development—or rather the return of an old one. In the fourteenth century, refugees fleeing Turkish expansion in the Middle East brought with them valuables including a Greek copy of Ptolemy's *Geographia*. Throughout the medieval period, work in the Ptolemaic tradition had continued in the Middle East, with Arabic translations of Ptolemy's texts appearing in the ninth or tenth century. Islamic scholars charted latitude and longitude using astronomical measurements that were much more precise than those of the Greeks and Romans, resulting in a substantial refinement of Ptolemy's legacy. For example, by the twelfth century, the Arab astronomer Al-Zarqālī had correctly amended Hipparchus' measurement of the Mediterranean by almost a third. By 1406 the *Geographia* reached Florence and was translated into Latin. By 1477 the earliest printed Ptolemaic atlas of twenty-six maps appeared in Bologna. Made with copper engraving plates, the maps' consistency from one atlas to the next was as remarkable a feature as their geographic detail and accuracy, which would have exceeded that of other

published maps of the time—including Isidore's T-O map, published in Augsburg in 1472.

The publication of Ptolemy's map created a global, if spatially inaccurate, sense of world geography. Christopher Columbus would follow it in his attempt to sail East to India, instead making his landing in the so-called New World, the Bahamas, in 1492. By 1500, Columbus's discovery of a back route to "India" had captivated Europe's imagination. It required a fundamental remapping of the globe, the first example of which appears by 1500 in the form of a portolan chart produced by Juan de la Cosa of Spain, master, mate, and owner of the famous Santa Maria and probable cotraveler with Columbus. Less telling as a map than as a document of discovery, de la Cosa's new world is grossly overestimated in scale. By 1506 the first printed map of the discovery appeared in Florence, produced by Giovanni Contarini and Francesco Roselli. By 1507 the German mapmaker Martin Waldseemuhler made a Ptolemaic style map on which the name America, for Amerigo Vespucci, first appears. The slow realization that this was a new world, not India, led to a flurry of mapmaking in which the makers staked claims to territory on behalf of their sponsors, clinching the Adamic connection between discovery, naming, conquest and mapmaking.

In addition to its inaccuracies, the Ptolemaic map's evenly spaced parallels created distortion, which further complicated navigation. A close look at the lines of the Ptolemaic map (see fig. 4.1) demonstrates the problem. Where Ptolemy had adjusted the meridians in his projections from the three-dimensional to the two-dimensional map, he had neglected to account sufficiently for the diminishing size of the squares approaching north. The German cartographer and engraver Gerardus Mercator solved this problem in 1569 by systematically increasing the distance between parallels as they moved away from the equator. Thereafter, a navigator could draw a straight line between two points on the Mercator projection and find a direct route from one location to another—a great boon for navigation,

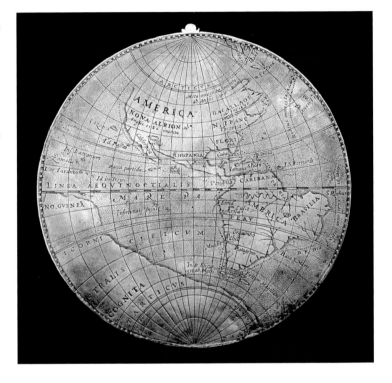

but not necessarily for geographic accuracy. The Mercator projection, with its diffused northerly parallels, results in greatly exaggerated representations of landmasses far north and south of the equator. On the Mercator projection, for example, Greenland is as large as Africa, when in fact Africa is fourteen times larger than Greenland. This produces perceptual distortions for the user. According to Stephen Hall, "the evolution of map projections is like a mathematical shell game that always seems to cheat the southern hemispheres."[11] Nonetheless, maps based on the Mercator projection are still found in most classrooms in Europe and the United States and remain the foundation for world geography. The resulting problems are both functional and sociopolitical. Computer weather modeler Michael Tobis writes that "the latitude–longitude grid … causes all sorts of nasty mathematical

problems at the poles where all the cells come together."[12] The bias inherent in picturing Europe or North America as proportionally much larger than, say, Africa, is obvious, and its ramifications are increasingly evident in the postcolonial age.

Indeed, the orthogonal map of Ptolemy as refined by Mercator can be seen as an expression of an exploratory, expansionist world-view, even as it has served as an essential way of representing the world since the Italian Renaissance.[13] What we must remember is to question the objectivity of the map—not only its grid form, but its points of interest. What was unknown to the explorer and his patron king or queen was simply left blank, or else filled in with imaginary material, not unlike the biblical and classical myths embedded in the T-O maps of the medieval era. An empty space filled with a fantastical cartoon would no doubt have fueled the exploratory fires of adventurers and investors alike. Jonathan Swift would pillory this inventive practice in his description of the imaginative dimensions of cartography: "So Geographers, in Afri-maps, / With savage-pictures filled their gaps; / And o'er uninhabitable downs / Place elephants for want of towns."[14] A historical view would see this practice as a continuation of the medieval tendency to populate Africa with "monstrous races."

Of course there have been important improvements in our conceptualization of the world since Mercator's time. In 1543 Copernicus rediscovered the heliocentric theory of the universe, confirming that the Earth is merely one planet of many orbiting the sun. Also noteworthy were Galileo's use of the telescope for geographic research and of the pendulum clock to improve longitudinal measurements. In 1884, an International Meridian Conference in Washington, D.C., resolved that Greenwich, England, would serve as a universal prime meridian at the center of the world's twenty-four time zones. The choice of England was certainly no accident; at the time the British Empire was the largest in the world: the proverbial sun never set on British soil.

By the twentieth century attempts were being made to accurately represent the size of landmasses approaching the poles, as well as the

interlocking forms of the continents. Toward this end, engineer and philosopher Buckminster Fuller theorized a "general law of total synergetical structuring" that replaced Mercator's grid with other regular geometrical forms.[15] By Fuller's account, the distortions north and south in Mercator's map projection skewed the size of continents and misrepresented the distribution of the Earth's resources, which he was committed to using as efficiently as possible. By replacing the elongated rectangles near the poles with triangles, he would diminish the distortion. In 1946, Fuller was granted the first patent issued in cartography in over 150 years by the U.S. patent office (no. 2,393,676). Fuller called this a "Dymaxion" projection of the world, and it was a method of projecting the surface of a sphere (the Earth) onto a planar surface (the map). The dymaxion form consisted of a cube going around the middle of the Earth with four equilateral triangle grids attached top and bottom to form the "poles." This form is called a cuboctahedron, meaning a cube capped by two four-sided pyramids made of equilateral triangles. The resulting two-way circle grid, which he called a "regular grid," was Fuller's first geodesic grid.

Fuller's Dymaxion map was followed famously in 1973 by the Peters Projection, so named for the German historian Arno Peters who invented it. Sacrificing the navigational straight lines of Mercator, the Peters Projection communicates landmass more accurately—continents are shaped to reflect landmass as opposed to being adapted to the unified field of the orthogonal grid. The resulting distortion of the familiar shapes of landmasses and the distances between them makes Peters of limited value from a navigational standpoint. Embroiled in controversy from the start, the map is nevertheless widely used in the British school system and is promoted by the United Nations Educational and Scientific Cultural Organization (UNESCO) because of its ability to communicate visually the actual relative sizes of the various regions of the planet. Africa, by this projection, is three times larger than Europe instead of roughly equal. But the Peter's Projection is not a more "natural" map. The map is still a projection of three-dimensional space onto a two-dimensional surface, which by definition involves a process of abstraction and distortion.

Like their ancient and medieval forebears, neither the Mercator nor the Peters Projection is objective or disinterested. Rather, every map reflects a set of vested interests. Map historian Denis Wood states the situation clearly.

> This interest is not disinterested. Neither is it simple or singular. This interest is at once diffused throughout the social system (in those forces enabling the reproduction of society as a whole) and concentrated in this or that moiety, guild or class, in this or that gender, occupation, profession, in this or that neighborhood, town, or country, in this or that ... interest and its particular goals and aims. Therefore the conservative forces, whose end is social reproduction in general ... and the transformative forces, attendant to the interests of this or that particular class or industry or part of the country, conspire to naturalize this product of so much cultural energy.[16]

Clearly, whatever the political agenda maps by definition serve particular interests. Even the road maps most of us have in our cars, or had until recently, are distributed for free at gas stations by oil companies and with a significant private stake in promoting automobile traffic. Two hundred million copies are printed each year in the United States alone.

Recent developments in mapmaking reverse, or at least complicate, this historic trend by placing the making of maps, or at least the plotting of destinations on the map, directly in each user's hands. Adapted to individual interests, the expansionist impulses of Ptolemy and Mercator, as well as the communitarian interests of the reformers Fuller and Peters, have been largely left behind in the new world of mapping. The Global Positioning System (GPS), for instance, originally developed by the United States Department of Defense beginning in 1973, guides individual drivers to destinations using triangulated signals from a legion of satellites. Based on coordinating points instead of a gridded field, orientation by these satellites is localized for each user. As a result, the visual organization characteristic

of the orthogonal grid has largely disappeared from the visual screen of these automobile and handheld GPS systems.

Mapquest.com offers conventional-looking printable directions and familiar-looking road maps. However, even this system links locations by routes unbounded by the fixed scale of the conventional map grid. The route map can be scaled as the viewer, with a click of the mouse, zooms in and out of the image, whose detail automatically adjusts to the view. Someone looking at a five-hundred-mile stretch of road, for example, has little need to know exactly where a gas station can be found en route, information that is very useful in reading an immediate proximity. Similarly, Google Earth allows users to zoom in on specific addresses using satellite images that do not show mapping lines. This fundamental shift away from the collective grid heralds a fundamental transformation in the perception of space in the twenty-first century. Gone is the rationalistic and totalizing worldview of the age of exploration and empire, and gone are the adjusted grids of recent communitarian reformers. Instead, satellites produce images for local, unique consumption.

New digital technologies have extended this logic such that instead of merely looking at these localized images, we can manipulate and add to them. For many, these new mapping devices evoke a sense of personal control and freedom. John V. Hanke, director of Google Maps and Google Earth, promotes this view: "What is happening is the creation of this extremely detailed map of the world that is being created by all the people of the world. The end result is that there will be a much richer description of the earth."[17] Unlike the standardized road maps of the past, highly individualized maps covering specific interests sit side-by-side in a digital universe where every fear and every pleasure has its map. As we have seen, mapping is a mechanism for developing a worldview. Historically, this view has been determined to a large extent by the demands of governments, religion, or political reformers, large centralized authorities for which maps have a homogenizing function. These new technologies, by contrast, express worldviews driven by all manner of individual concerns.

A quick view of Web sites devoted to mapping demonstrates that "millions of people are trying their hand at cartography, drawing on digital maps and annotating them with text, images, sound and videos. In the process, they are … collectively creating a new kind of atlas that is likely to be both richer and messier than any other."[18] Not surprisingly, a richer and messier map may sacrifice accuracy in the process. This new geo-web of worldviews is structured by interests as diverse as graffiti production in Washington State, hydrofoils around the world, cheap eats, yarn stores, the spread of AIDS, vineyards, the registered locations of pedophiles, and the latest movie star sighting. The world is truly being remapped for "love of self," which spans the range from merely selfish mapping to relational and changing social sensibilities, beliefs, interests, and agendas.

We are collectively creating a world atlas that is quite unlike Ptolemy's or Mercator's homogenizing tomes. Instead of the many places of the physical world being mapped out for universalizing ambitions, we now have virtual worlds revised ad infinitum by scale and content. Insofar as these mapped worlds refer to a real world traversed using maps, they share spatial features with their historic precedents. However, by virtue of scaled viewing, adding content, or searching by content, digital maps are simultaneously more and less tied to the reality they purport to represent than their historic counterparts. These new maps index a physical world in ever greater detail at the same time as they are constantly adaptable, receptive to collective and individual needs and fantasies about that world. What is unique, of course, is not the projection of a worldview onto a mapping practice or an adaptation of that practice to needs not intended by the inventor, but the coexistence of conflicting views of the world that are emerging as different groups craft maps for their differing agendas. In "The Interest Served Can Be Yours," Dennis Wood celebrates the contest: "Is it true? You color the map, you call the press conference, you press your point of view. It can be as slick as you like. The point is the acknowledgement of interest (we want to see dueling maps)."[19]

97

5 NOTATION 1025

THE SHIFT FROM DAY TO NIGHT AND BACK, the changing seasons, the lunar cycle, circadian rhythms, and the beating heart all mark the stretch of eternal time with a regulating pulse. Whether expressed in an alternating sequence (night to day to night again), folded one within the next (day to season to year), or laid out in the comparable but nonrepeating experience of one's own life (my birth, my growth, my decay), these pulsations all seem tied to a cosmic beat. For the duration of Western civilization, we have seen it this way, making analogies between natural rhythms and those of music. Recall philosopher John Dewey's proposition, cited in this book's introduction, that the "whirling flux of change" that is nature is organized by "rhythms."[1] The musical concept of rhythm was, for Dewey, the cement that binds the thinking human being to the environment through both the body's experience and the intellect's sense of natural order. As we shall see, the advent of musical notation corresponds to this highly organized corporeal and intellectual modeling of time.

The ancient Greeks believed that it was harmony, rather than rhythm, that provided a link between the Earth and its human beings and the heavens. Writing seven hundred years after his death in 490 BCE, the Neoplatonic philosopher Porphyry wrote of Pythagoras: "He

himself could hear the harmony of the Universe, and understood the music of the spheres, the stars which move in concert with them, and which we cannot hear because of the limitations of our weak nature."[2] For Pythagoras music appears as an expression of harmonic convergence, of coordinated celestial bodies. He saw the seven (known) planets, the (fixed) sphere of the stars, and the counter-Earth (the Greeks believed in a cosmic double of the Earth hidden behind a central fire) as related by the whole-number ratios of pure musical intervals, which created a musical harmony that resonated inaudibly yet continuously, producing a *musica universalis.*

In his cosmological dialogue *Timaeus* (ca. 360 BCE), Plato elaborated on the esoteric dimensions of Pythagoras, subjecting them to the steady gaze of his logic, tempered by his own faith in a good and orderly universe. Here Plato's demiurge, the creator of the universe, produced a harmonic "World Soul" that unifies music, the cosmos, and mathematical principles and is composed of note relationships derived from Pythagoras. Nearly two millennia later, astronomer Johannes Kepler (1571–1630) would take up the Pythagorean notion to express a discordant view of the world in his *Harmonice mundi* (Harmony of the world, 1619): in addition to different melodies that he believed expressed the nature of each planet in his system, Kepler's cosmos would produce two notes—mi for misery and fa for famine—forever singing "mi fa mi," a dissonant refrain true to the grueling nature of human life.

Although Pythagorean and Platonic harmony or Kepler's dissonance might seem fanciful to modern minds, their fundamental insight that music relates to natural phenomena has proven remarkably viable. For the modern astrophysicist, the wavelike nature of our entire physical world expresses pitch and rhythm. We know now, for instance, that the macrocosms of the universe as well as the microcosms of cells, atoms, and subatomic particles all vibrate constantly, emitting waves of energy even in their stable states. These waves (large or small) have a sonic dimension, as in the big bang theory—a bang is both pitch and rhythm. In 2005 the disc that forms the Milky Way

galaxy was found to be a drum-shaped form vibrating at a very low C major chord, some three million octaves below the middle C on a conventional keyboard.[3] In other words, even if the pitch of a galaxy is inaudible to the human ear, its pitch is still mathematically discernible. The same is true of the inaudible high pitches associated with molecular vibrations.

The simultaneous omnipresence and elusiveness of tones in our physical universe suggests that capturing them—representing the aural with visual symbols—might be a tricky process, and indeed this has proven historically so. Musical notation, which records music's dual traits of pitch and time, has progressed, regressed, digressed, and progressed again since its earliest incarnation. The first known music notation was written in cuneiform script in Mesopotamia and describes performing on a lyre, with some examples dating to the second millennium BCE. And though ancient Greece developed its own forms of notation consisting of symbols placed above text syllables, the Greeks could not notate for strictly instrumental music or for harmony. In any case, these ancient means were used only between the sixth century BCE and the fourth century CE, by which time their use had not only disappeared but been totally forgotten.

The roots of Western musical notation as we know it today can be found in the seventh century CE, but they took almost five hundred years to grow into the familiar musical staff: five horizontal lines designating pitch in the vertical placement of notes, and vertical lines representing groupings of notes, which contain the pitch patterns in regular intervals of time. This description—of vertical and horizontal lines—should ring a bell, if you'll pardon the pun: musical notation, in which the vertically disposed notes are read left to right, translated, and performed for the listener in highly regulated, horizontally expressed time, is a venerable form of grid. Beginning with the simple observation that on the compositional grid pitch is vertical and time horizontal, we can begin to appreciate its complex nature. Whereas in contemporary astrophysics pitch and rhythm are fundamentally indivisible (the slow pulsation of a galaxy simply happens in the key

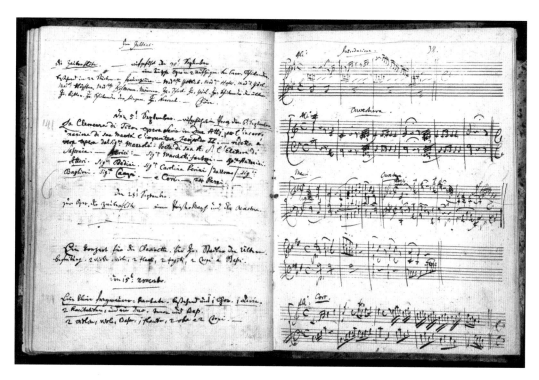

5.1
Wolfgang Amadeus Mozart,
notation pages 3 and 4 of "Thematic
Catalogue," 1791. MS 63, ff.3v–4.
Originally published/produced in
1784–1791. By permission of the
British Library Board. London,
Great Britain. All rights reserved.

of C), for musicians pitch and rhythm are largely autonomous and independently produced. The relationship of pitch and rhythm as expressed in musical notation therefore bares substantial resemblance to the evolution of the map grid, where latitude and longitude developed separately. As we shall see, the notation of pitch evolved first, in large part because the issue of time (meter) was predetermined by the structure of words in the Christian liturgy.

Pitch is determined by the frequency of vibrations internal to a string or a bell, say, which is dependent on shape and atomic makeup, whereas musical rhythm is created by the human action of beating, plucking, or blowing an instrument. In other words, pitch reflects sound qualities inherent in a material, whereas rhythm suggests patterns of external influence. This distinction has fascinating implications. The coordinates of the musical notation signify pitch and time, material and action, other and self. As a result, the compositional grid marks not only the pitch and time of music, but our active engagement with the physical world and the cosmos. Notation has fascinating implications here regarding the limits of human agency. Notation transcribes human actions on materials resulting in music, while at the same time music making is limited by the molecular structures inherent to the materials at hand.

For now let us return to pitch, the vertical component of our compositional grid, and to Pythagoras. Pythagoras's harmony of the spheres was not mere poetry: it derived from his practical experiments into the nature of pitch. Following a legendary pass by a workshop where the hammering of metal was sounding out various pitches, Pythagoras discovered that the tones were high or low depending on the amount of material sounded. Pythagoras would apply this observation, which first suggests a xylophone, most famously to the relationship between pitch and the relative length of a string, which changes on a one-stringed instrument with the placement of a finger. Pythagoras discovered that if a string is reduced in length by one half, whether by being half as long or by being pressed at its midpoint (as on a modern guitar neck), the note sounded will be the

same, but the pitch will be exactly one harmonic octave higher than the first. Likewise, when the length of a string is doubled, the pitch is one octave lower. The octave therefore requires a 1:2 ratio of string length, and the rule is universal. By the same logic, 6:5 of a C-string produces an A, 4:3 of the C-string produces a G, 3:2 of it produces an F, and so forth.

In addition to this discovery, the followers of Pythagoras, the Pythagoreans, found that other ratios produced consonance, or a seemingly universal principle of harmony pleasurable to the Western ear. For example, a ratio of string length of 2:3 and 3:4 produced the harmonies musicians call a fifth and a fourth, respectively, which come at the end of many Western musical works and bestow a sense of familiar, harmonious completion. Pythagorean principles of harmony in turn influenced Greek heterophony, music using multiple tones. This emphasis on pure pleasure, harmony, as distinct from intellectual and moral content, was problematic for Plato, who allowed for song as a fitting imitation of the utterances of brave men (a moral good), but banished virtually all other musicians from the ideal city of his republic on the grounds that they distracted citizens from more important concerns.[4] For Plato, as for early Christians, music was admissible only as a kind of support structure for rhetoric—the spoken word.

In his *De musica,* Saint Augustine (345–430 CE) wrote in the Platonic and Pythagorean vein, arguing that the mind transcends sensual reality and rises to the level of rational truth through rhetoric, but that music represents a path to the divine. The Roman philosopher Boethius (480–525 CE) pursued a similar idea, positing the number patterns of arithmetic, geometry, astronomy, and music as means to guide the soul toward the incorporeal, or nonsensual, knowledge. Having translating several key Greek texts on arithmetic and music, Boethius argued for the preservation of classical knowledge and offered a model for structuring university curricula that was applied for over a millennium. He grouped the mathematic disciplines together (arithmetic, geometry, astronomy, and music) as the Quadrivium,

meaning the four roads. Offered along with the verbal arts of the Trivium (language, oratory, and logic), the two areas made up the seven liberal arts. Significantly, the mathematically derived sense of universal order presupposed by the Quadrivium was considered foundational for the study of philosophy and theology.

For both Augustine and Boethius, pitch was both symbolic and abstract. Indeed, no standard mode of musical notation existed in their time, though Boethius diagrammed his theories of harmony by drawing a picture of a stringed instrument—a series of horizontal lines that perhaps became the lines of the musical staff. Writing in the seventh century, the influential theologian Isidore of Seville famously claimed that music could not be written, which he interpreted as a testament to its divine nature. Ironically, at about the time he was writing, the pragmatic needs of the Church, which began standardizing its liturgy and exporting it across Europe, created a demand for a notational system—though it would take two to three hundred years for such a standard system to be developed.

From the earliest days of the Roman Catholic Church, readings from scripture were alternated with call-and-response singing in the performance of the liturgy. Originally sung by the congregants, these early hymns and alleluias were of a simple kind. By the late fifth century or early sixth century, however, the audience refrain was often taken over by schola, a body of trained singers that later included soloists. Gregorian chant, named after the sixth century's Pope Gregory, is an example of the plainchant, which gradually dominated the liturgy. These mellifluous and monophonic chants (one note being sung at a time) consisted of sequential shifts in the melody, normally of a half or a full step so as not to overwhelm the scripture. By the middle of the eighth century, in response to Charlemagne's desire to retain the nuances of Roman singers, these chants were notated in the form of neuma, a system of calligraphic strokes, letters, and dots located above the liturgical text. Neuma were inflective, indicating the general shape but not the exact notes or rhythms to be sung. Later, heightened neuma appeared that showed the relative pitches

between neuma. These forms eventually led to the creation of a four-line musical staff that identified particular pitches. Gregorian chants are organized into eight scalar modes featuring characteristic beginnings, endings, and reciting tones around which the other notes of the melody revolve.

The neumatic form emerged as a by-product of the teaching of oratory, in which the accent acute (á), which moves up from left to right, and accent grave (à), which moves down from left to right, denoted pitch.[5] More calligraphic neumatic forms probably reflect hand motions. In practice, the neuma offered not a precise means of musical notation, but rather a mnemonic cue. It expanded the communicative range and effectiveness of the clergy. Instead of the audience being merely spoken to, the divine text is communicated in newly emerging tonal patterns that create a sense of sonic order. Imagine a world where almost no one is literate and where, paradoxically, the word of God is the origin of the world and the source of legal and moral authority. By tying sacred words to well-known melodies using neuma, the clergy and the public were better able to remember these sacred texts and also to connect to them through the emotionally resonant feature of the sung voice. These songs were well known, so it was not necessary to script specifically for tone. Rather, general directions—the melody moves a little up here, a little down there, this word is clipped and emphasized—were cues for remembering a song long heard in one's experience with the liturgy.

By the early eleventh century, the churches of Benevento in southern Italy were notating music using Beneventan neuma, which were written at varying distances from the text to indicate the overall shape of the melody. The designation of "high" and "low" written in vertical relationship to a single horizontal line seems obvious, since we've become accustomed to thinking about pitch as high and low. There is, however, no objective reason for the designation, and the importance of the innovation can scarcely be overemphasized. For with the arrival of high and low notes as a way to describe relative pitch tones, the vertical, two-dimensional, up/down pitch space of

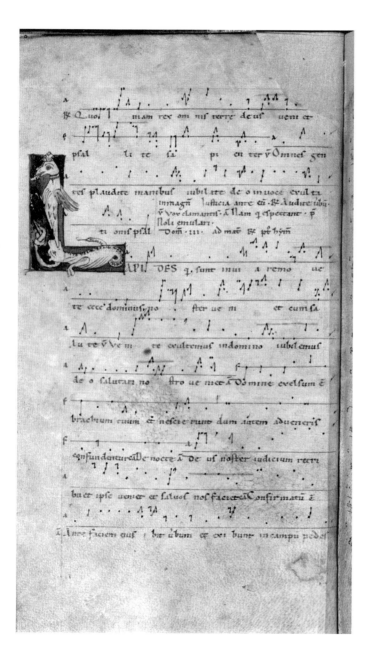

5.2
Chant for Third Sunday in Advent.
Image taken from an Antiphonal
originally published/produced in
N. Italy [Milan?], twelfth century.
By permission of the British Library
Board. London, Great Britain.

Western musical notation appears. As does the notational grid: the vertical pitch coordinate moves at a regular tempo along the line from left to right.

Significantly, this arc of notational development was not only a response to changes in musical structure, but an expression of religious symbolism. In about 876 CE, the scholar Johannes Scotus Erigena argued in *Concerning the Division of Nature* that polyphony (multiple notes performed at once) was a *musica mundana,* or earthly correlate of the music of heaven. Where Pythagoras heard each planet as a lone voice, Erigena imagined the whole cosmos as a chorus. The first known piece of polyphonic composition was written in Erigena's day, by French composer Roger de Laon, whose work consists of a main voice, or *vox principalis,* accompanied by a *vox organalis,* which sings a perfect fifth above the melody in what is called parallel harmony. The most consonant harmony outside of the unison and octave, the fifth is widely used in chord structure, song development, and Western tuning systems.

Although the contributions of these contemporaries exhibit no apparent overlap on the surface, a speculative read links them neatly: Laon's perfect fifth places three whole tones (seven semitones if we allow for half steps or black keys) between the main melody and the harmony, and these three contiguous notes mirror the consonance of the Holy Trinity, whose indivisibility is absolute. G, for example, is a perfect fifth above C; D is a perfect fifth above G; C is a perfect fifth above F, and so on. Indeed, harmonic intervals held great spiritual significance—both positive and negative—in this era. For example, the tritone dissonance is a half step below a perfect fifth and is therefore called a diminished fifth, as from B to F in C major scale. Later, the tritone was nicknamed "the devil in music" by medieval music theorists and was strictly to be avoided. The use of the tritone dissonance to communicate scary or disorienting passages in film scores, as in the shower scene of Hitchcock's *Psycho* (1960), demonstrates the durability of the association. By the fifteenth century, harmony was explicitly tied to higher levels of religious contemplation. In his

Declaration on the Discipline of Music, composer Ugolino of Orvieto argued that the monophonic music of the medieval plainchant was too plain. By his account, plainchant was unable to express the patterns of harmony that would necessarily stimulate the reasoned judgment of beauty and the divine.

Writing between 1026 and 1033, the Northern Italian composer and music theorist Guido of Arezzo made great strides in the development of modern notation, which introduced a level of flexibility to the writing down of notes that allow for notated, polyphonic harmony. Guido's work focused less on the symbolic aspects of notation than on the practical needs of the cantor, or schoolmaster and singer trying to teach a group how to sightread music, as shown by the association of the stave with the famed pneumonic device of the Guidonian Hand, which was not actually invented by him. Each part of the so-called Guidonian hand represents a specific note spanning nearly three octaves from G at the bottom of the modern bass clef to the E at the top of the treble clef. Pitch moves up from the tip of the thumb to the bass (G, A, B—do, re, mi) across the top of the palm of the hand, up the pinky, across the top knuckles of the fingers, before spiraling down the index finger around the bottoms of the digits and ending with a spiral circling across the middle of the ring finger to the middle joint of the index finger. In teaching, an instructor would indicate a series of notes by pointing to them on their hand, and the students would sing them. Significantly, the hand simplified giving visual cues to half steps between notes. Guido's contribution consisted of translating the existing mnemonic devise of the hand into a means of the staff notation, our musical stave, which is shown on the palm of the hand in the illustration.

Perhaps most important, it is in Guido's work that the single pitch line became two lines (red for F and yellow or green for C), and then four as seen above the ring finger. Further, the lines no longer symbolized the strings of an instrument, as they had in Boethius' theoretical writings, which meant that pitch values could be attributed to the spaces between the lines as well as the lines themselves.

110

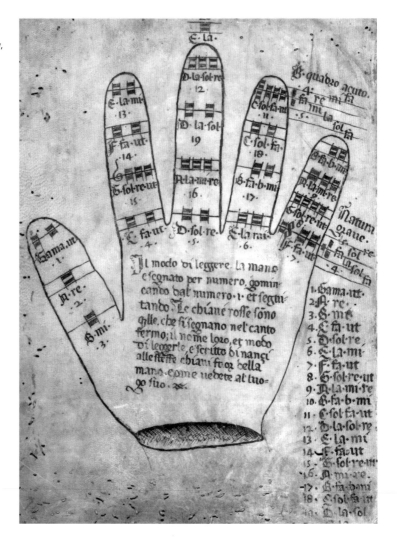

Guido expanded the number of permissible intervals in the liturgy to four, called the concordia. These greatly expanded both what could be sung and how, by expanding composition to eight modes (analogous to the modern keys), designated by a letter (F or C) to the left of the staff—what we now call clefs.

Beginning with this appearance of the stave, musical notation, composition, and distribution of musical manuscripts exploded in scale. By the twelfth century, at Notre Dame Cathedral in Paris, legions of scribes were copying Guido-style musical manuscripts by hand. Carried across Europe for use in church ceremonies, the manuscripts established Paris and the choir school at Notre Dame as the musical capital of Europe. Under Peter Lombard, the Bishop of Paris, the choir school became part of the university system and with that, subject to its standards of communicability set out for Boethius's Quadrivium. Standardization and mass publishing, albeit by hand, made Guido's notation the global standard for the medieval Christian world.

The organization of regular tones on the stave, an emergent gridwork, prompted advances in harmony unintended by Guido and the church fathers seeking musical standardization. The stave allowed for multiple pitches to be designated at once. In the eleventh and twelfth centuries, harmony would also necessitate notational designations of time, for the coordination of multiple voices meant that they would have to sing in rhythmic unison. Dominant at this point in Western history, and throughout the seventeenth century, was a theory of time derived from Aristotle.

Aristotelian time consisted of discrete individual times based on observable cycles: the rising and setting sun, the turning of wheels, and the birth, growth, and decay of human life. Measuring time would rely on the presence of someone able to observe these cycles. By this account, time is not absolute and cannot exist in the absence of beings able to count or measure it. The four elements of the material universe (fire, air, water, and earth) exist in a cyclical and interchanging relationship that is maintained by the sun, which in turn is maintained by God. Whether long or short, the measured pulse of

time in music was conceived as analogous to natural, cyclical, sensually verifiable rhythms.

Notated rhythm, as distinct from the rhythm of sung words, dates to the mid-thirteenth century. The first great composer of the Notre Dame School, Leonin, has been credited (in 1280, through a student known as Anonymous IV) with identifying six rhythmic modes that translated poetic rhythms into music.[6] Recently, credit for establishing these modes has shifted to 1250 and John of Garland (a magistrate from the University of Paris), whose *De mesurabili musica* predates Anonymous IV.[7] Whoever the inventor, these six modes consist of various arrangements of long and short values, called longs and breves, which are based on known poetic meters: long-short (trochee), short-long (iamb), long-short-short (dactyl), short-short-long (anapest), long-long (spondee), and short-short (pyrrhic). Not yet standardized, the duration of each note had to be understood from the position of a note in a phrase. The resulting patterned, modal rhythm is characteristic of the Notre Dame School. With few exceptions, one mode prevailed through a phrase, changing to a different mode only after a cadence, or habituated ending. The patterns suggest an association between musical and poetic meter that may reflect a mnemonic function, the musical modes serving as a tool for memorizing the liturgy in a largely nonliterate era. For example, the first mode (long-short, long-short) could be counted out as one-two/three/four-five/six in modern 6/8 time—six pulses of eight length notes—which is the rhythm of "Ave Maria" and "What Child Is This?" (also "Greensleeves").

Following John of Garland, rhythmic modes were given at the beginning of the composition, or after a rest or cadence when a change in the mode was desired. A change was indicated by showing a cluster of notes that would set the new pattern. The six modes explicitly organized time into modulated rhythms to unprecedented ends. These notated patterns or groups, known as ligatures, allowed for looser parallelism in harmony, as well as for the tenor voice's deviation from the melody. Since the inception of parallel harmony with the tenor

had been limited to holding down the melody structure of the song. Now the tenor voice could be measured into smaller, rhythmic units and opened up to more complex expression relative to other voices: this coordination is called counterpoint. From this point forward, the voice and instrumentation of musical would be (from a structural standpoint) subservient to rhythm.

Garland's *De mensurabili musica* (1250) solidified the modes of "measurable music" or rhythmic notation, while at the same time providing them with increased flexibility. Franco of Cologne, who wrote *Ars cantus mensurabilis* (The art of measurable music) thirty years later, also secured and freed the modal system. Determining that henceforth the length of the "perfect" long note would be divisible only by a standardizing two or three, he gave the rhythmic dimension of music a self-fulfilling logic no longer dependent on the meters of poetry. Likewise, the "perfect" measure consisted of time signatures in three beats—for example, the one-two-three, one-two-three associated with a modern waltz—its "perfect" disposition divine unto itself, reflecting the three-part structure of the Holy Trinity.

It is possible that these developments in the rhythm of music, specifically division into smaller temporal units, emerged from advances in the technology of time. The hourglass, which dates to the eleventh century, measured units of time less than one hour more accurately than the existing water clocks and candle clocks of the early Middle Ages. Using gears and gradually falling weights, the earliest mechanical clocks date to the thirteenth century, when tower clocks (probably developed by monks in northern Italy) appear in public places. Clearly, the idea that time could be highly standardized and divisible into smaller units had a place in public life as well as music.

Even so, the emergence of symbolically rich rhythmic modes, when coupled with a symbolically rich tonal system and liturgical content, suggests a mutually reinforcing system of meanings. Coupled with words, the melody and rhythm of the music made possible by the new notation suggested the multivalent presence of the divine. Writing about John of Garland, medieval musicologist Albert Seay

describes the effect of this coordination of meanings: "The composer's ideal is not the presentation of melody as such, but rather the emphasis on rhythmic patterns that are supported by melodic movement; these patterns are then organized on a large skeleton that can be grasped only by feeling *the symmetries from one group of formulae to another.*"[8] The rhythmic modes, in other words, expanded the sense of continuity linking tone and rhythm.

The notation of rhythmic modes was further refined in the fourteenth century by the French composer Philippe de Vitry, who would develop the basis for modern simple and compound modes by further dividing the longer note, as well as its fractional counterparts of the breve and the semibreve, into two smaller parts. The resulting combination allowed for perfect and imperfect rhythm patterns, which effectively ruptured the insistence on Trinitarian patterns and opened the door for secular song to be both written down and adapted to the Church. Whether the total measure was divided by double or triple, the *minim,* or smallest note, was of the same length. Thus double and triple divisions of notes could be juxtaposed, stimulating rhythmic counterpoint. "Imperfect" modes that support modern two- and four-beat emphases were now on the rise. Love poems might now be sung alongside sacred texts, while a sacred text could be adapted to familiar secular melody.

It was not merely polyphony that offended Pope John XXII (1249–1334), but the idea that secular music might merge with the sacred and penetrate the liturgy. After banishing polyphony from the liturgy in 1322, he spoke in his 1324 Bull *Docta sanctorum patrum* warning against the moral decrepitude of harmony. Ruling from Avignon, this powerful pope criticized composers for knowing "nothing of the true foundation upon which they must build. The mere number of the notes in these compositions, conceal from us the plain-chant melody, with its simple, well-regulated rises and falls. These musicians run without pausing, they intoxicate the ear without satisfying it, they dramatize the text with gestures and, instead of promoting devotion, they prevent it."[9]

Enchantment by playing Gregorian modes and secular poetry off of each other was precisely the preoccupation of *ars nova* poet, composer, nobleman, and church official Guillaume de Machaut (1300–1377). Machaut was one of several composers using isorhythms, in which, according to composer-artist Joshua Selman, "the length of the melodic phrase and the meter do not coincide. This means that the melody must iterate several times before its first pulse (ictus) re-coincides with the first pulse."[10] This creates a staggered effect of the melody catching up to the rhythmic mode, matching it momentarily, and then exceeding it again. For example, if a melody is four notes long, but the rhythm is moving in a one-two-three, one-two-three mode, the first note of the melody and the rhythmic mode will coincide in every fourth measure. Composers Igor Stravinsky and Steve Reich would famously revisit isorhythmic composition in the twentieth century. Experiments like Machaut's coincide with an explosion in the production of ambitious secular music, a shift away from the ecclesiastical function of compositional theory and movement toward an emphasis on the sensual effects of music. Especially in Italy, whose wealth and cosmopolitan links to the Far East established a more secular sense of culture than elsewhere in Europe, secular song was increasingly performed and notated.

In another example of how compositional innovations were triggered by nonmusical inventions (like the mechanical clock), in the mid-fifteenth century the prolific music theorist Johannes Tinctoris wrote the first dictionary of musical terms as well as *Expositio manus* and *Proportionale musices,* two treatises on the notation of rhythm that took an important cue from changes in accounting practices by describing the rhythmic modes as proportions. By the 1450s, the Medici family of Italian bankers had changed their accounting books to the Arabic-Hindu numbers that we use today. In order to trade using these numbers, a system was devised through which nonequivalent terms could be expressed proportionally (as in finding a lowest common denominator through which to express all the values). This instigated the so-called rule of three, or Merchant's Golden Rule, a

formula merchants used to calculate proportions of nonequivalent terms. A key feature of the standardization of musical mensuration probably came from this rule, which led to a simplification of proportion signs in mensuration to twos and threes.

The figuring of both the proportions of notes to measures and to each other now became highly homogenized, a process of standardization that is in keeping with the tendencies of those Renaissance humanists who saw man as the measure of all things. At this time, vertical bar lines (stems) began to be used to divide the horizontal lines of the staff into sections as a visual aid for lining up notes that were to be played or sung at the same time, and not as might be expected to divide the melody into measures of equal length. At this time, music featured fewer regular rhythmic patterns than in later periods: the grid was in some ways accidental since it served merely to line up notes to be played together. Some scholars have taken this visual standardization of musical composition as a sign of its subservience to the visual logic associated with perspective painting. By this account, the collaborative experience associated with plainchant and numerical symbolism of late medieval rhythm and harmony is replaced by a newly sovereign ego.[11] Musicologist Vincenzo Galilei, father of the famous scientist, described music in precisely these humanistic terms: "If a musician has not the power to direct the minds of his listeners to their benefit, his science and knowledge are to be reputed null and in vain."[12] As important as this emerging modern man was, however, it is important to recognize that the emerging bar lines at this time did not affect the musical modes, although they did allow for more complexity, since most music then featured far fewer regular rhythmic patterns.

Over time bar lines assigned time point and duration value, codifying the existing practice of accenting the note at the beginning of the compositional period.[13] Significantly, how a note is placed in the bar is not necessarily graphically identical to where it sounds in time. These regular measures (as expressed through the placement of bars) became commonplace by the end of the seventeenth century—we see

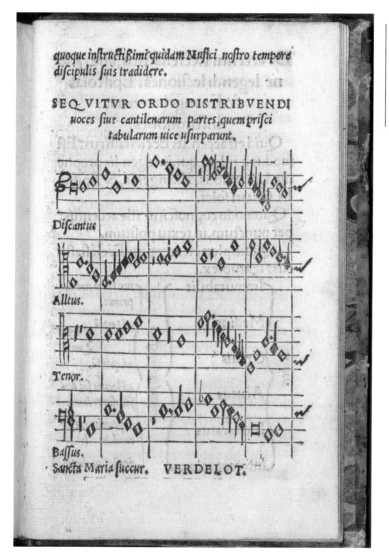

them in the compositions of Johannes Sebastian Bach, for example. Baroque music was rhythmically and tonally complex. Baroque composers assumed for the most part that they would write out only a basic framework. Performers embellished a notated framework, adding ornamental notes and flourishes. This practice varied considerably across Europe. Writing in 1774, Johann Adam Hiller described the importance of the bar and measure system in performing such complex works:

> Of two notes, side by side, of the same kind and value, and in a duple or equal division of the beat, one will always be long and the other short, according to their inner quality ... this fact has its basis in man's natural feelings, and also in speech. Two syllables cannot be spoken together without appearing that one is shorter than the other, although prosody sometimes wishes to take exception to this. The division of the measure determines which of the two is long and which is short. This is made apparent on paper by means of a line drawn through all five lines, called a bar line (what is included between two bar lines, whether one, two, three or twenty notes is called a measure).[14]

Whatever other flourishes might be added to a composition, the bar and measure system gave Bach control over the dense contrapuntal textures for which he is famous. Bach's interlocking thematic devices achieved intermovement unity in long compositions.

The use of measures enabled other kinds of counting as well. In rehearsal, a conductor or performer could now address each ictus with precision; a simple "let's go back to measure nine" would be sufficient. Later composers would write these numbers over the measures, aiding greatly in the efficiency of rehearsal. This evolution toward the use of measures of uniform length reflects a shift toward a new sense of autonomous time that replaced the Aristotelian, relational time of setting suns and shifting moons. By the mid-seventeenth century, Sir Isaac Newton had codified a new theory of time conceived as an empty, homogeneous, and infinite line, independent of the relative

space and time of individual objects and relationships in the material world. He called this Absolute Time, and it would reign until the twentieth century, when it would be challenged by Einstein's discovery of spacetime. Rather than forming rhythms by breaking a whole into ratios or fractions, the measure is made of uniform beats and pulses that can be thematized and varied, as they were by Bach's admirer and acquaintance Wolfgang Amadeaus Mozart.

As a result of this shift toward evolving patterns, a work could be written down in summary fashion, as was the case with Mozart's famed thematic catalog of works from the last seven years of his life (see fig. 5.1). This working journal titles and describes the work on unruled pages to the left of the score, while each right-hand page contains ten staves that show the first few notes and a short score summary of the dominant theme. This reduction to themes and summary elements demonstrates the extent to which Mozart's compositions consist of a sequence of units of equal length rendered rhythmic by accenting particular pulses and note relationships in the sequence. Like an architect working with a total design consisting of modular elements, these would be grouped together in the service of this larger pattern until a rhythmic hierarchy of coordinated metrical patterns was interconnected in the service of the whole composition.

In the late nineteenth century Matthias Lussy proposed a new form of rhythmic emphasis based on a psychological theory in which three kinds of accents were inherent in the performance of a work: metrical (instinctive), rhythmic (intellectual), and expressive (sentimental). He wrote, "In spite of the importance of the bar, metrical accent must give way to rhythmical accent, and both must in turn give way to the expressive accent, which will always take the lead and rule the others."[15] Others took a biological view, arguing that the quadruple meters (one, two, three, four, etc.) were most natural to the human ear and should be emphasized. The twentieth century would counter these diverse universalizing schemes with theories of rhythm that borrowed heavily from scientists' new claims as to the nature of time. Most important among the influences is Albert Einstein, who

transformed time from the Newtonian model of the absolute into a spacetime world of singular events. With this radical new modeling of time as space and vice versa, it makes sense that composers would craft works that could account musically for the relativity of the universe.

Consistent with the pervasive relationship between changing conceptions of time and notation that followed the invention of the mechanical clock in the thirteenth century and the principle of Absolute Time in the seventeenth, spacetime suggested new means of scoring music, even if the greater project of musical experience was relatively specialized. American composer Earle Brown (among others) changed musical notation by moving away from the strictly sequenced left-to-right, top-to-bottom aspect of the five-line stave and bar system. The resulting "open form" employed entirely graphic devices and consisted of a simple grid composed of instructional modules (sometimes pieces of conventional notation) whose order is left free to be chosen by the conductor during performance. Another American composer, Morton Feldman, adapted this system (retaining the strict sequencing of conventional notation) for a film score for two cellos that would accompany Hans Namuth and Paul Falkenberg's 1951 film of Abstract Expressionist painter Jackson Pollock. Pollock's sense of painterly space as driven by actions in time relates closely to Brown and Feldman's methods of graphic notation, as Feldman's recollections reveal:

> In thinking back to that time, I realize now how much the musical ideas I had in 1951 paralleled his mode of working. Pollock placed his canvas on the ground and painted as he walked around it. I put sheets of graph paper on the wall: each sheet framed the same time duration and was, in effect, a visual rhythmic structure. What resembled Pollock was my "all over" approach to the time-canvas. Rather than the usual left to right passage across the page, the horizontal squares of the graph paper represented the tempo—with each box equal to a pre-established ictus [articulated beat]; and the vertical squares were the instrumentation of the composition.[16]

The instrumentation consisted of general directions: an A note, for example, or silence. Brown's and Feldman's means of notating music using the graphic form as a "visual rhythmic structure" moves notation away from the left-to-right sequencing of linked notes that reflects composition's distant origins in rhetoric (the neum), while at the same time retaining the idea that horizontal movement indicates movement in time units and vertical placement tonal values—in this case the clustering of instruments. Significantly, the surface of these scores feels much like the omnidirectional spread associated with Pollock's drip paintings. Feldman would write other compositions inspired by abstract painting, including *For Franz Kline* (1962), *Piano Piece (to Philip Guston)* (1963), and *Rothko Chapel* (1972).

A third American composer, John Cage, a close friend and associate of Brown and Feldman, further revolutionized notation techniques in 1952, when he composed a piece consisting of four minutes and thirty-three seconds of silence in three movements. Silence, in effect, offers a challenge to the thousand-year-long project of tonal composition in the West, the project upon which the entire history of musical notation and music making itself is based. Though Cage continued to score works using the five-line stave (often broken) and specific sound input such as piano, radio, or water, this particular work has implications for graphic musical notation that extend its spacetime aspect into a more generalized cultural domain. Cage had long been experimenting with intervals of silence in otherwise conventionally scored works. *Sonatas and Interludes* (1946–1948), *A Flower* (1950), *Two Pastorales* (1951) and *Imaginary Landscape no. 4* (1951) all contained increasingly longer phrases of silence, but this piece went all the way.

4' 33" was written in three movements listed one above the other on a single sheet of paper with the simple time frames of Part I: 33", Part II: 2' 40", and Part III: 1' 20". When it premiered in Woodstock, New York, on August 29, 1952, pianist David Tudor performed the work by closing the lid of the piano at the beginning and opening it briefly at the end of each movement. No intentional musical sound was made. Despite the absence of musical notes in this composition, the

work contained the feature of organized sound in time that connects it to the tradition of notation I've laid out. Feldman noted as much when he described Cage: "I feel Cage's sense of overall scale is quite similar to Brian O'Doherty's observation concerning Jackson Pollock's painting, 'That an imaginary grid seemed always in operation.'"[17]

It can be observed that such a universal listening experience deviates far from the structured meters and pitches of notated music, that musical notation is a mere by-product of the network of people or listeners in space, working on the greater project of sharing musical sounds. Indeed, classical notation and music making often do not go together—think of the many rich musical traditions—folk, jazz, and rock music—that do not involve reading music this way. Harvard University's Howard Gardner has developed a theory of multiple intelligences that assesses the relationships between sensory data and the organizational and adaptive capacities of the human being—a body-based organizing principle that need not require the compositional grid. Gardner describes that musicality is concerned primarily with pitch and rhythm, its magic working deep in the brain as well as out in the social world. Although he makes no explicit mention of notation, potentially new auditory patterns and a greater complexity of patterns accompany developments in notation. He writes: "he [the composer] is always, somewhere near the surface of his consciousness, hearing tones, rhythms and larger musical patterns."[18]

In this tradition, musicologist Hoene Wronsky defines music as "the corporealization of the intelligence that is sound,"[19] meaning the organized embodiment of sound, placing emphasis on the corporeal dimensions of music. This corporeal aspect of music expands both the basis of its production as well as its potential for intelligible experience. The stretched and compressed rhythms of rock and jazz music, for example, may sometimes rely on the meter forms of classical and traditional music—but these meters are rendered elastic, responding seemingly to the performer's body or mood or conceptual play. As if the music were heard through the auditory equivalent of a fishbowl, the order stays close enough to convention to establish itself as a

variation relative to a given structure. Similarly, unconventional tunings of instruments in modern popular and classical music and the use of microtones, intervals of less than an equally spaced semitone, place further tonal options between the vertical positions of notes. As composer Charles Ives famously put it, microtones are the "notes between the cracks" of the piano.

The transcendent quality of this description, that music exists even between the cracks of the piano, like the ubiquitous music of Cage's *4′ 33″*, suggest that some organizing principle is always at work, even if it is not a compositional grid. The world offers tones and rhythms, to borrow from Gardner. This universal music constitutes a return to the values of music associated with the music of the spheres of the Pythagoreans and Kepler and Boethius's Quadrivium, not to mention our contemporary astrophysicists. Insofar as much of this work involves the universal principle of everywhere as well as the processes of demarcated time and careful listening, these composers and performers should be seen as working alongside the great philosophers of universal music in the distant past as well as with the structural knowledge of the interim. Songs and melodies are, for many, life's soundtrack even as life offers back its bass line—baboom. Pause.

6 LEDGER 1299

MODERN IMAGES OF ANCIENT WEALTH—from photographic documents of archaeological finds to scenes in Hollywood films like *The Ten Commandments* and *Raiders of the Lost Ark*—suggest that all such lucre was held in secret hoards. These images tend to look the same: unsorted piles of glittering gold coins, jewelry, and trinkets hidden in marble palace cellars, caves, or other veiled locales.[1] They are alluring, but misleading images: the people of the ancient and medieval worlds did not participate in rogue economies wherein each citizen kept his assets messily squirreled away until it was time to trade some gold for supper. Rather, their economies were highly organized, complete with detailed written accounts of the accumulation and transfer of wealth.

These financial lists are a primary source of historical information about the economy and society from which each comes. In the agrarian society of ancient Babylon, for example, land deeds and mortgages were recorded on permanent cuneiform slabs, such as the Chicago Stone (see fig. 2.1), which reveal how each family's assets were tied to land. In ancient Egypt, a special class of scribes kept tax records on papyrus sheets. Here wealth was also tied to agriculture, but the Egyptian systems were far more complex, the result of both

a strong bureaucratic order and the fact that they calculated and dispensed stores—real goods—as pay. The vastness of Rome necessitated a dual organization of assets in the immediate form of stores and in the abstracted form of coin, since it's easier to move a pocketful of coins across town than a cask of wine. The records of Appianus, a third-century Roman estate, show computation of the profitability of individual activities—vineyards, livestock, wheat, and slave labor, as well as money on hand.[2]

Greeks and Romans used a system of stores accounting that recorded what was available in store for future use or trade, as well as charge and discharge accounts of cash. Records of incomplete transactions, where money was to be paid at a later date or goods returned to an owner—the earliest form of credit—are also found here. Such transactions were guaranteed against pledged valuables, or "stipulations." These account books were kept by educated slaves on behalf of a patrician class. Balanced from left to right, with income listed on one side of the account and expenses on the other, they can be seen as an important precedent for modern accounting ledgers, which track assets and liabilities. They can also be seen, with their columns and rows, as a running tabulation that forms the appearance of a grid. This wealth was not, however, yet subjected to the homogenizing function of a money standard as the universal denominator of value. Thus although these records take the form of a grid shape, they do not yet herald the full-blown, computational grids of the ledger.

Each of these ancient accounting systems suggests the variety of mechanisms by which financial assets were managed in support of a set of social values. Ancient civilizations used financial records to transfer wealth, to tax it, to trade it, and to track it—in cuneiform, pictograms, and phonetic scripts legible primarily to a special class of scribes. Progressing into medieval times, these forms multiplied, bringing us the tally, the checkerboard, and the early modern double-entry ledger system, the last of which finally does translate wealth into the homogenizing module of the grid.

Although charge and discharge books existed for Church and Crown during the medieval era, the localized economies of this period did not, for the most part, require specialized written accounts for everyday financial matters. Rather, the ancient account system of the tally dominated.[3] Medieval statutes for university students in Paris demonstrate the everyday use of the tally in the feudal era: "Whoever wishes to have wine beyond this portion, whether at table or away, should record it on his tally, and reckon it according to his conscience. Of which tally one part remains with the servitor and the other with his master, and the receipt is to be tallied as soon as he gets his wine."[4]

Tallies could take the form of a marked board or a notched tally stick. Two cows, for example, might appear as two notches on a tally stick, and the payment of a third would prompt a third notch. As is well known by school children the world over, at five a long diagonal strike is put through the row of four notches. Tally sticks allowed for easy duplication: they were split with a hammer and chisel along their length. When more goods were owed and paid, new notches could be made in duplicate by simply bringing the split tally sticks together and adding a notch to both halves. These joined sticks would constitute a kind of contract between the holders, who would have agreed to bring the devices together for the purposes of adding new marks. The sticks' unique correspondence was altered in one crucial respect: one was cut shorter, and given to the debtor, and the longer piece, called the "stock," was given to the party who had advanced goods or funds to a receiver. The modern word "stockholder" and the term "the short end of the stick" derive from this practice. Inexpensive to produce and made of readily available materials (hard wood or sometimes bone), the tally's low cost and easy production partially explains its appeal. Tallies were rat and decay resistant, as compared to parchment, and resisted erosion when exposed to the elements.[5] What's more, unlike Roman account books produced by a special class of slave for their masters or Egyptian tax records produced by a special

127

class of bureaucratic scribe, the tally was intelligible at a glance to literate and illiterate people alike. Of course, the tally only functions in an ongoing relationship. A record from 1305 illustrates the problem clearly. "Owed ten gulden by a man since Witsuntide," one reads, "[but] I forgot his name."[6]

Sometime between the eighth and eleventh centuries, the checkerboard abacus, known in the ancient world in rudimentary form, entered Europe by way of Moorish Spain. The abacus could be used to add, subtract, multiply, and divide by moving markers, called "checkers," in ascending order of value from left to right. Ten checkers in the ones row equals one in the tens. Ten in the tens equals one in the hundreds. Ten in the hundreds equals one in the thousands, and so on. Use of the line-based tally and the grid-based checkerboard formed a two-step process of quantification that was as intelligible to the individual farmer as to the Crown. This isn't to say that accounting was a do-it-yourself endeavor: after the tally notches were totaled, professional reckoners performed the multiplication, division, and translation to money on the checkerboard. These reckoners, called "chequers" in England, were responsible for auditing feudal lands so that rents, sales, tithes, and fines could be served on behalf of the Crown. The Upper Exchequer functioned as revenue collector and treasurer, while the Lower Exchequer performed the humbler role of cash office for the king. Sheriffs, treasurers, calculators, silver smiths, and tally-cutters also gathered around the table for annual tax audits. Thus "The Chequers" has lent its name to many an English pub, where these transactions were executed provisionally around Easter and ultimately around Michaelmas (September 29).

Details of this process can be found in a contemporary account written in 1179 CE by a staff member of the Exchequer, Richard Fitznigel, who later became bishop of London. Fitznigel describes feudal barons squeezed into chairs crowded at one end of the table. The sheriff, who represents the king, sits opposite them with his clerks. The treasurer, his opponent, sits on the left side of the table with his supporters. (Negotiations between the treasurer and the

6.1

Thomas Rowlandson, engraving of
the Court of Exchequer. From *The
Microcosm of London* (R. Ackermann,
1808). This image of the Exchequer
in London shows a late tally board,
but the system was fundamentally
unchanged from the middle ages.
Courtesy of the Boston College Law
Library, Daniel R. Coquillette Rare
Book Room.

sheriff were often antagonistic.) On the right is the human calculator and a tally-cutter who cuts a final financial record, or end tally. The financial finagling could take from one to seven days. Its strategic nature suggests the game of chess. Indeed, Fitznigel reports, "as on a chessboard … struggle is joined between two persons, to wit, the Treasurer and the Sheriff who sits at his account, while the rest sit by as judges to see and decide."[7] After tallies on both sides were counted and notches translated into like units, they were calculated on the checkerboard, which looked quite like a conventional gridded game board placed either on a piece of cloth spread on the table or painted there directly. The table had a rim to stop the checkers from rolling off its edge. Despite the visual nature of the checkerboard abacus, negotiations between sides were executed by ear, since "inspecting a document meant hearing it read."[8] To a great extent this reliance on hearing reflects an illiterate society. Nonetheless, the movement of pieces around the board during the audit was conclusive. Once closed, an audit could not legally be reopened.

The medieval tally and checkerboard system was so well suited to the financial needs of the feudal system in England that it remained in place there for six hundred years. It was effective elsewhere in Europe as well, and appears in Marco Polo's *The Million*. The system prepared the groundwork for modern finance, providing a practical substitute for gold coins and a process for tracking credit, as well as the duplication method that presages the multisided transfers of money that are typical of modern forms of capital investment. Nonetheless, the checkerboard and tally system had a weakness: it could only record relatively simple transactions. Partnerships of more than two or three investors, for instance, are very difficult to record using this system since a single tally stick can be split only so many times to produce the necessary duplicate record.

By the twelfth century, a revolution in international trade developed that would eventually make the tally and checkerboard obsolete. Following the capture of Jerusalem by the Turks in 1075, waves of European men crusaded to retake the Holy Sepulcher in an ebb and

flow of invasion, occupation, and expulsion that lasted from 1096 to 1272. In addition to the wanton destruction of parts of the Middle East by some crusaders, trade with the region brought better quality craftsmanship, silks, spices, lost classical manuscripts, Ptolemaic maps, and the Arabic number system to the West. Whatever else they were in the time-honored tradition of imperial excess, the Crusades also stimulated tremendous cultural exchange and trade between Europe and the Middle East.

During and after the Crusades, the trade economy centered on the Northern Italian city republics (Florence, Genoa, and Venice), which became great maritime powers profitably defending the sea from piracy, building and selling boats and weapons, manufacturing and trading textiles and jewelry, and importing luxury goods to a materially impoverished Europe. Some profits could be made quickly, as with trading silk or spices after a single voyage. Others took time, as with the returns on an investment from the construction of a ship or from sending cargo through many ports on an extended trade mission. One need only imagine a pile of tallies altered at different locations, their matches left at far-flung ports of call, not to mention the hundreds of local currencies used in Europe and the Middle East, to predict the inability of the tally and checkerboard system to record complex international trade.

The trade of the late medieval period was complex, dynamic, and risky—too risky for single investors, it turned out, so partnerships were formed to share the risk and the profit. The earliest known commercial account record of such a partnership comes from Genoa and dates to 1155–1164.[9] These three small sheets of paper show profit calculations for three Mediterranean trade missions taken during those years and recorded by a notary, one Giovanni Scriba. Scriba's record lists money invested and paid out and documents a partnership between a merchant, Ansaldo Baiardo, and a partner, Ingo da Volta, the project's primary investor and profit taker. From this and similar documents it appears that partnerships would normally be formed

131

for single voyages or for the short term, after which the profit, if there was one, was paid out, and the venture was liquidated.

This record also suggests that partnership for the purposes of shared investment requires third-party organization and supervision. It is Scriba, the aptly named notary, who attests to the completion of the transaction and not either partner, since one of them might profit unfairly from the other. In addition to third-party verification, a new form of record keeping emerged here, too: the prototype for commercial ledgers. Rather than the mere measurement of the end total, the hoard associated with the tally and checkerboard, these new partnerships would rely on the double-entry ledger, which could track the movement of capital over time. Eight hundred years after its appearance, the double-entry ledger remains the primary accounting tool used by every business from the corner grocer to the multinational corporation. You can picture it in its traditional form: a wide book displaying a field of rectangular cells into each of which is entered a debit or a credit that, when viewed as a component of an interconnected whole, forms a piece of the financial portrait of a partnership.

The earliest known bankers' ledger, in fact a series of fragments from an unidentified Florentine bank book, dates to 1211, about sixty years after Ansaldo and Ingo's partnership in Genoa. The fragments were found in the 1880s in Florence, on the flyleaves of the fourteenth-century *Codex Aedilis 67*.[10] They show measurements of profit and loss linked to loans in Florence, Bologna, and Pisa, and mention Florentine, Bolognese, Pisan, Veronese, French, and English currencies. Considered the earliest known example of pure Tuscan prose when it was discovered, the ledger's relevance for historians of Italian language and accounting alike lay in the use of Tuscan stock phrases like "due to receive" and "are due," "as we may permit," and "as much as they may amount to." The consistency of the language in the 1211 ledger is significant as it suggests a legal norm.[11]

The organization of the 1211 ledger is as highly regulated as its language. Broken up into regular rectangles, it resembles the standard form of the basic grid. Each rectangle contains the status of a single

132

loan and lists the borrower's name, the amount of the loan, the loan date, the repayment due date, late fees, the guarantor of the loans and witnesses, and the date of the termination of the loan. Once the loan and charges had been repaid in full, a diagonal line was struck through each rectangle—a routine symbol suggesting well-established institutional standards. Routine forms are of course reproducible, which may in part explain how investment banks replicated so quickly with the development of the regulated ledger. Investment banking spread from Florence across Europe, funding, among other things, the military and romantic aspirations of Edward III of England. By 1388 the city of Florence had eighty investment banking houses.

In Florence and Siena around 1300, a more complex rendering of investment capital first appears: the double-entry ledger, which uses the familiar language of debits and credits that continues to the present day. Double entry was popularized by the Franciscan friar Luca Paciolo (sometimes Pacioli) in a 1494 textbook called *Suma de Arithmetica*, which included a chapter entitled "Account Keeping". Paciolo wrote for a broad audience; by the fifteenth century specialized accounting books were sufficiently commonplace in Italy, and his catered to the rapidly expanding reading public created by the new technology of book printing. Paciolo described his text as demonstrating "the system used in Venice, for by means of this one can find his way in any other."[12] In other words, "Account Keeping" dispersed the accounting practices of a great maritime trading power to the mass of traders. The rapid spread of the double-entry system across Europe as well as the frequent borrowing from Paciolo's text in the Netherlands, England, and Spain have prompted many to date modern accounting to this work.

As Paciolo's book describes, the double-entry ledger is a written financial document in the form of a book of parallel formatted debtor and creditor cells with an empty space between them. Paciolo instructed the reader to produce his books "without entering anything else in between" the cells, resulting in a sort of checkerboard pattern of filled and empty cells. The optical effect of a dynamic

133

134

balance between debtor and creditor cells across the page of the book reflects the actual effect that "all the entries of the ledger are chained together."[13] The balance is represented by separate columns: debit on the left (for assets) and credit on the right (for liabilities), terms that are admittedly paradoxical to modern economic sensibilities. Further, each asset and liability appears doubly. (An advance to a borrower is an asset to the bank since profit money is due at a later date, but it is also a debit for the borrower.) Whereas a tally stick might be split into two or on occasion three parts for multiple parties, a ledger can list a dozen or a hundred different investors as a project's liabilities and assets. What's more, investment and profit-taking can occur at various times in the life of a project. The ledger, unlike the exchequer's table, allows for incomplete transactions by recording debt owed or payment due at the location in the ledger assigned to balance. Balance, in other words, means equilibrium—and large-scale productive capital. In the words of historian A. C. Littleton, the ledger, which was key to the wealth of the Italian Renaissance, performs the wondrous task of "systematically rendering the Material [of wealth] into the Language [of numbers]."[14]

Ledger logic permeated not only the financial realm of Renaissance Italy, but its art production as well, and in fact their histories are remarkably intertwined. After tutoring a Venetian merchant, Paciolo left Venice in 1490 to study mathematics under the sponsorship of the architect and writer on perspective, Leon Battista Alberti, whose *Della pittura* included "what we might call the princes of rational perspective construction."[15] Paciolo's travels were sponsored by the Renaissance painter, Piero della Francesca, an artist well known for his use of perspective and a renowned mathematician and geometer in his own right. And Paciolo's last book, *On Divine Proportion* (*De divina proportione*), was illustrated by his friend, Leonardo da Vinci, the painter and master of perspective (see fig. 7.2).[16]

It seems plausible, then, that the appearance of *Suma de arithmetica* in 1494 should have some connection to perspective, at least in sharing a common sense of intellectual purpose. Indeed, both the ledger

and the screens of perspective paintings are grids that create spatial balances among many kinds of information. Alberti's geometric formula for calculating perspective in terms of a vanishing point is structurally analogous to the empty space between ledger entries Paciolo required. Like perspective painting, ledger entries balance on either side of a space that is disarticulated—filled by an object in the painting or left blank in the ledger. In both, diverse pieces of information are made to appear homogenous in the geometricized space of the field. Alberti described one-point perspective as "costruzione legittima," legitimate construction. For the illusion to work, each detail must be linked to the vanishing point, just as in Paciolo's bookkeeping, "all entries of the ledger are chained together." Indeed, it would not be inaccurate to observe that the chained together form of the grid is common to both perspective images and ledgers and that both, at least at this foundational time, suggested ways in which the entire world could be conceived in homogeneous and interrelated terms. In perspective, space is homogeneous. In ledgers, capital is. The implications are vast.

The homogeneity of capital in ledgers had a real-world correlate: an emerging social order that overtook feudal society. Another way to put this is that the ledger—or the decentralization that it represented—would erode the network of financial obligations centered on the feudal king. Indeed it did, as no less an observer than William Shakespeare observed in *2 Henry VI.* Here the loyalist Lord Say chides the rebel John Cade for empowering the masses, citing the demise of the tally as the catalyst for broader cultural and political transformation. "Thou has most traitorously corrupted the youth of the realm in erecting a grammar school; and whereas, before, our forefathers had no other books but the score and tally, thou hast caus'd printing to be used, and, contrary to the King, his crown and dignity, thou has built a paper mill."[17]

In a world in which wealth was no longer bestowed by the king, it became increasingly important to be able to justify the source of one's wealth—to show that it was rightfully earned. Sociologist James

Aho has written on this social role of the ledger: "The conclusion of the balance sheet, then, is not simply that such and such is the net worth of our business, but rather that such profit is morally legitimate. And it is so because it arises from a fundamentally equitable and balanced transaction. 'We owe no more than we have received and we have no more than we have already given.'"[18] The moral legitimacy implicit in the ledger became particularly valuable as usury—or money-lending at high interest rates—became troublingly common (by contrast with profits taken in the purchase and sale of goods).[19]

Again, Shakespeare provides a window on the financial times and more specifically a window on anxiety about modern finance. In *The Merchant of Venice* (1596–1597), the distinction between moral and immoral profit is illustrated in the characters of the Christian maritime merchant, Bassanio, and Shylock, the Jewish lender. Bassanio is forced to take an interest-bearing loan from Shylock while awaiting the return of several ships at sea. In the first scene, the surrogate merchant Antonio sets out the relative legitimacy of a trade-based economy:

> Antonio: My ventures are not in one bottom trusted,
> Nor to one place, nor is my whole estate
> Upon the fortune of this present year....[20]
> Thou knowest that my fortunes are at sea,
> Neither have I money nor commodity
> To raise a present sum.[21]

Then, in a scene notable for its anti-Semitism, Shylock disparages Bassanio for his religion, his simple (i.e., honest) financial practices, and his hypocrisy:

> Shylock: I hate him for he is a Christian;
> But more for that in low simplicity
> He lends out money gratis, and brings down
> the rate of usance here with us in Venice ...

He hates our sacred nation, and he rails
Even there where merchants most do congregate
On me, my bargains, and my well-won thrift,
Which he calls interest....[22]

The final expression of financial morality is yet to come in the fair and virtuous Portia, the object of Bassanio's love. Her wealth is held in the archaic form of a treasure chest hidden outside the city—one of those quintessential hoards—kept for her successful suitor and symbolizing her freedom from the moral corruption of capital investment.

By the eighteenth century, the view of credit had changed. In the modern era, investment banking and record keeping were routinely seen as affirmations of cultural progress. In the *Complete English Tradesman* (1726), Daniel Defoe tells a forlorn tale of a failed hosiery-exporting business and offers a well-known section on bookkeeping. Defoe is best known as a political dissenter and advocate for religious and civil liberties, as well as the author of *Robinson Crusoe*—in which accounting is key to the protagonist's survival on an uncharted desert island and the economic record distinguishes primitive nature from survival through acculturation.

The book echoes the history of accounting laid out here. Shipwrecked, Crusoe begins with a tally: "Upon the sides of this square post I cut every day a notch with my knife, and every seventh notch was as long as the rest, and every first day of the month as long again as the long one; and thus I kept my calendar, or weekly, monthly, and yearly reckoning of time."[23] Next, our marooned seaman moves on to the double entry method, producing an account of the state of his life since the shipwreck, complete with "debtor and creditor" entries:

And as my reason began now to master my despondency, I began to comfort myself as well as I could, and to set the good against the evil, that I might have something to distinguish my case from worse; and I

stated it very impartially, like debtor and creditor, the comforts I enjoyed against the miseries I suffered, thus:

Evil	Good
I am cast upon a horrible desolate island, void of all hope of recovery.	But I am alive, and not drowned, as all my ship's company was.
I am singled out and separated, as it were, from all the world to be miserable.	But I am singled out, too, from all the ship's crew to be spared from death; and He that miraculously saved me from death, can deliver me from this condition.
I am divided from mankind, a solitaire, one banished from human society.	But I am not starved and perishing on a barren place, affording no sustenance.
I have not clothes to cover me.	But am in a hot climate, where if I had clothes I could hardly wear them.[24]

139

The list goes on. The adoption of the double-entry format for the accounting of the state of the seaman's life (which we might practice as a list of "pros and cons") is an indication that, at least for Daniel Defoe, economic, spiritual, and physical states were subject to the same universal laws of debit and credit as the balance sheet.

Viewed through Defoe's eyes, the double-entry ledger can be seen as a portrait of Adam Smith's "invisible hand"—the effect of cash flows on all aspects of human economic and social life—which made its appearance in his celebrated economic treatise *The Wealth*

of *Nations* in 1776.[25] By this account, capital moves through society according to laws determined by the balance sheet and its singular emphasis on profitable investment. The invisible hand shapes society based not on human need alone, but on the ability of human needs to generate capital. One could say that the invisible hand has forward momentum, grasping at and redesigning social relationships in the image of the ledger. Defoe's use of the balance sheet in assessing his fate indicates as much—all activity is rendered in terms of a cost-benefit analysis.

A redesign of the ledger came in 1795, when French accountant and author M. Edmond Degrange invented an adaptation of the Italian method, combining the daily cashbook entry and the long-term ledger balance into one columnar system, later known as the American system, or the standard spreadsheet. The year of publication is important here: this was the final phase of the French Revolution, and the appearance of an accounting method requiring fewer specialized skills than Paciolo's system was consistent with Enlightenment ideals and the principle of democratic governance. Degrange's system merges daily entries, merchandise accounts, cash, bills receivable, profits, and balance all in one place, on paper roughly twice the width of normal paper sheets (hence "spreadsheets"). A grid of financial data, the spreadsheet places Paciolo's debits and credits with expenditures across the top axis, invoices listed down the left margin, and the amount of each payment in the cell where its row and column intersect.

In 1820 American accountant James Arlington Bennett's *The American System of Practical Bookkeeping* would appear—and flourish, with no fewer than forty editions to follow. Testimonials to the book's importance appeared within its pages by such luminaries as the Comptroller of the State of New York, the Mayor of Albany, New York, The Lieutenant Governor of New York, and several of New York City's business leaders. Bookkeeping was fundamental to the intertwined American political and economic agendas of the nineteenth century. It would even become a distinct profession: by 1835 Bennett

had opened a school of accounting in New York City, probably the first of its kind. Bennett's book is based on Degrange and Paciolo, but its cornerstone is its "balance chart," which explains the proper locations of credit and debit as applied to interrelated accounts. It represents Bennett's attempt to teach businessmen and accountants proper record-keeping practices for the interconnected corporate structures sustaining capitalist partnerships during the Industrial Revolution in the United States.

It is worth noting that Karl Marx's *Capital* (1865) dates forty years after Bennett's balance chart. One useful way to think of Marx's greater project is as a rendering of the hidden cost of labor embedded in the profit of the balance sheet. In this analysis, profit becomes a "surplus value," as unpaid labor. The capitalist ownership of the means of production in the form both of factories and raw materials forces the worker to sell their labor time for less than the capitalist can charge for it in coagulated form in finished goods. By Marx's account, this imbalance creates poverty. The critique makes particular sense from the perspective of the Industrial Revolution. In a factory in Manchester, England, for example, from 1860 to 1862, the work week averaged about eighty-two hours, in exchange for which the worker was paid a wage that covered only the meanest subsistence.

The hand-entered, wide-format spreadsheet ledger book of Degrange and Bennett would remain in use until the late 1970s, though hints of the next wave of computer-generated bookkeeping emerged in 1961, when UC Berkeley's Richard Mattessich pioneered computerized spreadsheets for use in business accounting. By 1969 Canadian entrepreneurs Rene Pardo and Remy Landau of Lanpar Technologies had invented an electronic spreadsheet application called LANPAR, an acronym for Language for Programming Arrays at Random. The two-thousand-cell spreadsheets used until this time by most companies would have taken six months to two years to program in FORTRAN, the dominant computer language of the day. LANPAR introduced forward referencing and natural order recalculation, which allowed for a complex set of connections to be quickly

charted across the array of cells of the electronic ledger. Bell Canada, AT&T, and General Motors all used LANPAR.

Computerized spreadsheets would change again beginning in 1978, when Harvard Business School student Daniel Bricklin, frustrated by available options of generating a ledger, imagined his calculator as an interactive spreadsheet. With Bob Frankston of MIT, Bricklin realized this daydream, cocreating the software program VisiCalc, which is often cited as the first electronic spreadsheet.[26] VisiCalc organizes data into columns and rows whose intersecting "cells" can have absolute or relative mathematical values assigned to them. This first one had five columns and twenty rows. The program soon allowed for faster code with improved arithmetic function and scrolling, while simultaneously shrinking the memory requirement to 20K. This last feature made the program viable for microcomputers, which in turn led to sales of one million copies. VisiCalc was the first "killer" application for personal computers, meaning it was so useful that it proved the value of the supporting technology. At the suggestion of a founding editor of *Byte* magazine, VisiCalc was written for the Apple microcomputer. On its introduction, Apple II immediately went into high demand with bond traders and bookkeepers—indeed the program was foundational to Apple's early success.

Similarly, when the next iteration of the electronic spreadsheet, Lotus 1-2-3, was launched in 1983, the IBM personal computer for which it was written became the best-selling computer on the market in a few months' time. The advantage of Lotus 1-2-3 over VisiCalc was its capacity to be integrated with databases, to include charts, and to perform more complex calculations. Lotus 1-2-3 became the first electronic spreadsheet program that was also capable of producing slick-looking and topic-specific graphic presentations. Equally important, Lotus 1-2-3 introduced named cells, cell ranges, and macros to the electronic spreadsheet program. Its command interface was still in PC-DOS, however, which required memorizing function keys and was therefore difficult for the common user.

In 1985 the innovations of Lotus 1-2-3 were made user-friendly with the introduction of Bill Gates's Microsoft Excel spreadsheet program, which first appeared, strangely enough, on the Apple Macintosh 512K. Excel's graphic user interface (GUI) featured a point and click mouse used to select keyed images, called widgets, that represent program actions and provide information to the user. Excel was also the first electronic spreadsheet program to use pull-down menus. Finally, Excel allowed the user to tailor the appearance of graphs using the spreadsheet information as well as the spreadsheet itself: fonts, character attributes, and cell appearance could be adapted to the tastes of each user. When Microsoft released the Windows operating system in 1987, Excel was among the first applications available with it, and for the ensuing five years Excel was Microsoft's flagship product.

6.3
Douglas R. Hess, Excel spreadsheet, n.d. This conceptualized image shows the spreadsheet bulging toward the third and fourth dimensions. With permission of www.shutterstock.com.

Excel also introduced selective cell recomputation. Whereas VisiCalc had introduced relative recalculation, in which values would automatically adjust to other changed values, Excel's recomputation was intelligent: only cells designated as dependent on another given cell are modified with selective commands. This allows for keeping a running "balance" with input from a wide range of accounts and accountants. It also opens up the idea of the spreadsheet grid from a totality to a set of modular cells. Each cell holds data, like a box on a piece of graph paper, and each cell's location is referred to by column and row, as on a two-dimensional grid; but each cell can be either dependent or independent in value, giving it a life of its own.

As the electronic spreadsheet has evolved, it has expanded to include the third dimension, and the fourth. In today's complex spreadsheets, a cell may be clicked for access to more information, called worksheets, which are subsets of the spreadsheet divided for the sake of clarity. The most advanced programs and users can use macros to reconfigure the data set in various ways, including viewing it through the lens of other spreadsheets. These manipulations introduce the graphical idea of the third dimension (the pop-up cube) as well as the dynamism of the fourth (time). Unlike VisiCalc, which was arguably designed to produce a two-dimensional spreadsheet printout like the double-entry ledgers of yore, recent electronic spreadsheets process entire matrices of interrelated spreadsheets and worksheets in a format that is literally inexpressible in two-dimensional printed form.

Recently, advanced electronic programs that allow for online live updates of entire spreadsheets have been introduced. This live, instant, interactive feature eliminates the need to manually tell the spreadsheet to recalculate values and has proven indispensable to certain financial operations, such as investment banking, where real-time calculation of stock, bond, commodities, futures, and mortgage values is essential to success. Computers can be programmed, for example, to sell an asset at a certain high or low and to pick up new assets as well—all the while maintaining a spreadsheet that records the

transactions. As useful as it is, the real-time spreadsheet is susceptible to fraud, since there is no way to record or freeze the value of a cell at a given moment without compromising the ability of the entire system to respond to the interconnected mathematical relationships that constitute its matrix. In other words, it is almost impossible to know where and when a cell was changed, from what value, and by whom. Whatever its strengths, the electronic spreadsheet produces no paper trail.

Thus the original intent of the ledger—to provide objective, static, incontrovertible evidence of financial data—has turned upside down. The latest computerized accounting systems are intuitive and evanescent. One thing, however, has remained the same, or rather come back around. If most of us can operate and understand our checkbook, with its single-entry running tabulation, or be taught the basics of double-entry bookkeeping, the same cannot be said of our abilities vis-à-vis the electronic spreadsheet, whose grid logic, inversions, and reversals depart radically from the double-entry ledger's status as a permanent record of productive capital and partnered investment. Apart from certified public accountants, few can comprehend the contemporary balance sheet, though because of its mass availability, many may use it. Thus we are not so far removed from the era of ancient accounting. Electronic spreadsheets, however common, return us to a state of financial blind faith in experts (whether CPAs or computer programmers) who function quite like the specialized Roman and Egyptian scribes.

7 SCREEN 1420

SMOKE SCREENS, SUNSCREENS, WINDOW SCREENS, and the room-dividing screens in Orthodox churches and synagogues are all forms of protective screens. They prevent exposure to dangerous elements like enemy ships, ultraviolet rays, bugs, or the opposite sex. These screens are opaque, or at least impassable to whatever they filter, blocking the dangers they filter out. The computer screen, the television screen, the movie screen, and the screen of illusionistic painting, on the other hand, are all transparent screens. The transparent screen creates a unifying sense of continuous space with the viewer. It is meant to be looked through. When functioning as intended, transparent screens virtually disappear for the viewer, which is to say the objects they display look particularly real or natural. These pictured realities are, of course, illusions. Understanding how these illusions come to be requires looking through the transparent screen, while also looking at it as if it were opaque. It is only by giving it some measure of visibility that we can understand the nearly absolute effect the transparent screen has on how we see the world as if through a window.

Beginning in the early fifteenth century, the flat, irrational, symbol-filled space of medieval art was transformed into illusionistic space by one-point, geometric perspective. One-point perspective—which

Masaccio (Maso di San Giovanni),
The Holy Trinity, circa 1425–1428.
Fresco. Photo: Erich Lessing/Art
Resource, New York. S. Maria
Novella, Florence, Italy.

148

allows a viewer to enter into an extension of his or her own world—scales and orients all elements of the pictured space toward the viewer by depicting a conical grid of diminishing size that converges deep in the world of the image. The point of this apparently conical form coincides with a point on the surface of the painting at the eye level of the viewer, creating the illusion that the depicted scene is on the other side of a transparent screen. Masaccio di San Giovanni's *Trinity* of 1425 is the earliest existing example of fully developed one-point perspective. The ceiling coffering produces much of the effect, since its sides form lines "into" the picture, orthogonals, which converge at a vanishing point at the base of the cross. This vanishing point is again at the viewer's eye level, which is why the painting looks so realistic. Compounding the effect, the *depicted* coffering is a visual extension of the actual architecture outside of the image, in this case of Santa Maria Novella, the Florence church that houses the fresco. As noted by its many practitioners, producing a perspective image like this requires the absolute coordination of the deep space of the image with the surface of the screen, the space surrounding it, and the viewing eye in front of it.

Broadly speaking, one-point perspective links the individual being to the image by connecting the viewing "eye" of the "I" both to the world of the picture and to the space of the viewer. This sense of continuous reality reflects changes in how people viewed themselves in relationship to the world, suggesting a new philosophy focused on the universal human being as opposed to the divine. Oriented toward a single human viewer, even a single eye, the perspective picture empowers the viewing self as capable of rationally comprehending the world and therefore less subject to the arbitrary winds of an almighty God than his medieval forbears. This empowered viewer embodies a new kind of human subjectivity, one that would make possible the ideal of the modern genius, an individual capable of changing the course of history, science, or culture. In his essay "What Is an Author?," French philosopher Michel Foucault associated this shift with the empowered subject of the early modern period.[1] Perspective

150

diagrams from a sketchbook by Leonardo da Vinci (1452–1519) suggest as much insofar as they show how an artist establishes this continuity between the viewer and the image, using sightlines drawn from the eye into the image.

Despite the continuity with the image suggested by Leonardo's sightlines, the apparently real world depicted in the image is one the viewer can never fully enter, even visually. The picture plane is shown as a bar that cuts through the sightlines. The eye of the viewer is at a specific location on one side of the screen and the scene is on the other. Leonardo's sketch brings us to the paradox of perspective: the same mechanism that produces the illusion—one-point perspective—also creates a certain distance from the represented scene. For the screen to work, each object shown on the other side of it must be distorted to approximate the illusion of its own reality, but the illusion only works from one viewing position. Seeing the ceiling coffering as arched squares in Masaccio's image, in other words, requires that they become curved trapezoids on the painted surface. If we were asked "What shape are those ceiling coffers?" we would tend to answer, "Those are squares," which is how we understand and see them.

To see the screen at work, it is useful to imagine the preparatory sketches required for planning a painting like Masaccio's. First, the entire image would be drafted onto an enormous gridwork. This gridwork would function like modern graph paper and would aid in organizing the regular geometric relationships between the parts of the image. The body and arms of Christ form right angles that break up the surface of the fresco into four similar rectangles. These are, in turn, broken into smaller rectangles and squares that regulate the two-dimensional space of the picture plane. Cutting across these squared forms is an equilateral triangle with its point at the head of Christ and at whose base the devoted stand. Laid over this triangle is another one, this time upside down, with its "base" across the top of the pillars and coffering and its tip at Christ's feet. Looking at the painted surface now, we see not just realistic square coffering on the ceiling,

151

but a trapezoidal, triangular grid directed toward a geometricizing surface matrix—the transparent screen.[2]

In *Perspective as Symbolic Form,* art historian Erwin Panofsky describes perspective as a mechanism that promotes a sense of both access to and distance from the pictured world: "The history of perspective may be understood with equal justice as a triumph of the distancing and objectifying sense of the real, and as a triumph of the distance-denying human struggle for control."[3] In other words, the transparent screen of perspective renders the world as objective, subject to laws the viewer cannot personally control, though simultaneously the viewer inhabits the same physical space as the image and thus does control it (at least visually). Perspective enters our everyday vernacular in just this double sense. If I say "keep it in perspective," or "what's your perspective?," Panofsky's double symbolism is precisely revealed. The first expression admits to the truth of a greater, objective world outside our control, whereas the second acknowledges our active and unique place in that world.

Panofsky describes perspective as a "symbolic form" not of things but of relationships between them. By this account, perspective is not just a pictorial device that makes paintings more naturalistic-looking according to an optical cone, it is how artists represented the changing sense of reality associated with the early modern, or Renaissance, period—specifically, the emerging sense that rational man is the measure of all things. The double sense of perspective also speaks to the contradictions that characterize the modern era: between the subjective and rational self, between collective and individual experience, and between the divine and the secular. Clearly, the study of perspective belongs to the broader category of intellectual history. Understanding the perspective screen therefore requires a digression into the emergence of Renaissance humanism and its impact on perceptions of reality, since that history helps explain its relevance.

The classical roots of perspective can be attributed to the renewal of interest in the classical world associated with the fourteenth-century philosopher and poet Petrarch, who is often credited with inspiring

the art and philosophy of the humanists. Born in 1307 to parents exiled from Florence to Avignon, Petrarch became poet laureate of Rome in 1345 and traveled widely as an ambassador. While traveling, he assembled a collection of forgotten Latin manuscripts, commissioned the first known translation of Homer from Greek into Latin, discovered a lost collection of the letters of the Roman orator Cicero, and wrote extensively on the importance of reviving classical texts and (equally importantly) honoring their individual authors. Following Petrarch others, too, took up the task of recovering classical texts, exploring their implications for modern Christian thought, coming to terms with the individual voices of their authors, and broadly expanding the possibilities for the production of new texts. This emphasis on individual authors represents a fundamental shift in the way human beings could be socially understood. The author is the central persona of a newly humanistic subjectivity.

153

One watershed discovery of the early modern period was the writing of Vitruvius (Marcus Vitruvius Pollio, ca. 75–25 BCE), the architect, engineer, and writer whose *De architectura* was recovered by Poggio Bracciolini, a Florentine copyist and writer on classical texts, in 1414. Vitruvius' most famous declaration was that a structure must exhibit *firmitas, utilitas,* and *venustas*—durability, usefulness, and beauty. As an imitation of nature, Vitruvian architecture should shelter human beings from the elements while at the same time expressing geometric harmony. Perfect natural proportion was expressed in the geometrically harmonious circle and square, which in Leonardo's famous sketch of Vitruvian Man circumscribe the greatest work of art according to Vitruvius, the human body. Not surprisingly, perhaps, Vitruvius has been seen by many as the inspiration for another architect, Filippo Brunelleschi (1377–1446), who is the widely acknowledged originator of perspective in 1415.

However, the story of the screen may be more complex than its Vitruvian origins would suggest. It is possible that Brunelleschi took another newly discovered classical text (or a combination of the two) as his muse in his invention. Ptolemy's second-century atlas,

the *Geographia,* was brought to the West by the Ottoman Turks in their middle thirteenth- and fourteenth-century westward push, and it reached Florence by 1406. It has been said that Brunelleschi learned of Ptolemy's atlas by way of his friend Paolo Toscanelli, the Florentine mathematical geographer and enthusiast of Ptolemy. For Brunelleschi's purposes, the perspectivally influential moment in *Geographia* might have arrived in a single description of a map that portrays the spherical Earth such that the curved grid of latitude and longitude would appear straight from a central point of view, creating a right-angled center (see fig. 4.1). As Ptolemy described it:

> Let it be required to map on a plane a ringed globe containing a part of the earth within itself, in the hypothesis that *the eye occupies such a position that it will be collinear with the points* where the meridian through the tropic points [longitude] intersects the parallel drawn through Soēnē [modern Aswan] on the surface of the earth … will produce *an illusion of a single straight line since the eye is situated in the plane through them,* and also that the parallel [latitude] through Soēnē will appear as a straight line *at right angles* to the central meridian for the same reason.[4]

Ptolemy's description contains most of the elements of systematic, one-point perspective: the central point where the orthogonal lines "into" the picture space converge, a fixed position for the viewers' eye on the picture plane that corresponds to that point, a solid geometric form that is shown in the picture, and coordinated planar grids that bring these elements together. His instructions provide a mechanism for creating the illusion of a sphere on a flat surface—a lesson in spatial representation that applies directly to making convincing representations of other things in space as well.

But Ptolemy is not the earliest point of reference in our perspective story. The connection between the eye and the thing being looked at (known as the "visual ray" in the Greco-Roman era) reflects Ptolemy's synthesis of the Greek mathematician Euclid's book *Optics*

(ca. 300 BCE). Euclid, who was widely studied in the early modern period as well, described optics thus: "straight lines diverge outward from the eyes to comprehend vast spaces…. These visual rays form a cone whose vertex is located in the eye and whose base is formed at the boundaries of visual objects."[5] In his response to Euclid, also called *Optics* (ca. 170 CE), Ptolemy addressed the illusions produced by these rays under various circumstances of distortion of color and line. What Ptolemy described in *Geographia* is a distortion—in the form of an illusion—produced by the coordination of points on the Euclidean "base" (the gridded globe as the visual object) and a plane (a gridded screen) placed parallel to it "since the eye is situated in the plane through them." Although the medieval and classical periods had highly developed forms of intuitive and symbolic perspective, to the best of my knowledge Ptolemy's description is the single example of systematic, one-point perspective before the early modern period in Italy, albeit it in highly abbreviated form and without particular influence in the visual arts until its rediscovery by architects in the fifteenth century.

Like Ptolemy's projection, Brunelleschi's perspective consisted of an eye looking from a single point at a deep space containing a geometric solid. In Brunelleschi's case, this point consisted of a small hole pierced in the center of a twelve-inch-square painting of the octagonal baptistery in the cathedral plaza in Florence in 1415. The viewer looked through the hole from the back of the painting at the plaza while holding a mirror in front of the painting. The two plazas (the real plaza and the painting of it reflected in the mirror) were virtually indistinguishable from each other—that is, the illusion worked from the point of view of one eye fixed to the back of the painting. Rather than glancing around the plaza, allowing the eye to rest furtively here and there on the surface of the image, Brunelleschi's eye was rendered immobile by the single viewpoint of the hole. While there is much scholarly debate on the exact mechanics of Brunelleschi's panel, for the sake of this argument, we can go with the general account that lines could then be drawn from the edges of the picture plane toward

the eye hole/center point on the horizon line. By *some mechanism* the painted baptistery and plaza were scaled in accord with the viewer's sightline and the image of the plaza effectively oriented toward the viewing subject's single, fixed eye. The *appearance* of systematic perspective was the result.

However, the appearance of perspective and systematic method used to produce the illusion are not necessarily the same event. Indeed, it is possible that the effect of Brunelleschi's picture—as famously "first" as it is—was produced mechanically rather than mathematically, as is often supposed. Skeptical accounts have therefore suggested that Brunelleschi's hole was created by a drafting tool that produced rigid sightlines using a hinged arm attached to the center of the image and that, when this was removed, the viewing hole resulted. Others have suggested that the hole was produced by strings threaded through the image toward points on the plaza, a visual cone whose trajectories were then simply transferred to the painted panel. Still others suggest that the image was actually painted onto glass or a mirror with Brunelleschi simply tracing carefully what the glazed surface showed, an observation that seems plausible given that the "sky" in his painting was reportedly made of exposed mirror. New technology allowing larger panes of clear glass used for windows was invented in the late 1300s, just before the 1415 appearance of Brunelleschi's painting, in Venice. For the first time, one could look though a piece of clear glass large enough to see the world on the other side laid flat upon it as if in an image. It could stand to reason that Brunelleschi was simply exploiting the visual effect of this new technology. These are all possibilities that would guarantee the empirically correct image without needing a geometric system to produce the effect.[6]

All of this means that Brunelleschi's invention could mark the beginning of one-point perspective without necessarily indicating the systematic use of the transparent screen and a system of orthogonals to organize the illusion. The viewing hole and center point need not be gauged in terms of Euclidean cones or coordinated Ptolemaic grid points in order to operate effectively. Regrettably, neither

Brunelleschi's image nor his own writing about it have survived, and thus very little is known about the extent to which his invention was truly systematic. What is known, however, is that the invention was attributed to him and played a pivotal role in the development of early modern philosophy, mathematics, and visual thought. In 1435 the architect, writer, and painter Leon Battista Alberti dedicated his *Della pittura,* the famous how-to manual for producing perspective images, to Brunelleschi and credits the older architect with the invention of perspective.[7] This method would be simplified and refined by, among others, Leonardo da Vinci, a half century later. Articulating the relationships between parts of the painting procedurally, Alberti offered formulas for the diminution of sizes of things (especially geometric solids, buildings, and paving stones), as well as the distortions in their forms.

Alberti explained the system geometrically, producing a theory of pictorial form based on how light rays passing from the viewing eye to the landscape would strike a plane placed between the eye and the landscape, as shown later in Leonardo's sketchbook (see fig 7.2). The plane was analyzed in terms of a grid, or screen, of coordinates, much like looking through a plated glass window. One of Alberti's devices for constructing perspective was a *veil.* The veil, a broad grid of colored string, was hung in front of the object or scene being represented. The grid lattice provided a two-dimensional, flat means of organizing the surface, while also assuring proper foreshortening, the distortion of a three-dimensional object so that it is seen in space. The veiled grid stresses the most empirical or concrete aspects of the artist's labor in transcribing a real scene. The images that appear on the gridded plane and the veil are called planar projections and behave according to predictable geometric formulae; an ellipse, for example, is produced by a cone sliced at an angle by a plane.

Alberti's instructions begin in terms that marry Euclid's optics to Brunelleschi's viewing eye and a transparent screen that is both picture surface and windowpane-veil. Describing the surface, Alberti writes, "I draw a rectangle as big as I like," and continues by describing

the space on the other side, "which for me is like an open window through which I see whatever is to be painted."[8] The four borders drawn, he continues with his instructions: "Then, by sight, I place within this rectangle a point at the place where the central line of vision comes—because of which it is called the center point." The path of visual rays, which were understood as material projections from the eye and believed to capture the shapes of objects, would be drawn as lines projected from the center point of the image toward the surface of the gridded screen. This would later be called the vanishing point—it is the place where the orthogonals meet on the Masaccio. Again, this point is adapted explicitly from Euclid, whose third proposition states: "Once a visible object reaches a certain distance [from the eye], it can no longer be seen."[9]

In his text, Alberti described the space of perspective as *costruzione legittima*, legitimate construction. Perugino's *Delivery of the Keys to Saint Peter* (see fig. 3.6) illustrates all of the essentials of Alberti's rational perspective: the center or vanishing point hidden in the church doorway, the orthogonal lines that converge on that point as seen in the forward thrust of the pavement lines, the horizon line that establishes the relationship of the viewer to the landscape, and the distance point. The distance point is set outside of the picture itself, on the horizon line, and normally at a 45 degree angle from the middle of the bottom of the painting. This would form a right triangle with one point at the middle of the base of the screen (between Christ and Saint Peter), another at the vanishing point, and a third outside of the painting. The distance point determines the degree of distortion of the pavement squares. In paintings with pavement like this one, it can be found easily by drawing a line diagonally across the squares of the plaza corner-to-corner. Used as a point of reference for all lines parallel to the bottom of the painting, the line connecting the center of the base of the image to the distance point produces a geometrically regular progression into the image. The horizontal lines that make up the tops and bottoms of the squares in the plaza were placed in accordance with the line linking the distance point to the bottom

center of the painting. These horizontal lines are called transversals and would be at right angles to the central orthogonal that moves up the center of the image to the vanishing point. If the fan form of the orthogonals that meet at the vanishing point give us infinitely deep space, transversals determine how deep the space is and the speed with which it is visually traversed.

Together, transversals and orthogonals form a steadily diminishing grid into the space of the image. Further in the distance, as the orthogonals approach the vanishing point, they become closer and closer together until they disappear. Transversals and orthogonals structure the interior of the perspective box on grids that let us determine exactly where each person and building is on the plaza depicted in Perugino's painting. Through one-point perspective, the pictured world was given concrete figurative and geometric boundaries, the edges of forms being understood through a system of finite planes and cubes.[10] Since all form had a basis in mathematics for Alberti, the perfection of the system lay in its being geometrically demonstrable. Using planar projections, he could gauge the size of distant objects in the image using similar triangles. What's more, objects in a painting could be precisely located in space by the "latitude" and "longitude" of the homogenized space of the picture.[11] With the invention of perspective, the space of the image and the world of the viewer could be brought together concretely as *substance étendue*—extended or outstretched material—almost as if the viewer were part of a map projection.[12]

Raffaello Sanzio (1483–1520), better known as Raphael, produced in 1511 a fresco entitled *School of Athens* that goes a long way toward demonstrating the philosophical relevance of this sense of visual continuity—a continuity that is the result of the screen's transparency. Raphael's work shows regularly receding squares on the floor and ceiling that create a sense of concrete location for the figures in the images, as well as a sense of spatial continuity with the viewer. Commissioned for the private Vatican library of Pope Julius, the painting's deep space offers a visual reconciliation of Roman Catholic theology with

159

classical philosophy and astronomy by placing the individual authors of these disciplines in the context of the Vatican in a classical perspective box. In the middle of the picture stands Plato (pointing upward, and rendered with the face of Leonardo da Vinci), representing the idealism of a world governed by abstract laws and forms. Aristotle (gesturing toward the ground) represents the empiricism of a world governed by concrete observations. In front of them Euclid appears with a compass and slate and the face of Raphael's friend, the architect Bramante of Urbino. Pythagoras and Ptolemy (facing away from the viewer while holding a globe) make appearances as well. *School of Athens* is thus nothing less than an imaginary rendering of Plato's

Academy—with the greatest minds of the classical era melding identities effortlessly and conversing with those in early modern Italy. In 1439, the great patron of art and science, Cosimo de Medici, had attempted to reestablish the intellectual vigor of the ancient Platonic Academy in Florence. This image presents the viewer with the coming of these two academies at the same time as it proposes a rationalization of space and historic time that is associated with the emerging modern era.

There are, however, other, more politically charged, explanations for the legible rendering of space represented by the perspective screen. The same Arab expansion that returned Ptolemy's *Geographia* to Europe brought with it the introduction of gunpowder from China in about 1240. By 1313 this basic ingredient of destruction was being exported throughout Europe from Ghent, and from the fifteenth through the seventeenth centuries military technology advanced apace. In short, the invention of perspective coincided with a time of dramatic threats to early modern Italy, a time when precision concerning space and distance would have been of the utmost importance for protection and aggression alike.

By this reading, it is no mere coincidence that Niccolò Macchiavelli's *The Prince* (1513), which offered a systematic mechanism for establishing political dominance in an era of contested power and regional infighting, was written for Lorenzo de Medici, the great art patron. In addition to inspiring *The Prince,* Lorenzo supported Donatello, Michelangelo, and Leonardo, who is widely credited with making the first attempt to imagine a view from the air using cartographic information. This perspective view appears in Leonardo's famous bird's eye sketch of Milan (ca. 1500) and is impossible to divorce from his well-known experiments in weapons design and aviation (see fig. 11.1). Similarly, in addition to providing benign directions in perspective, Alberti proposed in his *Ten Books of Architecture* (1452) a new form of pentagonal fortification with increased resistance to gun-powder-propelled cannon fire. Indeed, perspective homogenizes the relationship between the grids of art, architecture, cartography, politics, artillery

161

design, and technologies of fortification, clearly arguing for its broad cultural relevance.

Addressing these connections to military technology and militarily ambitious patronage, recent scholarship has associated perspective with a militarization of vision itself in the modern era. In these accounts, perspective vision becomes a mechanism of control or mastery. For example, in *The Vision Machine,* French cultural theorist Paul Virilio argues, "The panoply of acts of war … always tends to be organized at a distance, or rather, to organize distances."[13] By this account, the perspective screen articulates sublimated violence against others, particularly against political enemies and disempowered subjects who might never experience visual (or military) control of the homogeneous field of perspective space. In other words, its critics suggest that perspective creates false consciousness and represents a cipher for control of, among others, the so-called savages in the expanding colonial empires of Europe. Virilio again: "The advent of the logistics of perception and its renewed vectors for delocalizing geometric optics … ushered in a eugenics of sight, a pre-emptive abortion of the diversity of mental images, of the swarm of image-beings doomed to remain unborn, no longer to see the light of day anywhere."[14] Virilio is arguing that our uncritical acceptance of the homogenizing field of perspective diminished our collective ability to see and know the world in its detail (perspective vs. pluralism). Virilio's view assumes no necessary defensive function of the homogenized field in the lives of human beings and, furthermore, neglects to account for the use of perspective in politically contentious ways.

Nevertheless, Virilio's critique is supported by the totalizing aspect of French philosopher and mathematician René Descartes, whose *Analytic Geometry* (1637) demonstrated for the first time that geometry could be explained algebraically. Through the process of pure thought associated with algebra, Descartes theorized that the geometric order of the universe could be explained numerically and, in a circulation of the logic, be projected wholesale back onto the human environment. The geometric projection seems absolute: "It

is only necessary to follow the same general method to construct all problems, more and more complex, ad infinitum."[15] This statement is both homogenizing and reductive, reducing the entire world to a single, geometrically homogeneous space to which a mathematical system can be applied wholesale. The world, by this accounting, is knowable through the rationalizing approach of the experimental method. This is how Descartes is routinely condemned by modern critics. However, there are other aspects of Cartesian thought that should complicate the picture. In *Meditations on First Philosophy* (1641) Descartes argued that the knowable world is a projection of the rational mind: "I think, therefore I am." That is, only the mind is known for certain, and therefore the external world does not necessarily exist or, if it does, should be understood as possessive of infinitely many human viewpoints.

One of most interesting examples of an adaptation from Descartes involves a fundamental shift toward multiple viewpoints that could be seen as playing some role in the evolution of perspective. "Infinitist" mathematician Gérard Desargues (1591–1661), a close friend of Descartes and one of the founders of the French school of projective geometry, expanded on Kepler's idea that parallel lines in a plane meet at infinity by suggesting that there are, therefore, infinitely many points of orientation for those lines. In other words, there are infinitely many human beings who constitute these many viewing points. Published in 1640 as *Brouillon projet d'une atteinte aux événements des recontres du cône avec un plan*, Desargues's work describes a crowd of viewers, each with his or her own perspective screen in front of his or her face. In effect, this argues for the reality of multiple perspectives, while at the same equating perspective with a higher, more reasoned truth. A student of Desargues, Abraham Bosse, would evolve from this a theory of art in which painting does not represent the world of things "as the eye sees them or believes it sees them, but such as the laws of *perspective impose them on our reason*,"[16] a viewpoint that suggests that the laws of perspective, which inform reason, supersede vision itself.

163

7.4
Voltaire, *Elemens de la philosophie de Neuton,* frontispiece (London, 1738). Photo: The New York Public Library/Art Resource, New York.

L. F. Dubourg inv. I. Folkema sculp.

Despite important disagreements with Descartes and his followers on the substance of space, Sir Isaac Newton's *Mathematical Principles* (1687) fundamentally extends this logic. Newton inscribed Kepler's newly conceived solar system in three-dimensional, unchanging, absolute space. Events would unfold in this enduring space in a strictly determined sequence he would call absolute time. Newton wrote, "All things are placed in time as to succession; and in space as to order of situation."[17] In other words, absolute time determines the sequence of events and absolute space the location of them. With this realization, Newton clinched the "background geometrical structure" of the universe.[18] Newton's universe was seemingly limitless: "There remains only the unlimited stretching out of space in length, breadth, and depth."[19] This universe of points permanently fixed by length, breadth, and depth constitutes a totally stable, cubical grid through which planets moved and whose trajectories could be mapped and tracked geometrically in it, like Perugino's pavement, but in three dimensions and, significantly, without a single vanishing point.

This geometric worldview is illustrated in the frontispiece to French philosopher Voltaire's *Elemens de la Philosophie de Neuton* (commonly *Elements de la Philosophie de Newton* in modern spelling), a celebrated popularization of Newton's discoveries published in Amsterdam in 1738. In the top left corner of the illustration we see the background geometrical structure of the universe pictured as a gridwork stretched over the celestial globe, a geometrically organized image of outer space. Voltaire's collaborator and lover, Mme. du Châtelet, appears in the role of a goddess, reflecting the light of truth—not from a divinity but from Newton—onto the inspired writer. Significantly, Newton is shown with a compass, measuring the celestial sphere whose form is echoed in the foreground by a modern Earth globe surrounded by the instruments of geometry: a compass, a right angle, and a hinged pair of parallel straight edges. Here, Heaven and Earth behave predictably, according to one set of geometrically conceived physical laws.

The Newtonian order displaced man (the Earth) from the celebrated central position, replacing him with the sun. Instead of man being the measure of all things, a position affirmed by the directed focal point of perspective, the human being was now one mere component of many in an unlimited and unfocused, orthogonal universe. Not surprisingly, then, absolute space was not only a major scientific discovery but a world-changing social and spiritual one as well: it overturned the comforting idea that is common to all religions of the Book (Judaism, Christianity, and Islam)—that man is geographically and spiritually at the center of God's creation. Poet John Donne spoke for many when he lamented this decentralized order in terms that emphasize the relationality of points: "'Tis all in pieces all coherence gone; all just supply and all relation."[20] In addition to theorizing the fixed nature of absolute space along the lines of cubed space, Newton introduced a functional grid to explain the mechanics of that movement as the result of gravitational and frictional forces moving in squared and parallelogram forms through absolute space. He is therefore often seen as the father of modern mechanics. With his tightly woven laws, Newton produced the impression of a regulated universe in which every single moving body obeys a geometric logic. Significantly, unlike a world made for man's benefit by a benevolent God, man was not in any way at the center of this new system of physical laws.

Given this shift, perhaps it makes sense that perspective evolved throughout this period in accordance with this changing worldview. Instead of the orthogonal and the single point that oriented a concrete world toward the individual man of Renaissance humanism, artists adapted perspective to shallow space, irregular spaces, and infinite space. One means of transforming the space of the image involved emphasizing the surface-organizing effect of the veil: in the North especially, the grid of the veil was less subservient to the orthogonals than in Italy. In addition, new levels of detail were desirable as expressions of the burgeoning science of optics. Although this evolution predates the scientific revolution associated with Newton, it would

7.5
Albrecht Dürer, artist drawing a
model in foreshortening through
a frame using a grid system.
Woodcut from *Unterweysung der
Messung* (Treatise on Perspective)
(Nuremberg, 1527). Photo: Foto
Marburg/Art Resource, New York.

167

7.6
Jan Vermeer (van Delft), *The Glass of Wine,* circa 1661–1662. Oil on canvas, 66.3 × 76.5 cm. Inv.: 912C. Photo: Bildarchiv Preussischer Kulturbesitz/ Art Resource, New York. Nationalgalerie, Museum Berggruen Staatliche Museen zu Berlin, Berlin, Germany.

not be inaccurate to describe the evolution of the form of perspective as part of a broader shift that moves from the emphasis on everyday life associated with the Protestant Reformation, which began in 1517, toward the experimental method associated with the Scientific Revolution. It is toward this shift in perspectives—the worldview and the perspective of painting—that we now turn our attention.

German artist Albrecht Dürer was renowned for his promotion of the veil, which he studied during trips to Venice in the 1490s and 1500s and illustrated in a woodblock print in his 1525 *Painter's Manual.* His *Man Drawing a Recumbent Woman* offers an example of its effects. From the artist's vantage point in the image, the model's body parts fill the total space of the image. This amorphous, bodily field of vision is squared into geometric units that lack Alberti's central tenets of horizon, vanishing point, and distance point. As a result of the close proximity of the veil to the body, multiple central points are suggested by the body's folds, which obscure any possible horizon line. To direct our attention to the decision not to emphasize the distance view, Dürer situates the closely proximate woman and artist in front of more typically Albertian windows with horizons in them. In contrast to that deep space, she is virtually pressed up against the veil, suggesting an image that would communicate nonoptical sensory experiences, for example touch, with its multiple points of contact.

The sense of immediacy created by Dürer's use of the veil suggests a private relationship to each individual object (in this case a body). Whereas for the Northern artist the veil produces a sense of visual experience with each object, for the Italian artist the world that contains those objects has been emphatically systematized as if viewed through the clear glass window.[21] The formal contrast suggests ways to interpret images regionally. The Northern-based Protestant Reformation of the sixteenth and seventeenth centuries emphasized a highly personal relationship to God and the divine nature of everyday things as revealing God's beneficence, whereas Italian humanism tended to portray the world in terms of the universal human being.

169

Not just the veil, but other techniques of representation can be charted in terms of this distinction.

Dutch painter Johannes Vermeer is associated with the emphasis on the distance points far to the left and right of the pictured field. By emphasizing the distance points to the left and right of the image, this form rejects the aspect of perspective space that hubristically placed the universal human being at the center of God's creation. The tile work on the floor of Vermeer's *The Glass of Wine* (1661), for example, does not emphasize the single point in the middle as in a Euclidean cone, but emphasizes the two distance points such that each square is distorted into a wide diamond. By widening and directing the viewer's focus to both sides of the image, this doubled distance point causes the viewing eye to scan from one side of the image to the other, the eye moving laterally across the image, which offers a scattering of small details across the middle with extremely clear, scientific precision. In place of the humanistic worldview, the viewer is offered a world of individual, precise details and the distinct sense that he or she is no longer at the center of it. Instead of the steady gaze predicated on an emphatic focal point, the viewer's gaze ranges through the painted world—a multifocused world of scattered details. Indeed, the center of the image is filled with a looming black void, a painted landscape so dark that it shows essentially nothing.

Compounding this multifocused effect, Vermeer's figures were often set next to glass windows in states of quiet repose: playing music, reading letters, and writing. These last two activities refer to lives and loves located outside the picture. *The Glass of Wine* almost revels in the luminosity and clarity of the still relatively new technology of clear plated glass. Captured as it moves through the window, Vermeer's light is crystalline. From the immediately captivating flood of light at the left the eye moves across the image to a bright dot dancing off of the edge of the wineglass at the mouth of a sullen girl. The light, which dances enticingly at her lips, warns of her decline at the hands of the lurid man who seems all too eager to refill the cup. Even though Vermeer was Catholic, the hard-hitting morality tale is consistent

with the values of the Protestant Reformation, where an interest in everyday life as viewed through everyday materials symbolized a quiet communion with God. A harbinger of the Enlightenment, the captured light in glass represents the divine as material reality.

This interest in light effects was not isolated to the arts, however. Rather, it reflects a shift in the science of optics that also played a role in Vermeer's sensibility. Johannes Kepler's *Ad vitellionem paralipomena* (1604) offered a scientific explanation for the effects of perspective that is consistent with the new heliocentric view of the universe. Kepler stated that parallel lines meet at infinity and that the lens of the eye is nothing more than a refractor that bends light in order to focus it on a retinal screen—effectively arguing for infinity in pictorial terms. Perspective would no longer necessarily frame a world of concrete objects in a mapped and finite space, as it had at its inception. Rather, it could be adapted to a newly infinite universe with the sun at its center. As illustrated by *The Glass of Wine,* with its two-point perspective vanishing points placed outside of the image, this universe exceeded the capacities of human perception.

Significantly, Kepler also theorized how like the perspective screen the human eye is. In Kepler's system, light is reflected from objects and projected onto the retina in a pattern that conforms to what is seen, but is upside down, the human retina functioning in a manner identical to the perspective screen developed by artists! In order to prove his theory, Kepler built a tent and, by putting a small hole in the side of the tent and producing an upside-down image of the outside scene on the other opposite wall, constructed a large-scale analogue of the human eye. The projected image is remarkably consistent with the laws of perspective, suggesting both that human beings see things according to its laws and also that the mind intervenes in the perception of the image as right-side up.

The apparent affinity between Kepler's mechanism and the human eye was close enough to prompt revision of Euclid's ancient theory of vision. The famed camera obscura, known to Leonardo but not fully understood until much later, works just like Kepler's experiment. It is

a box with a single hole on one side, which causes an exact image of the world outside the box to be projected upside down on the rear of the box. Many now believe that Vermeer used the camera obscura as a visual aid in constructing his paintings, though to what extent is hotly debated. What can be said is that, even though the geometry of the photograph and the perspective painting differ with respect to the situating of a focal point, which can be anywhere in painting but which is fixed in the center of the camera lens, the single hole of the camera obscura functions much like the single hole of Brunelleschi's experimental image of 1415: light rays move in straight lines through the hole, effectively producing a perfect one-point perspective image on the "screen" at the back of the box. The modern word *camera* comes from the term camera obscura, and indeed the photographic image captured famously on light-sensitive paper by Henry Fox Talbot in 1839 owes its logic to Kepler's discovery and to the broader field of perspective studies.

Given their single focal point, it has been argued that cameras were invented in order to produce the effect of perspective images. Photographer and historian Joel Snyder argues persuasively for this view:

> We accept as realistic pictures that were made in strict accordance with the rules of perspective construction that we could never judge as being similar to anything we might or could ever see…. We accept pictures that are in sharp disagreement with what we now take to be the facts of vision (e.g. an architectural view across a plaza in which all objects in every plane and across every plane are in focus; a brief look around the room he is sitting in will convince the reader that we cannot see that way)…. Cameras do not provide schematic corroboration of the schemata or rules invented by painters to make realistic pictures. On the contrary, cameras represent the incorporation of those schemata into a tool designed and built, with great difficulty and over a long period of time, to aid painters and draughtsmen in the production of certain kinds of pictures.[22]

In other words, human vision is binocular and multifocused (we see through two eyes that scan the viewed scene), whereas cameras use lenses with a single focal, or vanishing, point. The photograph is both visually and conceptually the product of the fifteenth-century screen as an image-making method, but the camera does not replicate actual human vision the way we assume it does.

Many modern critics and artists have been deeply critical of the transparent screens of perspective painting and photography, arguing that both attempt to trick the audience into believing propaganda. The philosophical critique of the transparent screen as symbolic of false consciousness reached its apotheosis in French writer and film-maker Guy Debord, who argued against the orthogonal view of the world that he associates with commercial film and mass culture. By Debord's account, the illusionistic thrust of the orthogonal, with its single vanishing point as viewed through the transparent movie screen, creates for the modern viewer a false sense of empowerment. By merely sitting in a cinema, the viewer is passively absorbed into a world controlled by corporations and governments, a society of the spectacle where participation itself is an illusion. Debord's book and film *Society of the Spectacle* (1968) described the spectacle as "a social relation between people that is mediated by images," meaning commercially produced, photographic images of consumer culture. The structure of his film would counter the spectacle by being made entirely of existing film footage taken from the cinematic mainstream. These film fragments were roughly collaged together to encourage the audience to look at the clips critically, rather than looking through them as a participant in an illusion. The idea would be to look at the transparent screen of film as if it were opaque in order to ask, What is being filtered out? And why? Indeed, many viewers today have become accustomed to the critique of the screen, so much so that the fragmentary cut or rough image has become a marker of authenticity.

Today, embedded journalists working for official news sources photographing the American war in Iraq represent the imagery of war produced for a more sophisticated society of the spectacle. Portable

video gives the home viewer a sense of being there that is no less "real" than for the witnesses to Masaccio's *Trinity* some five hundred years ago, particularly as smooth edits and vistas worthy of the highest level of cinematic polish are spliced with images shot by camera phones and other devices of low-grade screen value. Produced for viewers acclimated to film clips as evidentiary, these collaged scenes are of course rife with propaganda. Thrilling images of wartime adventure in the desert are wedded to a set of low-grade images that testify to the reality at hand, even while body bags and the most grotesque injuries to American soldiers and civilians are quietly withheld.

Following Debord, the French philosopher Gilles Deleuze wrote eloquently about the frame, meaning the boundary between the depicted scene and the "outside" of the image. Deleuze argued that the framing dimensions of film are underemphasized in analyses of perspective space that base too much on the illusion-producing qualities of the image-making apparatus. When a director shows a scene through a window, for example, he or she is repeating within the logic of the film the same framing mechanism that informs the structure of film itself. In Alfred Hitchcock's 1954 *Rear Window,* for example, Jimmy Stewart—playing a photographer confined to a wheelchair after an accident—spies on his neighbors through the rear window of his Greenwich Village apartment, a circumstance that produces multiple frames, screens, and single, double, and triple points of view within the greater logic of the film. Here is Deleuze:

> Doors, windows, box office windows, skylights, car windows, mirrors, are all frames.... The great directors have particular affinities with particular secondary, tertiary, etc., frames, ... and it is by this dovetailing of frames that the parts of the set or of the closed system are separated, but also converge and are reunited. In one case, the out-of-field designates that which exists elsewhere, to one side or around; in the other case, the out-of-field testifies to a more disturbing presence, one which may be said not even to exist, but rather to "insist" and "subsist," a more radical elsewhere, outside homogeneous space and time.[23]

Homogeneous space and time refers, of course, to the controlled space of perspective, meaning that by manipulating the frames and points of view, the director subverts the mechanism of control associated with the camera focal point. These words are as applicable to films and network television as to the computer screen. On the Internet many streams of news coexist, constantly refining the sense of what is included and excluded from the closed system by being effectively put "to one side or around." It appears that the virtual window of the rough-hewn blog suggests the "more radical elsewhere" as a constant feature of the Internet—or more specifically of the multiplicity of origins differentiated from representations of the world in official news sources.

The dual construction of perspective necessitates a more nuanced sense of the form this apparent authenticity takes. The screen of the apparently rough image is both looked through for content, and looked at for evidence of its being made by a nonprofessional. Static, awkward shots and moving or multiple focal points are all evidence of the authenticity of the image in the blogosphere, the Internet, and images borrowed from viewers by sources like the Cable News Network (CNN). In the words of historian Anne Friedberg, "the upright screen" has "many 'windows.'"[24] These many windows coexist in ways inconceivable at the time of the invention of the screen but remain indebted to its visual logic and communicative aims. As archaic as the painted screens of early modern Italy may seem today, in other words, they go a long way toward educating our minds' eyes for the many-windowed worlds we inhabit.

8 TYPE 1454

UNTIL THE ERA OF MASS LITERACY IN THE WEST, the word of God and the process of bearing witness to His creations were largely auditory phenomena. This should not be surprising, for the voice is where it all began. Chapter 1 of the Book of Genesis makes it perfectly clear that the world and human life were both brought into being by creative speech acts: "And God said, Let there be light…. And God said, Let there be a firmament in the midst of the waters…. and God said, Let the earth bring forth grass…. And God said, Let us make man in our image." And it was so. Throughout the foundational period of the religions of Judaism, Christianity, and Islam, the spoken word of the Lord was constitutive of earthly reality itself. Melodious variation can be found in the Eastern Orthodox tradition, in which God sang the world into existence.[1]

The laws governing human behavior in the religious tradition likewise emanated from His speech. According to Exodus, the laws of Moses were taken by dictation from God on Mount Sinai. Moses engraved these commandments on two stone tablets over forty days and nights and then communicated the Covenant to the idolatrous mob at the base of the mountain, as Exodus 35:1 describes: "And Moses gathered all the congregation of the children of Israel together,

and *said* unto them, 'These are the words which the Lord hath commanded, that ye should do them.'" Significantly, although the laws of Moses and Hammurabi were written down (see figs. 2.2, 2.3), few people could read them. Instead, they gathered around to be read *to*. For a very long time, the standardization of language and law that we associate with the tablet, in other words, was, to a large degree, a Church and government affair, not an activity of the people. Legal doctrines had to take the form of the spoken word to be understood and followed. Recall, too, from our history of the ledger, that medieval audits were oral exchanges.

The auditory basis for communication with the divine—which is retained in the tradition of the screened Roman Catholic confessional—allowed communicators of religious law in oral societies to function as substitutes for God's presence by representing Him in speech. The physical position relative to congregants of the minister, rabbi, or muezzin in churches, synagogues, and mosques (speaker above, public below) also recalls the early days of solely spoken-word liturgy. Indeed, religious architecture itself reflects these traditions—its vaulted ceilings promoting the acoustic carriage of spoken words over distances. The spoken or sung word is literally all-powerful, but what it gains in potency and immediacy it loses in accuracy and permanence. Translation into the organizing grid of mass-distributed type—the Book in book form—was a useful development in a world increasingly valuing permanence, transportability, and a more diffuse distribution of power.

Throughout the Classical period, longer works like the Old Testament or the works of Aristotle were written on papyrus scrolls, rolled reeds of cellulose that were more convenient than stone tablets but extremely vulnerable to heat and moisture. By the second century BCE, double-sided parchment scrolls of sheep or goatskin had been developed for the library at Pergamum in Asia Minor. These and a special calfskin parchment called vellum were more costly but also more permanent than papyrus. Receptive to the stylus or pen in a way that stone and papyrus never could be, vellum made possible

the shift to the rounded letterforms of Roman majuscule (upper case) from the square, hammer-and-chiseled letters associated with Greek and Roman monumental stone work (see fig. 2.4). Further, the durable and portable vellum scroll could be carried to the furthest outposts of the empire, where local variations in penmanship crept in to influence the standard forms of Greek and Roman letters.

In addition to the stone tablet and the scroll, short Classical texts were also written on temporary wax tablets, six or seven of which could be bundled together into a codex. These bundled codices would evolve into modern books—bundled, folded leaves bound at one side. The majority of Classical codices were temporary texts such as school notebooks, but a few collections of imperial laws or constitutions in the first century BCE took the form of the codex. The Christian Church, eager to distinguish its books from the common scroll forms of pagan writings, adopted the vellum codex as its textual medium by the second century CE.[2]

The codex, like the scroll, was highly portable and durable, and thus it was transported efficiently to distant Roman towns, where Christians were spreading their gospel. Nevertheless, the rigors and dangers of the early medieval era isolated people linguistically. For the next several hundred years, the script styles and dialects of Latin evolved independently of each other. What had been Latin dialects evolved into the Romance languages: medieval French, Italian, Portuguese, and Spanish. The independent processes of evolution were so sweeping that someone from Rome would find it almost impossible to read the script of England not only because it was a different language, but because the Latinate letters took vastly different forms in different languages.

Between 800 and 1200, beginning with the efforts of Emperor Charlemagne (747–814 CE), standardized script was introduced throughout Europe. Allowing for greater legibility and common understanding among the linguistically isolated countries of Europe, this script would change how language was written in the West from that point forward. The most distinctive feature of the new script was

"Carolingian minuscule," which introduced the first widely used lowercase letters. Further, the Carolingian minuscule lent a new convention to script: adding a space between each word. These innovations led to great advances in communications, at least for those few people with access to books.

The publication of books in the Middle Ages was carried out through careful copying from an original or through the dictation of a text to scribes who would then write word by word, often in a monastery's scriptorium. Writing out the entirety of a manuscript was not always a mere mechanical exercise: collectors or students would copy the words as a means of studying a text. In any case, because the labor and materials used to produce a book were extremely expensive, even an established monastery or university might have only a few dozen of them. Cambridge University, for example, founded in 1209 and the second-oldest university in the English-speaking world, was renowned for having one of the greatest university libraries of its time. By 1424 it had 122 volumes in its library. This is a surprisingly paltry collection by modern standards, but imagine the number of eyes that scoured those volumes. Indeed, sometimes simultaneously: students made the most of their resources, often gathering collectively around a single document.

Whether in a congregation, a scriptorium, or a library, then, the experience of the biblical text, and texts in general, would have been social in nature, an experience far removed from the solitary act to which contemporary readers are accustomed. Another significant difference between the medieval and contemporary reading experience is that the former was largely pictorial, which accommodated the low literacy rates of the general public (even the lower clergy were only semiliterate). There are important exceptions, most notably in India and China, where literacy remained high throughout the medieval period, and among the minority Jewish populations of Europe, where literacy in Hebrew was fundamental to the survival of the faith and the study of the Tanakh and the Talmud. The comparatively small

scale of the Jewish population, however, meant that book sharing and copying sufficed for this population's needs.

What some have called the first printed books were codices of gathered woodblock prints, some with a few lines of text, relaying the Christian narrative.[3] Produced primarily in Germany and the Netherlands, these prints, which date to about 1400, show scenes from the lives of saints and the Bible so as to suggest pious behavior. These woodblock prints were inexpensive, making it possible for even the very poor to engage with religious imagery in the home. These *Biblia pauperum,* or "poor man's Bibles," proffered an inexpensive and concise form of visual storytelling that could be bound and sold at a cost much lower than handwritten and illustrated books. They were made on a new material: paper, which was especially cheap to fabricate. Produced in Spain by 1150, paper came from China with the Muslim conquest, and by the fifteenth century was used as a substitute for costly vellum. These early books were an important harbinger of the Protestant Reformation, which shifted the focus of religious experience from the spectacle of oral recitation in cathedrals to a personal, literary relationship with the divine. Cost efficiency of new print media made such private contemplation possible—a circumstance which suggests the mutual dependency of the technological and religious revolutions to come: print made the Protestant Reformation possible at the same time as the Protestant Reformation made print necessary.

In 1454, a jeweler from Mainz, Germany, named Johann Gutenberg, invented the three-part invention we call "moveable type" that consists of cast-metal letters, the printers' ink they would transfer onto paper, and the presses themselves. He had at his disposal the prerequisites and precursors of paper, the codex, textile-printing blocks, the oil-based pigments via Flemish and Italian easel painters that suggested to Gutenberg a printing ink made of boiled linseed oil and lampblack, and the wine presses adapted by bookbinders to keep pages and binding flat. (It's worth noting that moveable clay calligraphic characters were designed in China circa 1040 by Bi Sheng, a calligrapher, but

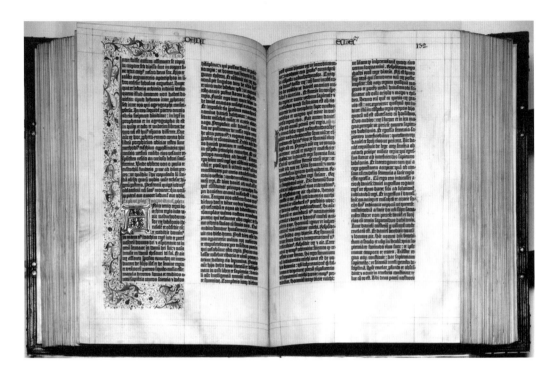

there is no firm evidence that the technology came West.) Gutenberg's genius lay in assembling all of these elements together into the viable printing process that produced the famed "forty-two-line" Bible, which is named for the number of lines on each page. These pages were printed from letters individually die-cast in metal alloy as rectangles and squares, then organized on a gridded, adaptive armature that could be reset with new letters for subsequent pages. Hence "moveable" type.[4]

With Gutenberg's invention, not only could published texts be radically standardized for form and content, vast numbers of them could be produced at once. Thus moveable type gave the general public access to the standardization of language long ago engraved in the tablet. The forty-two-line Gutenberg Bible consisted of 643 leaves in a print run of about two hundred copies. Though a modest run

by today's standards, a comparable run of the Gutenberg Bible made by hand would have taken one scribe roughly two hundred years. It has been suggested that the famed myth of Dr. Faustus, who sold his soul to the devil for knowledge and power, derives from this moment. Gutenberg's partner, Johann Fust, attempted to pass off the printed Bibles as handmade ones while on a sales trip to France in 1456 or 1457. "After the French observed the number and conformity of the volumes, they decided that witchcraft was involved," according to Philip Meggs. "To avoid indictment and conviction, Fust was forced to reveal his secret. It has been claimed that this event is the basis for the popular story … of German magician Dr. Faustus (Johann Faust in an early version), who grew dissatisfied with the limits of human knowledge and sold his soul to the devil in exchange for knowledge and power."[5]

Instantly valued, print technology spread quickly and commercial publishing houses soon were founded across Europe. Venice, already the center of international trade, banking, and bookkeeping discussed in the Ledger chapter, claimed its first press in 1469 and became a publishing center by 1500, by which time the city had 417 printing presses. This astonishing growth suggests that the invention of moveable type spawned a far-reaching cultural revolution—and indeed it did. The grid of the printing press generated mass literacy.

The potential quantity of printed volumes is the obvious great advantage of mechanical printing. A less frequently cited advantage is accuracy. Hand copying could produce texts that were rife with errors or elisions. Johann Heynlin and Guillaume Fichet, two scholars at the Sorbonne who established the first university press in 1469 or 1470, described the implications of their venture: "Now the printers … can produce truly correct copies."[6] In other words, the standardization of format that accompanied moveable type publication allowed for exact duplication. Or at least any errors would be the same in every copy of a printed book: with moveable type came the persistent nuisance that is the typographic error (the typo), after all.

Equally importantly, the location of a given portion of text was identical from book to book, which made possible comparative close readings among various readers of identical prints. New conventions in book content and organization supported this process. With standardized pagination came subject indexes, for example, which allowed for quick comparison between authors on a given topic. Tables of contents allowed for quick perusal and overview of the book's subject matter. Another major effect of moveable type was the introduction of hitherto unavailable Classical texts in both university and commercial contexts. In France, Germany, and Italy, texts by Cicero, Ovid, and Virgil, as well as the modern humanists of the Renaissance, were published. By 1500 virtually the entire catalog of Classical literature as it was known at the time had been published and distributed through a network of universities, print shops, book dealers, and book fairs. Thus moveable type spread the word widely and consistently, the book's very informational structure adjusted in kind, universities flourished, and intellectual history was revived among the reading public. A new level of dialogue and scholarship was born, sparking a revolution in the study of the sciences and humanities, expanding access to education to nonscholars, and an explosion in the scale of universities across Europe.

These broad societal effects of Gutenberg's invention are both awesome and widely known. He is often cited at the top of news media surveys of people who changed the course of history. We will now turn to the more esoteric material and experiential qualities and impacts of mechanical type. A quick look at the type in Gutenberg's Bible shows a Germanic style, with the vertical proportions of the letters reminiscent of Gothic design—like tall, slim Gothic windows. Mechanical type also imitated the hand-scripted calligraphy of the scriptoria. By 1500, however, the type design of mechanically printed books was becoming modernized. Types were losing their decorative flourishes and being made to resemble "Roman" type (a misnomer, in fact, since the style was taken from the Carolingian minuscule). Though variations persisted for centuries, authoritative publications

were increasingly predisposed to seemingly classical letters based on the highly flexible modules of the circle and square.

Consider the difference between hearing words read aloud and streaming along by eye at the pace afforded by standardized, geometric type. The heard word travels through space, carried by sound waves that emanate from the speaker's mouth, while the read word is a silent object. In the words of media theorist Marshall McLuhan, the invention of moveable type "translates man from the magical world of the ear to the neutral visual world."[7] McLuhan understood this sensual shift as just the beginning of the consequence of moveable type. The newly rapid speed of knowledge acquisition and the regular pulse of mechanical type on the mind of the reader were so pervasive as to change the very nature of being human. They created what he called the "typographic man."[8] This modern reader exchanged the social or discursive aspect of spoken and heard text for one that is read privately in silence. Thus the printed page forms a neutral or apparently blank slate for the communication of impersonal, objective knowledge.[9] Or so it would seem.

Knowledge is never impersonal or objective. It exists as a communicator of the social flow of society both in terms of the conceptual basis of the society it supports, as well as the way it forms and is formed by social institutions. This complicated state of affairs was assessed critically by Michel Foucault in his histories of modern institutions such as hospitals, prisons, and, most important for our purposes, modern universities predicated on the advancement of objective knowledge:

> The problem is at once to distinguish among events, to differentiate the networks and levels to which they belong, and to reconstitute the lines along which they are connected and engender one another. From this follows a refusal of analyses couched in terms of the symbolic field or the domain of signifying structures, and a recourse to analyses in terms of the genealogy of the relations of force, strategic developments and tactics.[10]

Given this observation, it comes as no surprise that the social sphere of the Roman Catholic scriptorium and the oral tradition were replaced by other social forms. But a shared written language was needed first.[11] Toward that end, moveable type standardized the many spoken languages of Europe with the first published books of grammar.

Until its invention, the regional dialects of German, English, French, and Spanish were spoken locally. Even within one country, a dialect could be incomprehensible to someone from a few hundred miles away. The lingua franca of Europe used in the churches and for travel was Latin. Now, the standardization and distribution of the Romance and Germanic languages through printing essentially purified Latin out of existence. As one author describes it, "typography arrested linguistic drift."[12] Significantly, the publication of texts in the vernacular tongues of Europe also inspired patriotic identities, creating the "uniform, centralizing forces of modern nationalism."[13] For example, there is a close tie between the creation of a standard written German at about the time of Luther's theses and the emergence of modern German nationalism when this became a spoken form in the early nineteenth century.

In summary, just as the ledger challenged the economic organization of society around the king, the patriotism wrought by print technology challenged the international authority of the Roman Catholic Church, not only in terms of relative influence, but even over its own scripture. In Gutenberg's home city of Mainz, for example, Archbishop Berthold von Henneberg issued an edict in 1485 forbidding the issuance of liturgical texts in German. "We have found that Christ's books of the holy services, and texts on divine matters have been translated from the Latin language into the German tongue to be handed to the common people," the edict stated, "which can only be to the detriment of our religion."[14] Translation into German, in other words, would loosen the Church's hold on reading and interpreting the Bible for each worshipper while at the same time sending Latin, the universal language of the Church across Europe, into disuse.

In 1517 Martin Luther posted his *Ninety-five Theses* for reform of the Roman Catholic Church on the cathedral in Wittenberg (about three hundred miles from Mainz). At this point between ten and twelve million volumes of printed text had been published using Gutenberg's mechanical invention and the Bible was available in German, French, and (by 1526) English.[15] Clearly, even without Martin Luther's intervention, the Roman Catholic Church would have had trouble holding back the floods of change, but over 300,000 copies of Luther's theses being duplicated in virtually every language of the European continent assured that the Church's power would never again go uncontested. Luther called printing "God's highest grace" and indeed, this technology led the Protestant Reformation in its sweep across Northern Europe.[16] The later reformer John Calvin (1509–1564) argued vehemently for the printed word as a superior means of conveying religious teachings. Criticizing lavishly decorated Catholic churches as immoral for ignoring the fourth commandment against graven images, he wrote, "The illiterate should not be given graven images but should be taught to read."[17]

And read they did. Catering to and developing the taste of a burgeoning merchant and professional class of readers, the presses of Europe published everything from religious to philosophical to scientific to political and popular content. They also disseminated broadsheets recounting the geographic discoveries that literally changed the shape of the world, including eleven editions in seven countries of Columbus's letter to Ferdinand and Isabela of Spain detailing his discovery of the New World in 1493—an early best seller.[18] Modern theater is unthinkable without identical copies of scripts that can be distributed to actors sharing a stage. (Just imagine if William Shakespeare had been born before the invention of moveable type.) The astronomer and printer Regiomontanus set up a press in Nuremberg, Germany in 1470 that turned out duplicate sine tables, tangents, trigonometry tables, and technical treatises and emphasized the importance of training apprentices capable of reading them.[19] In 1543 two fundamental books in the establishment of a

modern scientific paradigm were published: Nicolaus Copernicus's *On the Revolution of Heavenly Spheres* (*De revolutionibus*) and Andreas Vesalius's *On the Fabric of the Human Body.* The impact of both would have been diminished had they not relied on the newly standardized mathematical formulas, table forms, and illustrations made possible by printed technical literature. Uniform means of data-keeping and documentation allowed mathematicians and scientists to share their work, effectively ushering in the Scientific Revolution.

The familiarity of the names of these sixteenth-century thinkers—Luther, Shakespeare, Copernicus, and Vesalius—who were the founding fathers of the modern disciplines of Protestantism, literary theater, astronomy, and biology, demonstrates another effect of moveable type. As described at some length in his essay "What Is an Author?," Michel Foucault associates the conception of the modern idea of the author with the emergence of modern communications technology.[20] During the classical and medieval periods, differences from one text to another were introduced by various scribes and copyists. Thus all texts were, to varying degrees, collaborative projects. The modern idea of the individual author, by contrast, is only possible under circumstances that permit the exact copying of texts, their multiplication in great numbers, and the clear articulation of a single source.

It is an odd twist of printing fate that the idea of unique authorship, which is associated with the ownership of an idea, emerged with the sublimation of the individual handmade mark to the standardization of mechanical text reproduction—which is to say early graphic design. On close examination, Gutenberg's forty-two-line Bible shows the underlying grid that would structure the entire text according to a proportional system on the surface of a page. This layout shares a genealogy with the tablet, but the mechanics of type suggested modern typographic proportions—modular ways of subjecting the page to a systematic principle of proportional, rectilinear design. Not surprisingly, medieval page design reflects the geometry of the matrix of supports that held die-cast type. In the words of book historian Johanna Drucker, "Page designs became more insistently

linear and regularized owing to the mechanical demands of the print medium."[21]

Some have argued that the uniformity of information associated with the modern printed word depleted the social, sensory, and spiritual richness associated with medieval texts and religious experience.[22] But Drucker's observation does not mean that the form of the typographic grid necessitated some sort of rationalist revolution per se. Nothing in the act of organizing materials (whether visual or otherwise) necessarily renders them more rational, if by rational we mean devoid of sensory or social complexity or spiritual affect. Indeed, quite the opposite is true. As the emergence of the tablet clearly demonstrated in the ancient world, letter design (typography) is as old as writing itself. A jeweler by trade, Gutenberg employed a scribe, Peter Schoeffer, who aided in both the type design and cutting of the first typeface letterpunches. Linked to the long tradition of hand-written texts, the typographic tradition at Gutenberg's disposal represents 3,000 years of alphabet design and evolution. The letters used by gothic scribes like Schoeffer, called blackletter or Gothic script, were essentially copied directly for the first moveable typefaces. The depth of this tradition, coupled with the association with this revolutionary medium, virtually guaranteed that the new technology would remain close to the blackletter form, especially for the religious texts with which the new medium was initially associated.

However, in Italy the humanist revolution necessitated typography with Classical associations, such as Venetian and historicist antique styles. These typographers worked from inscriptions found on Greek and Roman buildings and tablets, which were based on squared forms that offset the thick and thin strokes of the letter body with feet, called serifs (see fig. 2.4). Written language had, however, evolved in the interim. As a result, Italian scribes and humanist scholars searched for ancient minuscules, small letters, to match the capital letters of Roman inscriptions. Since most of the classical manuscripts were transcribed during the Carolingian Renaissance, humanist scribes believed the Carolingian minuscule was authentic

to the ancients. With some adjustments over the course of the next hundred years, this *lettera antica,* as it was called, formed the basis of most of the Western type faces that followed.

These two traditions, the Gothic typefaces of Germany and the North and the Romanizing typefaces of the South, indicate that the knowledge associated with moveable type was far from neutral, even though its form was standardized and reproducible. Examples abound. Leonardo's illustrations for *The Divine Proportion* (1509), for example, show how the golden ratio—that key to the nature of the body itself—could be applied to print in the form of font and page design. Similarly, the preeminent French printer of the early 1500s, Geofroy Tory, conceived a cosmological synthesis of human proportions with Pythagorean and Neoplatonic mysticism in his understanding of typography. In Tory's designs, the body of man was mapped onto a grid, whose squares were each associated with a different muse. According to Drucker, "These proportions also

191

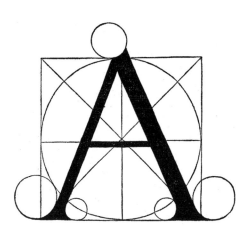

Quefta letera A. fi caua del tondo e del fuo quadro:la gã ba da man drita uol efler grofla dele noue parti luna de lalteza. La gamba feniftra uol efler la mita de la gãba grof fa. La gamba de mezo uol efler la terza parte de la gamba grofla. La largheza de dita letera cadauna gamba per me zo de la crofiera. quella di mezo alquanto piu bafla, com me uedi qui per li diametri fegnati.

8.4

New York Times on the launching of *Sputnik 1,* October 3, 1957.

corresponded to the openings and intervals on the mythic flute of Virgil, themselves each governed by a Muse, while the mouth and shaft of the flute each signified the 'I' and the 'O.' Inscribed within this system, the letters were inherently aesthetic and symbolic."[23] As Drucker points out, the capital letters "O" and "I" had specific associations based on formal qualities. Likewise, the letter "Y," with its two limbs diverging, stood for the Pythagorean oppositions of good versus evil, virtue versus temptation, and so on. Tory further posited that letters could be mapped onto the human anatomy to form a systematic yet organic *l'homme lettré,* or "man of letters" where, for example, the letter "Y" demarcated the collarbone and "D" the ear.

The field of book design was extremely dynamic from the Renaissance until the nineteenth century, with changes in taste producing debates between, for example, those who preferred the learned and Classical associations of Roman fonts and geometrical layouts and those who favored the medieval and regional associations of Gothic fonts and vertical columns. (We can see these evocations play out today in the amalgam of font styles in the *New York Times,* for example, where the apparently objective Times New Roman font is used for articles and an adventurous Gothic font for the headlines.) New kinds of publications also prompted innovations. Broadsides and advertisements aimed at ever-wider audiences, for print changed overall design even while the basic technology of the printing press remained unchanged until the nineteenth century. Most significant of these new publications and designs was the regular news periodical, which appeared in about 1645, almost two hundred years after Gutenberg.

Now, papers such as the *Leipziger Zeitung* and *London Gazette* reported on the news weekly or daily on newssheets of unbound copy. The experience of reading these papers was quite unlike reading a book, in which consistently spaced letters run from upper left to lower right to tell a story from cover to cover. For one thing, in newspapers there were multiple stories starting here and there under different headlines. The scale of newspapers was also very different. By

194

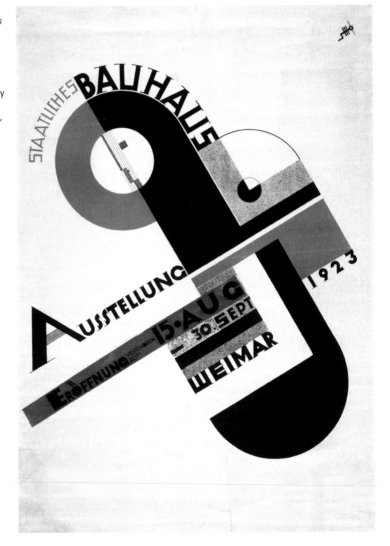

conventional accounts, the reason for their relative immensity was a 1712 tax the British Parliament imposed on each paper sheet, which led printers to economize by using larger single sheets. In *Seeing the Newspaper,* graphic designer and historian Kevin Barnhurst rejects this exclusively economic interpretation, arguing instead that the large paper format was also meant to evoke the authority of oversize books, which were more expensive historically and reserved for important subjects.[24] Stylistic conventions like columns of type also had a particular origin, in this case technical rather than associative: the revolving press with giant rollers that spews out large newssheets is disposed to producing narrow pillars of text. In summary, the story of graphic design suggests an amalgam of sources, the appeal of a technology lying in its ability to affirm familiar values while simultaneously offering new design possibilities and therefore new ways of structuring and understanding content. Tied to and expressing social transformations, designers and poets alike have always played with the typographic grid. William Blake (1757–1827), for example, produced engravings that defy the grid explicitly. His illustrated poems suggest that the graphic effects of letters and page design can have a symbolic power as forceful as that of the visual arts. French poet Stéphane Mallarmé (1842–1898) likewise advanced this idea, producing "concrete" poems in which the form of the letters on the page is synchronized with the meaning of the words. In the 1920s, the dynamism associated with regular text in diagonal form seemed to articulate the spirit of industry and change associated with the modern era, as shown in advertising for the Bauhaus. By 1928 graphic design proper caught onto this artistically acquiescent grid when Dutch designer Jan Tschichold popularized the diagonals, asymmetry, and flexible modules of the Bauhaus in his influential book *Die Neue Typographie* (*The New Typography*).

Tschichold's dynamic style did not take hold of standard newspaper design, of course. Barnhurst described his time as a youthful designer as "an arranger of rectangles," which confirms the power of the grid even in late twentieth-century graphic design.[25] But the newspaper

8.6
Emmett Williams, *Four-Directional
Song of Doubt for Five Voices,* 1957.
With permission of the estate of
Emmett Williams.

196

grid, as rectilinear as it is, is not rigid. Taking a lead from the standardized modules of Bauhaus industrial design and architecture, in particular Le Corbusier's golden ratio measuring device, *le modular,* twentieth-century graphic designers have developed modular grids with the size of each box unit (article) determining its amount of information (words). Rather than a highly regulated stream of text presenting information in a uniform narrative chain, the modular typographic style invites text of different sizes, columns of varying widths, and images of any size. The resulting newspaper surface is one that is apt to be scanned. A story can, of course, be followed through to the end, but the mosaic of multiple articles attracts the once-over glance.

One interpretive take on the modern conversion of the verbal into the visual grid is Fluxus poet Emmett Williams's 1957 performance piece *Four-Directional Song of Doubt for Five Voices,* which starts with five gridded cards, each representing one word of the statement "you just never quite know." The cards are distributed to and read by five performers whose meter is regulated by dots placed within the gridded "score" and a metronome. It is theoretically possible that the grammatical sequence "you just never quite know" will assemble itself during the performance, but instead the words assemble themselves in a sequence of "you knows" "quite justs" and "never nevers" that demonstrate how indeed, we just never do quite know, do we? Everyday experience is thus literally expressed in the form and content of the poem, even though it takes the form of a spatiotemporal grid.

Literary content is usually associated with a story line or a narrative arc, or some other directional framework appropriate to the typical sequencing of words on a page. Visual content is normally associated with a field of squares, the perspective screen of absolute space. Williams's poem exploits the intersection of both: language is spatialized on the grid and the visual field is structured by the linear requirements of language. This coherence of visual and linguistic form is associated with the modern movement in concrete poetry. Williams's concrete poem *Four-Directional Song of Doubt* utilizes the organizational logic of the grid, its spatial form, to move the

poem from the confines of traditional print media, which says what it means in sequence, and toward the multidirectional, spatial logic associated with the visual arts.

In that process, a certain distance is gained from normative linguistic intelligence, or what Harvard University's educational theorist Howard Gardner calls "a sensitivity to the meaning of words (and) the order among words."[26] What replaces it is "a sensitivity to the sounds, rhythms, inflections, and meters of words."[27] These sensory elements, which are generally subservient to the literal content of words, are made available to the audience through the imposition of the visual grid—one that is external to our normal perception of language. In other words, intermedial process grids effectively reverse the terms of value normally associated with writing; instead of saying what is meant, the form itself speaks and, conversely, sheds light on writing generally. John Dewey's description of the function of the grid is useful: "new patterns are almost automatically constructed. The squares run now vertically, now horizontally, now in one diagonal, now in another."[28] This omnidirectional visual experience seems to be precisely what Williams has in mind, for the reader/performer holds to the sequencing of the forms while resisting the meandering thrust of the graph form. Looked at this way, the grids of concrete poetry are distinctly different from the grids of moveable type.

One might argue that this modular layout spells the end of typographic man—which is to say of absorbed reading. McLuhan actually attributed the end of typographic man to the invention of the telegraph, another communicative means whose structure of constant interruption and brevity of sentence structure requires a fundamentally lesser degree of attention than, say, reading the Bible or a novel word for word. The scrolling, pop-ups, and full-color accompanying imagery of digital "texts" distract us ever more; we now read in a state of constant commotion. So-called slipping literacy rates come as no surprise. The challenge to writers, educators, publishers, and graphic designers is not to eliminate the stimuli, but to generate literacy training that adjusts for this new environment. McLuhan predicted the

dangers of the current state of affairs: "Sheer visual quantity evokes the magical resonance of the tribal horde."[29] One could respond with an update on Calvin: the illiterate must be given not only words, but the critical skills to see that those words are images, in order to learn the authoritative texts of our time.

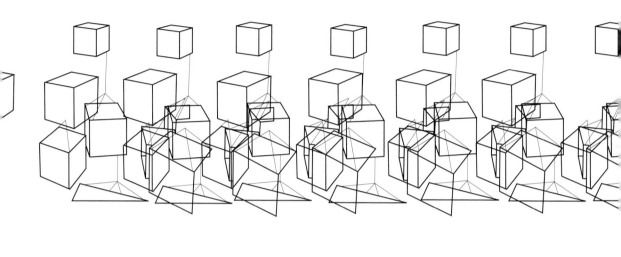

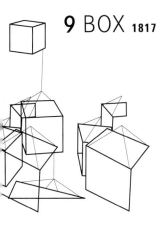

9 BOX 1817

AS A PRELUDE TO OUR CHAPTER ON THE BOX, let's take a walk on a commercial dock, circa 1950. According to Marc Levinson's rich history of the shipping container, "the dock would be covered with a jumble of paperboard cartons and wooden crates and casks. There might be steel drums of cleaning compound and beef tallow alongside 440-pound bales of cotton and animal skins. Borax in sacks so heavy it took two men to lift them, loose pieces of lumber, baskets of freshly picked oranges, barrels of olives, and coils of steel wire."[1] This cargo of many shapes and sizes was well suited to filling every crevice of trade boats, the pointed prows and sloping hulls of which created all manner of unusual spaces and made varied containers necessary for packing a cost-efficient full load. Small items like wheels of cheese might best fit into the prow, while great rolls of cloth could be pressed along the hull flanks. Out in the open cabin, fifty-kilo bags of coffee could stabilize a stack of barrels. Fitting this cargo puzzle together was the laborious job of the longshoreman. It could take a swarm of men a month to unload and load a vessel.

This scene began with the explosion in shipping and trade that accompanied the age of exploration and the Industrial Revolution, and it remained unchanged for four hundred years. Industrialization

brought with it many kinds of standardization, but shipping lagged behind. Even as packaging became standardized and objects made of an increasingly uniform character by newly automated machines, the graduated form of the ship remained the same—and so did the diversity of its cargo. By the 1960s, however, consumer goods began conforming to standardized "paperboard" cartons invented in the nineteenth century. A larger box might contain smaller boxes for easy transportation and storage before and after its time at sea. The box is unloaded into stores, where vast systems of shelves form a circulatory system that sustains cities and towns alike. The shipboard shipping container finally became inevitable. Today, a company puts manufactured goods into a retail box, puts these retail boxes into a shipping crate, freights these shipping crates in a shipping container, and finally disgorges the goods in appropriately named "big box" stores like Wal-Mart.

How we get from the invention of the manufactured box in the nineteenth century to the freight shipping container a century later is a story of technological invention, of shifting attitudes toward national boundaries, and of the apotheosis of the multinational industrial manufacturing system. As we shall see, the box presents a many-sided portrait of modernity: in addition to transportation, it shows up in architecture, art, and education. Perhaps no other grid module has had the profound impact on human life of the simple box, a realization of space in the form of a container. The box, to put it succinctly, is where the automation of human life meets absolute space. But the single box does not make up the form of the grid any more than a single brick. It must be placed with other boxes to become a network we would call a grid.

In 1817 the inventor Sir Malcolm Thornhill produced the first manufactured paperboard box in England, about two hundred years after the Chinese first invented paperboard itself. Paperboard, essentially a sheet of thick pressed pulp, gave the box a good head start, but it lacked the durability necessary for long-distance shipping. In 1856 the English inventors Healey and Allen patented corrugated paper.

First used to add rigidity to men's top hats, it would evolve into what we call cardboard. In 1871 New Yorker Albert Jones filed his first patent—for a stronger corrugated paper that could withstand the jostling of shipping. Jones wrapped bottles and glass chimneys in the revolutionary material, which was made by hot-gluing a sheet of fluted paper between plain, exterior liner sheets. In 1890 American Robert Gair took the next step, constructing the first corrugated cardboard box. Conveniently, these were precut, standard-sized, and produced as storable, flat pieces that could be opened up, folded, and glued on demand.

These highlights in the early life of the box coincided with Chicago's destruction by fire and subsequent reconstruction and economic recovery with which I began this story. In addition to the entire downtown, the Chicago fire destroyed the first inventory of Aaron Montgomery Ward, who would officially begin his Montgomery Ward mail order company in 1872 with a single-sheet catalog offering 163 items not readily available in rural America. By 1890 this "wish list," as loyal customers called it, had grown to include ten thousand items and inspired competition by a Minnesota merchant, Richard W. Sears, who in 1893 partnered with Alvah C. Roebuck in Chicago to form Sears, Roebuck and Company (see fig. 0.3). Through mail order, Sears and Montgomery Ward could pass on the advantages of volume buying directly to consumers. As a railroad hub serving the greater western part of the country, Chicago was a logical base. By the early 1910s Sears invented a network of belts and chutes that would move goods through the building and direct boxed orders to a mailroom, which would ship them out around the country. According to Sears, Henry Ford, father of the assembly line, admired what he called the "seventh wonder" of the business world.[2]

But location and systems were not enough: mass sales couldn't have happened without the manufactured box. By 1900 custom-made wooden crates had been largely replaced by corrugated boxes offered in standard sizes. Rather than being specially made to hold unique objects, the packaging process was reversed. Now objects were made

9.1
Interior of traditional grocery store
with early box packaging in a German
village, n.d. Photo: Ulrike Hammerich/
www.shutterstock.com.

to easily conform to the standardized box, representing a fundamental shift in packaging of goods. The Kellogg brothers, for example, owned a famous sanatorium in Battle Creek, Michigan, where they promoted the consumption of their "Battle Field Toasted Corn Flakes" cereal as a health food. Originally sold in bags, in 1914 this cereal would become the first food sold in a manufactured cardboard box to the masses. Each box was covered in a Waxtite freshness wrapper-bag, which served two functions: it kept the contents fresh and indicated the freshness of this newly branded product. It was only a matter of time (fifty years or so) until Swanson would make the first "TV dinner," a complete frozen meal in a box.

Along the way, grocery stores transformed from small-scale markets full of open casks doled out by the scoop to daily shoppers to expansive supermarkets where the clientele could find perishable goods in standard weights sealed in boxes that ensured longer freshness. In the contemporary supermarket, virtually everything but meat and fresh produce is sold in hermetically sealed, standardized containers, many of which take the form of the box.[3] The adaptability and uniformity of the manufactured box, along with its dual function as an advertisement, made it ideally suited to cultures of mass consumption. Indeed, functional consumerism is almost unimaginable without the box form of packaging, which communicates the identity of almost every branded consumer product.

Given the success of manufactured boxes in generating and supporting a retail structure in the service of a consumer society, it comes as some surprise that it took a long time for the majority of wholesale goods to follow the Kelloggs' lead. As our description of the 1950s dock suggests, olives were shipped in bulk in barrels, coffee in fifty-kilo bags, and so on. They were then divided and packed into retail packages at special packaging plants. This paradoxical circumstance persisted for so long not only because of the odd crevices of cargo boats. Rather, it reflects entrenched, archaic billing practices in American shipping. In the United States the price of shipping was based on the specific goods being shipped, which meant that products—domestic

9.2
Container Ship, n.d. Photo:
Opla/www.shutterstock.com.

206

or imported—had to remain "unpackaged" for easy inspection. The manufacturer would thus begin by loading a truck with merchandise piece by piece, unloading at a dock, reloading onto a boat, unloading individually again, then reloading onto another truck that would feed into a wholesale storage facility, where the product would be packaged for retail sale, and finally, through one more cycle, end up at a retailer.

Despite four months of hearings in 1931, weight-based shipping—a far more functional measure that would have allowed for packaging at the site of manufacture—was still determined to be illegal in the United States.[4] The laws finally changed after 1948, following the successful use of Conex shipping boxes for transporting American soldiers' belongings during World War II. The commercial market followed with the Dravo Corporation of Pittsburgh promoting its "transportainer" and the Missouri Pacific Railway its "speedbox." These early containers were only about eight feet long and therefore remained inefficient for large-scale, industrial use. However, the redundant loading and unloading of individual wares onshore finally changed radically on April 26, 1956, when an aging tanker, the *Ideal-X,* left

Newark, New Jersey, and arrived in Houston, Texas, five days later with fifty-eight aluminum truck containers aboard.[5] The brainchild of trucking magnate Malcolm McLean, this system meant that a container (the trailer of an eighteen-wheeler truck) could be filled once, as it left the manufacturing facility, and unloaded once, as it arrived at its final destination. The days of the longshoremen were numbered. Soon, a computerized system of cranes could unload and load a ship in a single day, leading to such significant economies of scale that, even after 9-11, less than 1 percent of all containers are opened for examination by border agents. The shipping container makes moving goods so cheap that economists have called it an "essentially costless" part of the production process.[6] No doubt, recent environmental awareness and peak oil prices could change that assessment.

In New York City the relatively high electricity, labor, and real estate costs of production were historically offset by proximity to the harbor and ease of transportation. The high cost could be justified. The explosion in container shipping made that advantage moot. According to Levinson, "Between 1967 and 1976, New York lost a fourth of its factories and one-third of its manufacturing jobs. The scope of this deindustrialization was widespread, with forty-five of forty-seven important manufacturing industries experiencing double-digit declines in employment," in part as a result of real estate costs.[7] At that stage, 83 percent of job losses were the result of factories making relatively local moves—to Pennsylvania, upstate New York, and Connecticut. Twenty years later, the factories and the jobs would leap again, this time to other countries with cheaper labor, most notably Mexico and Central America, India, and China. In other words, the decline of manufacturing in so-called first-world economies is directly related to the rise of the shipping container as moving goods across national boundaries became "essentially costless." Is it possible that high oil costs could reverse this process, bringing aspects of manufacturing and production back to more local emphasis? It is certainly too soon to tell, though there can be no doubt that higher costs of shipping have implications beyond the obvious.

The negligible cost of shipping today has also led to the dispersal of the production process, so that various parts of one product might be made in multiple countries, then brought together by container ship to form a whole. The Barbie doll is a case in point. With the invention of that all-American icon in 1959, Mattel Corporation began manufacturing its plastic dolls in one piece in Japan and shipping them once to the United States for retail sale. By the middle 1990s, Barbie's body was made in China using molds from the United States, machine parts from Europe and Japan, and plastic from Taiwan. Her nylon hair was made in Japan, the pigments used to paint her were American, and her cotton clothing was made in China.[8] Globally wrought Barbie is not unique. Many consumer products have such hybrid identities, thanks to a steady stream of unfinished and finished goods moving continuously from port to port.

These highly adaptive streams of unfinished goods that easily consolidate into a finished product have made possible "just-in-time delivery," which Toyota spearheaded in the 1990s. Storage of goods and parts is a waste of capital, of course, but production on demand effectively renders much storage unnecessary. Just-in-time means that there is no backlog of materials in the system and no unused merchandise. Logistics management, a term historically associated with moving large numbers of people at short notice in the military, is the defining term for production today. The Barbie doll, for example, would involve gradual composition across at least five national borders and boxing and shipping from China for distribution in the United States on demand. Because of improvements in ship design and the compressed process of loading and unloading, the final trip takes just over a week; as recently as the 1970s such trips required a month.

The rate of increase in the movement of goods around the world by container is staggering considering how new container shipping is. Germany's largest port at Hamburg, for example, handled eleven million tons of cargo in 1960; in 1996, forty million tons passed through, with 88 percent of it in containers. In 2002 the NKK Corporation (Nihon Kōkan Kabushiki-gaisha) designed the *Malacca-Max* super oil

tanker. According to Levinson, if built, this tanker would be a quarter mile long and one-hundred-ninety feet wide, descend sixty-five feet below the water line, and could carry nine thousand standard containers—enough to fill a sixty-eight-mile line of trucks. Regardless of whether this super shipper is ever built, there's no arguing that advanced capitalism would not be possible without the container box, which transformed the loosely integrated economy of the nineteenth century into the vertically integrated corporate structure of the late twentieth and twenty-first.

Before we move on from shipping containers to the architectural form of the box—namely, the skyscraper—a brief interlude in the form of a few compelling ideas that bring the forms together. LOT/EK, a New York–based architect team, and Containercity.com of London have each designed rooftop additions and apartment interiors and complexes made from shipping containers for a sophisticated urban clientele. Artist Marjetica Potrc has proposed similar structures situated on rooftops as an alternative to the typical shanty dwelling. In 2004 Australian architect Peter Ryan designed a collapsible cardboard house that could be rapidly shipped to disaster areas in shipping containers. Officials in Sumatra, Thailand, and East Timor are considering ordering Ryan's cardboard house not only for disaster zones, but for student housing and eco-tourism.

The architectural adaptation of shipping containers and boxes, though clearly attuned to current recycling trends, also follows established inclinations in modern architecture, in particular, the propensity to house humans in boxlike structures. Among the architects who best demonstrate this urge is Louis Sullivan, who was lured to Chicago after it burned to the ground in 1871, stimulating a building boom that saw the city's population triple to 1,098,570 by 1893.[9] Albeit famous as a proponent of the decorative treatment of skyscrapers, Sullivan would be inextricably associated with the rise of the stripped down, steel-skeleton modern skyscraper, which was an extraordinarily efficient place to house hundreds of thousands of newcomers on a newly articulated gridiron (see fig. 0.2). Sullivan saw the innovation

210

objectively, coining the phrase "form follows function" in an 1896 poem so resonant it is worth quoting in full:

> It is the pervading law of all things organic and inorganic,
> Of all things physical and metaphysical,
> Of all things human and all things super-human,
> Of all true manifestations of the head,
> Of the heart, of the soul,
> That the life is recognizable in its expression,
> That form ever follows function. This is the law.[10]

While for Sullivan this form included decorative elements, the blank facades of full-blown modernist skyscrapers abandoned virtually all forms of surface ornamentation, favoring, instead, an engineering aesthetic. This reduction to apparently pure, functional exterior form reflected the human activity that went on inside, where work and leisure were organized around mass production and efficiency. Indeed, the skyscraper embodied and serviced a newly modernized work life, creative life, and psychological existence for urban dwellers.[11] The advent of stenography, for example, created ample new business opportunities for women, whose appearance in professional settings contributed substantially to the equation of skyscrapers with new social and professional norms.[12] (In the interest of modesty and efficiency, women were often required to work in open, easily observed spaces.) (See fig. 0.3.) Skyscrapers were more broadly a symbol of a modern lifestyle. Architectural writer Thomas Bender has argued that New York's skyscraper enthralled businessmen, who found in it "for themselves and for others a culture that looked like their group values writ large."[13]

The French modernist architect Le Corbusier equals or exceeds Sullivan as a proponent of the skyscraper—at least in theory. Corbusier designed vast, interconnected, imaginary cities that would house millions in utopian, high-efficiency "machines for living," replacing rundown old cities like Paris. In his Ville Contemporaine urban plan,

211

a cluster of sixty-story, steel-framed skyscrapers would be linked by a highly rational circulatory system of integrated roadways. Inside the towers, domestic and work spaces were designed for living and working. The spirit and the body would be cultivated in nearby parkland accessible by mass transit and automobile. Gigantic glass curtains would frame the towering skyscrapers, erasing the distinction between public and private life. This glass curtain form is most famously associated with the post–World War II skyscrapers of fellow modernist Ludwig Mies van der Rohe, whose Seagram Building New York (1957) resembles an upended shipping container rendered in glass.

Building on a tradition of logic widely associated with Jean Jacques Rousseau,[14] both architects made transparency fundamental to their work. Transparency of materials and the flooding of light into carefully grid planned interiors symbolized the dual process of enlightenment and the apparent rationalization of everyday life. That architectural form has social consequences was deeply embedded in Le Corbusier's famous dictum of 1923 that "It is a question of building that is at the root of social unrest today: architecture or revolution." In the tract called "Architecture or Revolution" he proposed that the new built form would result in a reduction in crime and of revolutionary fervor by stoking the worker's deep satisfaction in this newly modernized, ultratransparent urban space.[15] This space would be ultraefficient, appropriate to mechanization, a concept summarized handily in Mies's phrase, "Less is more."

In *Discipline and Punish: The Birth of the Prison,* French philosopher Michel Foucault takes a more sinister view of transparency, analyzing the widespread societal ramifications of the revolutionary eighteenth-century designs of Jeremy Bentham's prison architecture, the panopticon.[16] The panopticon is a tower set in the center of a ring of cells from which a guard perpetually observes a prisoner—or at least the prisoner never knows whether he is being observed or not, and thus effectively feels *always* under observation. Foucault likens this state of imprisoned transparency to the everyday experience of increasingly pervasive surveillance. Le Corbusier's failures were not

only fodder for theory: the massive public housing developments and modern high rises devised the world over in his wake, such as Chicago's infamous Cabrini Green public housing project, made real-life, boxed human beings anything but satisfied.

While parts of cities were designed for this efficiency, the full-scale utopian skyscraper cities imagined by Corbusier and other modernists never came to be. Whatever design limitations these models have, and they are substantial, the loss is nevertheless palpable. Such cities might have resulted in a decrease in automobile pollution or increased land and wildlife protection. Instead, the human needs for mobility, community, privacy, and stylistic and environmental diversity that were widely disregarded by modernist architects have led many to reject the high density associated with high-rise living. The comforts of suburban and exurban development are amply evidenced by sprawl. Architectural historian Robert Bruegmann has demonstrated that the tendency to enjoy the economic and cultural benefits of a city while living elsewhere is a historic and not particularly modern phenomenon, as is often supposed.[17] Sprawl did, however, pick up pace as modern mass transit and home mortgages made individual home ownership available to the middle class.

At the time of their appearance in the 1880s and 1890s, skyscrapers dominated America's image of itself as a leading player in the machine age. Within a few decades, the dystopian vision of the city as corporate city-state in the 1927 film *Metropolis* prevailed. A year after Fritz Lang's masterpiece, a lesser-known but equally pointed cultural critique of the skyscraper came along: Sophie Treadwell's play *Machinal* portrays the mental decline of a female office worker at the mercy of a skyscraper. As art historian Merrill Schleier writes, "In *Machinal,* the skyscraper extends beyond the boundaries of the physical office space to encompass living quarters, leisure activities, and modes of travel, resulting in the virtual *skyscraperization* of the life of the main character, Young Woman. Mediation and regulation by the skyscraper also occurs at the bodily level, infiltrating her comportment, gestures, speech patterns, sexuality, and, finally, her

213

psyche."[18] Feminist historian Angel Kwolek-Folland has argued that "greater specialization and its accompanying spatial arrangements were thought to promote greater efficiency by expunging work of all superfluous gestures, detail and distractions."[19] Functionality, it could be said, is a mechanical value system that when imposed on organic people can have severe consequences.

Architects and critics Robert Venturi, Denise Scott Brown, and Steven Izenour famously argued against the plain, functional box in their 1972 book *Learning from Las Vegas: The Forgotten Symbolism of Architectural Form.* As they point out, all buildings are boxes of a sort, but the history of architecture proffers buildings as symbols—cathedrals, civic buildings, and regional architectures symbolizing and instantiating the social order. For them, the buildings made in the form of symbols (a duck-shaped building for a duck store) and the decorated boxes (sheds) of the Las Vegas strip offered symbolic richness and formal diversity missing from the purified surface of the modernist container for living. They argue "that architecture depends in its perception and creation on past experience and emotional association and that these symbolic and representational elements often be contradictory to the form, structure and program with which they combine in the same building." [20] They continue in terms of the depletion of symbolic association in the universalizing modernist box: "The forms of modernist architecture have been created by architects and analyzed by critics largely in terms of their perceptual qualities and at the expense of their symbolic meanings derived from association."[21]

Recent popular fiction and film continues this connection between modernist architecture, disassociation, and social collapse. Isaac Asimov's 1950 book *I, Robot,* for example, in its 2006 film remake version, extends the overdetermined model of rational efficiency and Cartesian spatial control to the artificial intelligence of the building itself, as if the miscalculated ideals of skyscraper architects were perversely translated into the soul of the building. The film details how the U.S. Robotic Company is taken over by the central computer,

VIKI, or Virtual Interactive Kinetic Intelligence. VIKI is housed in corporate headquarters in a skyscraper that looms over Detroit. The year is 2005, and VIKI has determined that people are too self-destructive to run their own world. (The film takes place beside a dried-up lake bed that was Lake Michigan, once among the planet's largest sources of fresh water.) So she turns the company robots against the human beings. Significantly for our purposes, the robots are housed in a field of stacked shipping containers, from which they emerge to protect the skyscraper that houses the mother brain. The embodiments of the shipping container and the skyscraper are thus better able to sustain survival than the self-serving human being.

Critical of the exploitative habits of the mechanized world, engineer and philosopher Buckminster Fuller theorized an oppositional

9.4
Buckminster Fuller Geodesic dome building Expo '67 (Montreal). Photo: Norman Pogson/ www.shutterstock.com.

"general law of total synergetical structuring" that flourished in his geodesic dome designs. Fuller's first geodesic grid attempted a substitution of the post-and-beam or steel thrust architectures of the box. Instead, Fuller proposed an isotropic vector system based on tensile, synergetical structures. The Montreal Biosphere, first exhibited at Expo '67, is his best-known built dome. Though the dome is extraordinarily strong, the design never caught on as widely as Fuller hoped. He anticipated that it would solve the postwar housing crisis. Although curvilinear architecture has gained traction today, Fuller's domes were, at the time, perhaps, too weirdly futuristic for the more conventionally domestic taste of the generation that had survived the war. They were also inefficient within the gridiron city form, since corner spaces would not be occupied. While we might ascribe to Fuller messianic and utopian tendencies, the curved grids of his geodesic domes resonate with critiques of the skyscraper and the gridiron made fifty years later.

Like Fuller, contemporary architect Ken Yeang has criticized contemporary architecture for languishing in the modernist box-based skyscraper mode: "Their basic planning remains the same. Whether in concrete or in steel, most are still nothing more than a series of stacked trays piled homogenously and vertically one on top of the other, while at the same time seeking to optimize net-to-gross efficiencies…. The consequence is a damaging and alienating form of high-rise existence for their inhabitants, that ultimately only expeditiously satisfies the real estate developer's financial return on his investment."[22] Writing from Malaysia, one of the most rapidly developing urban areas in the world, Yeang has proposed an alternative: complex, open-mesh vertical buildings that incorporate parks and irregularly shaped living spaces. Yeang's method is admittedly, even desirably, inefficient, if by efficient we mean only a short-term return on financial investment.

The box, in all its apparent efficiency, has served not only architecture but the nonfunctional art of painting. In other words, even art for art's sake has made good use of the utilitarian box. Two major art

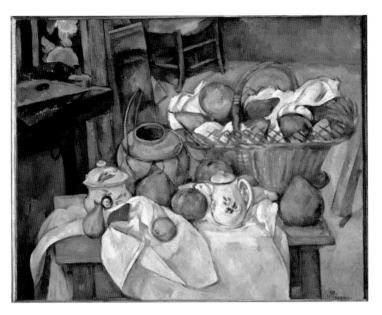

9.5
Paul Cézanne, *Still Life with Fruit Basket,* 1888–1890. Oil on canvas, 65 × 81 cm. Photo: Erich Lessing/Art Resource, New York. Musee d'Orsay, Paris, France.

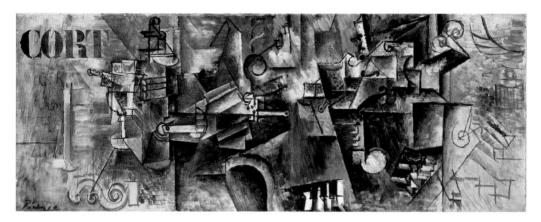

9.6
Pablo Picasso, *Bottle, Absinthe Glass, Fan, Pipe, Violin and Clarinet on a Piano*, 1911–1912. Oil on canvas, 50 × 130 cm. Photo by Jens Ziehe. Photo credit: Bildarchiv Preussischer Kulturbesitz/Art Resource, New York. Nationalgalerie, Museum Berggruen, Staatliche Museen zu Berlin, Berlin, Germany. © 2009 Estate of Pablo Picasso/Artists Rights Society (ARS), New York.

movements of the early twentieth century in fact relied on it. When Paul Cézanne (1839–1906) advised painters to "treat nature by the cylinder, the sphere, the cone," he might have included the cube. By Cézanne's reasoning, a tree can be seen most accurately if it is treated geometrically like a cylinder, apples and human heads like spheres, and mountains like large, lumbering cones. Manmade artifacts, by contrast, often take the form of the cube. In the background of his *Still Life with Fruit Basket* (1888–1890), for instance, the side view of a chair, table corner, and cupboard establish a geometric field of cubical corner forms that is the "other" to nature's platonic solids, the rounded forms of the cylinder, sphere, and cone that make up the fruit basket in the foreground. Cézanne was interested in how human binocular vision, which produces two slightly different views of each form, could adapt itself to the recognition of painted forms in space. The slightly shifting focal points of his paintings are thoroughly visible, here in the table edges that do not line up and in the disjunctive edge of the cabinet. This shifting focal point fractures the grid; the image is no longer regulated by the relationship between a grid and the diminishing orthogonal lines associated with the screen of perspective painting.

Cézanne's geometric solids and multiple focal points suggested new possibilities in picture-making to Georges Braque and Pablo

Picasso, who between 1907 and 1914 launched the movement we know as cubism (from the epithet critic Louis Vauxelles bestowed: "bizarre cubiques"). The legacy from Cézanne is clear: a variety of shapes is reduced to a narrow range of geometric forms, which are then depicted from many perspectives at once. In cubist images like Picasso's *Bottle, Absinthe Glass, Fan, Pipe, Violin and Clarinet on the Piano* (1911–1912), the titular subjects are so fractured and abstracted they resemble shattered glass. Though cubism's initial viewers recoiled at the novel style, cubism was not an effort to irritate. French philosopher Henri Bergson suggested that representing three dimensions on a two-dimensional plane best emulates the experience of walking around an object: "Once in possession of the form of space, [the] mind uses it like a net with meshes that can be made and unmade at will, which, thrown over matter, divides it as the needs of our action demand. Thus, the space of our geometry and the spatiality of things are mutually engendered by the reciprocal action and reaction of two terms that are essentially the same, but which move each in the direction inverse of the other."[23] Given the geometrical complexity of cubism, it should come as no surprise that Braque and Picasso were familiar with some of the theories of the famous mathematician of four-dimensional geometry, Henri Poincaré, through their friendship with another mathematician, Maurice Princet.[24]

The influence of cubism on the art of the twentieth century can scarcely be overstated, and the effect was not only visual. For some, the shattered cubist surface suggested political commentary, representing a world on the brink of destruction. For others, the objective analysis of painterly space suggested a movement toward full-blown abstraction. Russian Suprematist painter Kazimir Malevich's *Black Square* (1913–1915) exemplifies this modernist impulse. Entirely black and unabashedly flat, it marked the total closure of the box of perspective. After Malevich, many painters have followed, making black squares, white grids, and rectangular color fields. In the 1950s and 1960s, German painter Joseph Albers paid "Homage to the Square" in a series of paintings of colored squares nested one inside the next. In the following decades, American painter Agnes Martin rendered

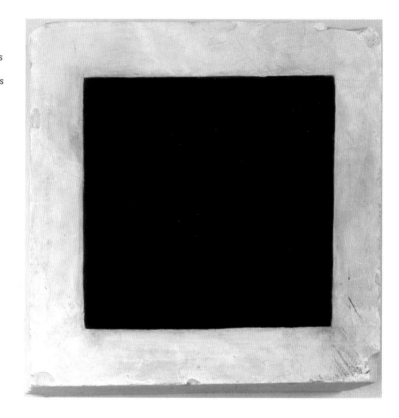

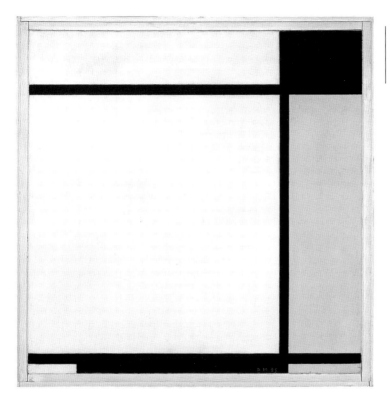

works that were no more than pencil-line grids on white canvas. The list could go on.

Theories on why modernist painters exchanged the perspectival box for a flat surface abound. In 1954 the American art critic Clement Greenberg proclaimed that "pictorial space has lost its 'inside' and become all 'outside.'"[25] The chief characteristic of modern painting, according to Greenberg, was flatness, because flatness was inherent to painting and distinguished it from the other arts. Here he drew from the German "aesthetician" Gotthold Ephraim Lessing, who in an influential 1766 essay distinguished between the arts of poetry and painting: "painting employs wholly different signs or means of imitation from poetry, the one using forms and colors in space, the other articulate sounds in time."[26] Rejecting all temporal references, painterly flatness necessitates both a radical separation of space and time and eradication of all nonpainterly values such as narrative, illusion, and perspective. By this argument—Greenberg's highly influential one—painting would progress to the ever greater abstraction, flatness, and purity associated with the purified picture plane.

In her paradigmatic "Grids" essay referenced in this book's introduction, art historian Rosalind Krauss emphasized the flattening and geometric function of the closed box of modernism. Hers is among the most articulate of modernist critics' attitudes toward the painterly grid: "The grid states the autonomy of the realm of art … flattened, geometricized, ordered."[27] The Dutch painter Piet Mondrian's work is among the most vivid articulations of the grid by an artist and appears, initially at least, to be consistent with this view. In his emblematic grid paintings, Mondrian marks the plane with a few horizontal and vertical lines that seem to be utterly removed from the world of objects, thoroughly denying the third dimension and apparently guaranteeing Krauss's "autonomy" of the object. Significantly, this autonomy requires that nothing is happening in the picture, no matter how abstract. The ultimate grid picture appears as an image of pure space as opposed to events in time.

However, even the flattest modernist form is dynamic, things change as we view them, and we often assign meaning even to abstract forms. As American philosopher John Dewey's description of looking at a checkerboard suggests: "The squares run now vertically, now horizontally, now in one diagonal, now in another."[28] Dewey could well be looking at a painting by Mondrian. Doing so prompts a destabilized and shifting experience of pulsating square voids and quadrilateral planes that hover, slide, and twist. In time, the edges of the black lines swell and flex in a choreography of convex and concave pulsations that stretch and bend the fields they contain. The fields, in turn, seem to push and pull from the surface's gridded lattice that seeks to contain them. Far from the geometricized, ordered, and merely flat surface proposed by Krauss, in other words, Mondrian's paintings engender temporal retinal interference patterns and a state of radical flux. Is it not, therefore, justifiable to describe his modernist grids as representations of time as much as space, no matter how that undermines the orthodoxy of both modernist and postmodernist critics? Indeed, Mondrian described his boxy grids in just these terms: "The rhythm of relations of color and size makes the absolute appear in the relativity of time and space."[29]

The preponderance of the box-module grid in both visual art and architecture, it turns out, is not a natural progression toward purity, as Greenberg and Krauss would have had it. Recent research has shown that it stems from a direct source: the broad program of early childhood education instituted by German education reformer Friedrich Froebel's kindergarten curriculum. Based on encounters across the senses of sight, touch, and sound, kindergarten came into popularity in the 1890s. Mondrian, Paul Klee, Wassily Kandinsky, Corbusier, George Santayana, Buckminster Fuller, and Frank Lloyd Wright were all educated in the Froebel kindergarten tradition.[30] The impact of this education is both vast and specific. Even allowing for the fetishization of childhood by modern artists positioning themselves as unsullied visionaries, the linkage to the kindergarten desk

223

reveals elemental aspects of modern form. Wright describes the desk in prescient terms:

> I sat at the little kindergarten table-top ruled by lines about four inches apart each way making four inch squares: and, among other things, played upon these "unit lines" with the square (cube), the circle (sphere) and the triangle (tetrahedron or tripod).... The virtue of all this lay in the awakening of the child-mind to the rhythmic structure in nature—giving the child the sense of innate cause-and-effect otherwise far beyond child comprehension. I soon became susceptible to constructive pattern evolving in everything I saw. I learned to see this way and, when I did, I did not care to draw casual incidentals of Nature. I wanted to "design."[31]

Wright's awakening to form, while indicative of a distillation of all nature to geometry, includes the emphatic realization that he had found a "constructive pattern evolving in everything," indicating a multidimensional, even interdisciplinary, sense of design—all stimulated by a kindergarten desk!

Froebel's kindergarten curriculum comprised two mirrored processes that evoked the evolution and articulation of geometric forms in one, two, three, and four dimensions: the giving of "gifts" from the teacher to the student, and the giving of "occupations" from the student in return. Gifts were impressions of the outside world transformed into inner geometric concepts. They moved from the concrete to the abstract. Occupations moved from the abstract back to the concrete, as students translated geometric concepts into outer expressions, including design.[32] The first gift, which was given at birth, consisted of six colored balls of yarn, each a color of the light spectrum. When rolled across the gridded kindergarten desk or between players, the balls would indicate axes or force lines. The balls of yarn were also explicitly symbolic of celestial bodies.

After the first gift, color was withdrawn from all subsequent gifts, to focus attention on form. In a grouping of forms that is reminiscent

of Cézanne, the second gift involved only a cone, a cube, and a sphere, which would be moved over the desk surface to explore what Froebel called the "parallelogram planar point-system," a term that suggests both geometric crystal growth and vector motion studies. The former would be particularly important for Wright and for Mondrian, whose repeated forms suggest crystals. The final occupation of the kindergarten curriculum came full circle, so to speak: the student was given a lump of clay and asked to form a perfect, solid sphere. From there, students were off and running, ready to incorporate all of embodying and embodied geometries into their worldview. A book-length study of the relationship between modernism and Froebel's curriculum, not to mention the progressive education of John Dewey and Maria Montessori, is clearly necessary.

Perhaps the best-known artist to engage with the box as such is American Joseph Cornell, who is often associated with Surrealism because of the psychologically suggestive imagery found in his boxes. However, when Alfred Barr, first director of the Museum of Modern Art, invited Cornell to participate in the *Fantastic Art, Dada, Surrealism* exhibition of 1937, Cornell responded that he saw himself as an American Constructivist, not a Surrealist. One gallery owner of this period, John Bernard Meyers, who visited Cornell's studio, said he "had everything on the wall, and all the boxes on the shelves. The way Mondrian composed."[33] Though the geometry of Mondrian seems like a far cry from the wide range of objects Cornell culled from the libraries, newsstands, flea markets, and junk shops of Manhattan, when assembled, the objects form a tight symbolic system suggesting what art historian Lindsay Blair has called a "gravitational pull that holds all things in place" and "establishes order for the universe."[34]

Cornell's *Roses des vent* (1942–1953) includes twenty-one compasses ("roses") hinged at the top against partial maps of New Guinea and Australia. The compass needles move slightly with floor vibrations, suggesting a world of ever shifting orientations that explicitly rejects any stable notion of space associated with Mercator's map projections, with the Cartesian space of the screen, or with Newton's modern

226

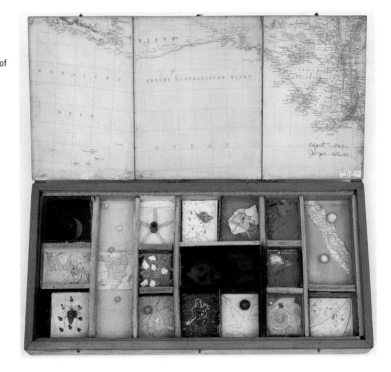

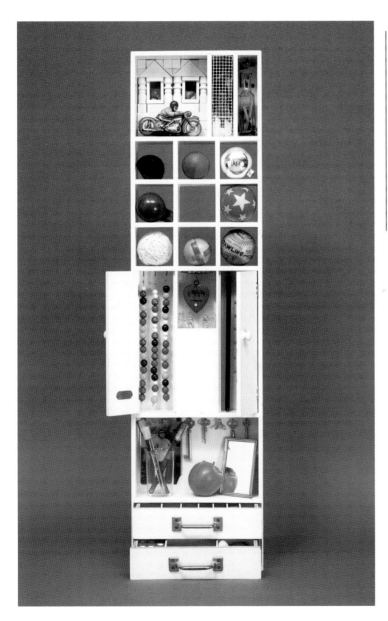

227

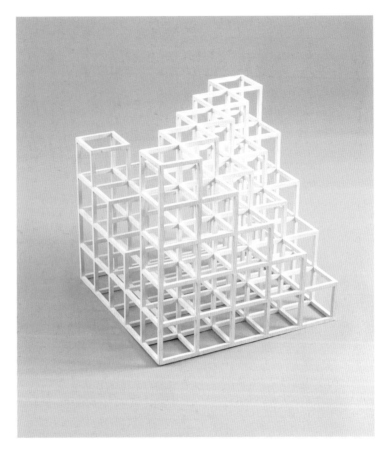

9.11
Sol LeWitt, *Cubic Construction:
Digital 4,* opposite corners 1 and 4,
1971, Painted wood. 24½ × 24¼ ×
24¼". The Riklis Collection of McCrory
Corporation. Digital image © The
Museum of Modern Art/Licensed by
SCALA/Art Resource, New York.
The Museum of Modern Art, New
York, U.S.A. © 2009 The LeWitt Estate/
Artists Rights Society (ARS),
New York.

mechanical universe in general. Cornell repeatedly changed the materials inside the box over many years, further suggesting a container of overlapping temporal functions: memory, global time, and physical change in a box. Instead of producing a gridwork that changed visually through the process of retinal fatigue, as in Mondrian, Cornell's *Roses des vent* actually changed.

Even so, Cornell's careful organization of his contents gives the boxes a resolved quality that is unique among ambitious art of this period. The boxes have been both riffed on and criticized as nostalgic. When Fluxus artists George Brecht and Robert Watts responded to Cornell by making boxes of their own, for example, they would, according to art historian Benjamin Buchloh, "foreground the accumulation of objects over the mere mapping of the painterly surface by the grid structure of the found crate."[35] Brecht's *Repository* (1961), for example, contains an assortment of balls (tennis, plastic, rubber, and baseball) and other small objects (pocket watch, bottle caps, toothbrushes, and a plastic persimmon). At least until they entered the museum, these items remained accessible for examination: things could be pulled out and put back into the box. Thus this work displays what Buchloh has described as the opposite of Cornell's "contemplative passivity," namely, "performative enactment, one where object and subject would suddenly appear as equal actors."[36] Brecht's box, in other words, is far from passive container; it is more like the Froebel object.

Whereas Brecht's *Repository* celebrates the multisensory life of the grid, modernist critics argued against the idea of "performative enactment" described by Buchloh. In his famous 1967 article "Art and Objecthood," for example, Michael Fried condemned minimalism for its "theatricality."[37] Despite its refined appearance, minimalist sculpture was seen as an assault on aesthetic experience because its modular construction broke up the singularity of aesthetic experience associated with absorptive viewing. Even as the work of Sol LeWitt clearly affirms the values of the modernist box as a container and rationalizer of abstracted space, it was viewed by modernist art critics like Fried and Greenberg as opposed to media purity and the aesthetic

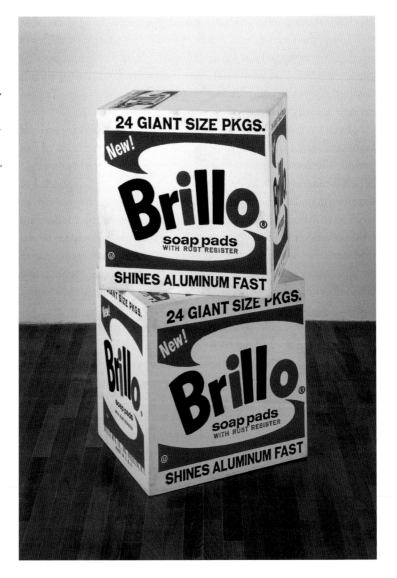

values of fine art. In terms that express just this state of affairs, but from a postmodern standpoint, Krauss highlighted its objectivity in her assessment of LeWitt: "The diorama of analytic sensibility, the grid, forever leaves the viewer outside looking in."[38] As expressions of the box, however, it is difficult to pry apart the modern from the postmodern, since minimalist sculpture so closely resembles the shelves of container buildings that they could be seen as skeletal images of the container.

If LeWitt offers a three-dimensional, nonfunctional image of the container along modernist lines, it could be said that Andy Warhol's famous *Brillo Boxes* of 1964 emphasize the apparent utility of the commodity that would fill it. These boxes, duplicates of actual Brillo soap pad packaging, have been called the first major artwork of postmodernism.[39] As almost seamless reproductions of the manufactured box, they extend the complex distribution logic of the manufactured box to the art object. Pop art has been interpreted as both a democratizing intervention of everyday materials into the elite art world and a banal affirmation of consumer values.[40] With Warhol, it is both: the emergence of the branded commodity of the early twentieth century has been embraced by the art world. Not surprisingly, the *Brillo Boxes* were a favorite among the titans of industry who represent the majority of contemporary art collectors.

Danish artist Eric Andersen has also taken on the box, but in a different mode. His 1990 installation *Opus 90* began as a homely pile of boxes, a three-dimensional spread of cubes evocative of minimalist sculpture. *Opus 90* was simultaneously kinesthetic and spatial: visitors moved around the boxes, which were later suspended from the ceiling by mechanical lift so that one could peer inside and see the small contents swimming in an excess of space inside each box: a toy, a key, a glass, a stuffed animal—objects evoking the imprint of their owners, as well as commerce and manufacture. In Andersen's hands, the postminimalist box has extended beyond its abstract association with absolute or empty space, or even manufacture, becoming instead a node in spacetime. Rather than the homogenized box of commodity

9.13
Eric Andersen, *Opus 90*. A four-dimensional voyage through a phase of an ever-changing artwork. The Royal Museum of Fine Arts, Copenhagen, May 1990. Photo by Sisse Jarner. Reproduced with the permission of Eric Andersen.

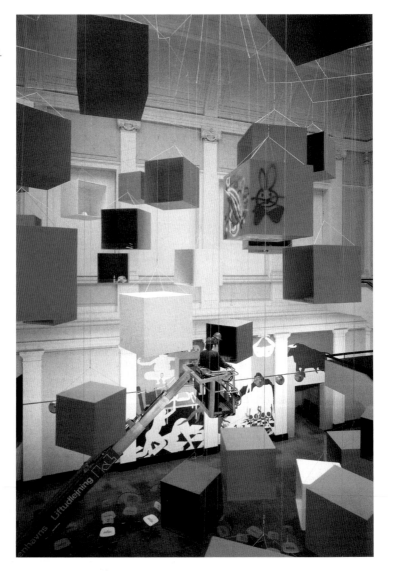

culture, Andersen offers the box in all its potentiality: it can go anywhere, hold anything, and be transformed into anything imaginable.

Opus 90 reminds us of the common observation that a child presented with an expensive new toy becomes quickly bored with it and plays instead with the box it came in. The bigger the box, the better. The comic strip character Calvin, of Bill Watterson's *Calvin and Hobbes* comic strip, transforms himself by stepping into a simple cardboard box, the "transmogrifier," to be "whatever you'd like to be"—an eel, a baboon, a giant bug, a dinosaur, and a stuffed tiger are all possibilities. The box effects change by shuffling up the molecules of the human body. Rather than packaging a finished product, as boxes do in the adult world, the transmogrifier box creates something new. It also works as a time machine, effecting a temporal shift that substitutes for the change in place normally associated with the shipping function of the box.

Clearly, boxes express innumerable imaginative possibilities. The playtime association with the cardboard box is so potent that one was added to the National Toy Hall of Fame in Rochester, New York, in 2005, suggesting that we have witnessed a fundamental shift in how the box reads as a cultural symbol. Even as large-scale container shipping demonstrates a kind of apotheosis of the box, the humble cardboard box has come to roost in the imaginary, as a symbol of transformation and time travel. One wonders whether the cardboard box bears so much resemblance to the "idiot box" of television or the "smart box" of the computer—functionally the same box—that it has come to stand for the entertainment and information that those plastic boxes have brought into our daily lives.

10 NETWORK 1970

LET'S BEGIN WITH THE OBVIOUS. A net is a textile whose crossed fibers are knotted at the intersections, forming a pliable grid of squared spaces that can be used to snare fish or fowl and to hold things like groceries or hairdos. By definition, what a net contains is larger than the spaces of its grid; a minnow will slip through a net made for catching trout. Another key characteristic of the net is its adherence to form: the net stretches and shapes itself around the objects it contains, creating a physical, visible articulation that specifies each curve, edge, or planar shift of the object. When a net holds a fish, for instance, we see over its scaly surface a geometric pattern that spreads where the fish's volume swells and compresses where it narrows. The appeal of the fishnet stocking depends on this feature, emphasizing the calf muscles and ankles by translating them into greater and smaller squares. The 3-D computer graphics that articulate planar shifts exploit this same variable-module aspect of the net.

Nets have two interrelated physical characteristics: there is the size and space of their modules, and there is the structure of strings that delineate these modules and interconnect the whole nodal system of strings. It is this second characteristic that we associate with the contemporary understanding of "network," a ubiquitous image

that permeates our scientific, economic, and social worlds. To cite just one example: recent research suggests that obesity, smoking, and depression do not arise independently, but result from social networks in which each individual represents a thread in a continuum of highly influential relationships. In the words of Albert-Laszlo Barabasi, a physics professor from the University of Notre Dame, "In the past few years we have been seeing a network revolution…. People sensed that networks were out there, but they never had large enough data sets to start understanding them in quantitative fashion."[1] Indeed, getting a fix on social networks is overwhelming, for they involve "you, your family, your friends, your friends' friends and your friends' friends' friends," and grow exponentially.[2] But as technological networks—the World Wide Web, for instance—grow ever more powerful, quantitative comprehension is increasingly within reach. Social, global, and digital networks are examples of *the* emergent, definitive grid of the present—and it all began with the ancient form of the hand-woven net.

Willow nets were made in Stone Age Finland as early as the eighth millennium BCE and have been found in Stone Age Europe, Central Asia, Peru, Lithuania, and Estonia dating to 6000 BCE.[3] The most common fibers for ancient nets, however, are flax and hemp. Flax was domesticated in Iran and Iraq by 5000 BCE, and spread to Syria, Egypt, Switzerland, and Germany by 3000 BCE. Domesticated hemp had a similarly itinerant run at about the same time, spreading from Central Asia east to northern China and north to Switzerland and Germany. Interlace netting, which closely resembles woven cloth and is sometimes called "false weaving," consists of an over–under action of a "warp" string held under tension and a "weft" string inserted across it. (Woven fabric evolved from the net, losing the knots along the way. Fabric is held together by the friction and tensile pressure of threads held at right angles in an over–under weave.) Warp-weighted looms using stone weights first appeared in about 6000 BCE in Hungary, and fully evolved Egyptian and Mesopotamian horizontal ground looms date to just before 3000 BCE and spread northeast

across Europe over the course of two thousand years. Given this expansive movement across the world, it is peculiar that nets and textiles are almost entirely absent from general world histories, which tend to emphasize military might and industry: guns, germs, and steel determine "the fate of human societies," by one recent account.[4]

An important exception to the lowly status of the net and the textile in writing world history is the well-known role that a secondary feature, their trade, has played in the development of global trade networks. Even the best-made cloths are prone to breaking down, which means that cloth must be ever replenished through manufacture or trade. The Phoenicians—who sailed the Atlantic coast from northern Africa to Spain trading wool yarn, dyes, and textiles—dominated world trade from 1700 BCE to the first millennium BCE. Mycenaean culture collapsed and the textile trade died down around 800 BCE, when Greek colonization spread murex (a blue, shellfish-based dye) north up the Adriatic coast to Italy and Sicily. By 750 BCE, an extensive textile trade stretched across the Mediterranean, incorporating many civilizations, from the Levant north to Anatolia, and linking Syria to Palestine and southern Mesopotamia. In short, the extraordinary usefulness of the pliable grid of woven textiles to wrap, clothe, contain, and protect was instrumental in establishing international trade networks. Indeed, the commercial development of virtually every ancient civilization was either directly or indirectly associated with the textile trade. Further, the textile trade networks that blanketed civilization, forming a grid themselves, necessitated the invention of maps, the ledger, and block printing, for example—to name just a few of the other grids that have propelled technological and cultural dispersion.

The Persian Empire, which dominated the middle sixth to middle fourth century BCE, built the first superlong roadway (1,700 miles) to facilitate the trade network incorporating the many cultures they controlled from Macedonia in the west to the Indus Valley in the east, from Uzbekistan in the north to much of Assyria in the south. The materials and technology for weaving Chinese silks, made

on mechanical foot treadle looms since the eighteenth century BCE, had moved along the famous Silk Road to the Mediterranean by the first century BCE. The Persian roadway would eventually be incorporated into the much larger Silk Road network, which linked the east and west when warfare or peacekeeping permitted. Venetian explorer Marco Polo would detail the lives of the many cultures dispersed along the Silk Road in his *Il Milione* (1299).

Given the centrality of the textile trade to economies of the early modern period, it is not surprising that technological innovations in weaving became a bellwether for changes to manufacture associated with the burgeoning Industrial Revolution. The first half of the eighteenth century would see the registry of many British patents for textile manufacturing technologies, including the flying shuttle, the roller spinning machine, the flyer-and-bobbin system, the cotton carding machine, and the water-driven textile mill. These innovations quickened yarn production, produced more uniform yarns, and increased the productivity of a single loom operator tenfold. They also resulted in labor displacement to industrial towns and cities, where factories rather than domestic workplaces prevailed. And this in turn led to social unrest throughout England, as the cottage-based weaving industry and guild system transformed into a modern, industrial factory system. The United States of course has its own story of exploiting this new technology and those who would power it: with its supply of cotton and slave labor, the U.S. produced textiles of equal quality at substantially lower cost.

The most important invention for the industrialization of the textile trade—the punched card loom, invented by Joseph Marie Jacquard in 1801—not only creates a gridded product, but takes the form of a grid itself. Holes punched in cards inserted into the loom allow or disallow the threading of needles, called Bolus hooks, through them. The needles then raise and lower harnesses carrying warp threads above or below the weft to form a given pattern. Various cards with different sets of holes can create complex images such as flowers, vines, and wildlife. In addition to these design capacities,

punched card looms could be programmed to produce vast amounts of cloth quickly. What once required the skills of a master weaver working laboriously by hand now required only a loom operator and assistant working with preprogrammed cards. While Jacquard punch cards largely supplanted the creative craft of hand weaving, they also prompted a fundamental shift in the conceptualization of information that would much later play a role in the invention of the computer.

The adaptation of the punch card to information technology was suggested, however, quite soon after Jacquard's invention, by Charles Babbage, a British mathematician and economist. Building on the table-making legacy of the French Baron Gaspard de Prony, who "conceived . . . to manufacture logarithms as one manufactures pins," Babbage saw the numerical patterning of Jacquard's card loom as a model for producing the standardized functions of a mathematical computing machine.[5] He designed his "difference" and "analytic"

calculating machines between 1820 and 1846, the first of which was limited in scope to producing mathematical tables and the second of which was expanded to include any mathematical computation, including logarithms. Because of funding shortfalls, the second machine was never completed, although the Difference Engine on permanent display at London's Science Museum still works. Babbage was completely forgotten until the 1930s. Ada Byron Lovelace, daughter of the British poet Byron and namesake of the Ada programming language, identified the connection between the two technologies from the start, describing in 1843 how "the Analytic Engine weaves algebraic patterns just as the Jacquard loom weaves flowers and leaves."[6] Her analogy has endured: the language of computing frequently invokes textiles—consider the programming fabric, the Internet, and the World Wide Web.

The punch card, then, is the mechanism of transition between the soft grids of textile technology and the hardware of the information age; it translates the net from its physical expression in textiles to a modeling form that would tabulate, sort, and integrate. Babbage's analytic engine would use loops of Jacquard's punched cards to control a mechanical calculator, suggesting the tiered hierarchy of data, information, and knowledge that we see today in modern computing and knowledge management. His proposed analytic engine structured numerical data in physical form (Jacquard cards) that could be tied together in strings to form relationships (information), whose patterns belong to the greater field of mathematical knowledge, in his case logarithms.

Jacquard cards inspired not only Babbage's invention; they ended up having many other adaptive functions. They fueled player pianos, for instance, with each data hole determining the playing of a key. They served as early ID cards–*cum*–train tickets, recording a passenger's name, gender, age, hair color, eye color, height, and weight. After traveling west with one of these "punch card photographs," economist and mathematician Herman Hollerith devised the idea of utilizing them to administer the U.S. census of 1890. Recording information gathered by census takers, seven hundred mechanical punch card

machines punched over sixty-two million cards, one per resident. One hundred census machines then read these cards, each as efficient as twenty human tallying clerks. Like the Jacquard loom, the punch card readers gathered information from the cards using pins, in this case 288 of them, each spring-loaded. Where there was no hole, the pin retracted and had no effect. Where it went through a hole, it would dip into a mercury cup, completing an electrical circuit that sent a pulse to one of forty counters and adding a positive tally.[7] Whereas the census of 1880 was recorded by hand on twenty-one thousand pages and took seven years to count, with Hollerith's system the count took only two-and-a-half years and ushered in the era of mechanized information processing.[8]

The census machine could count, but it could not calculate. That innovation would fall to James Ritty of Cincinnati, Ohio, who invented the cash register in 1879. Ritty was bought out by a coal man, John H. Patterson, who founded the National Cash Register Company (NCR) in 1884. In 1911 Patterson fired his top salesman, Thomas J. Watson, who in turn became president of the Computing Tabulating Recording Company (CTR), and purchased Hollerith's patent on his census machines. Applying these to commercial, calculating use, and apparently sensing a global wave of interest, CTR changed its name to International Business Machines (IBM) in 1924.

10.2
Computer punch-card, circa 1970. Photo: Graeme Dawes/ www.shutterstock.com.

Leasing out punch card machines to corporations, IBM made a fortune selling punch cards at only a fraction of a dollar per thousand. By the 1930s, they were selling three billion cards a year. With their seemingly random series of holes punched on the grid, IBM cards became emblematic of the era of mainframe computers and a new, radically disembodied kind of information that today we call data.

The first large-scale automatic digital computer capable of mathematical functions was the result of a collaboration between Harvard University and IBM, which hoped to expand into a new area that would combine office machine technology with complex calculating. By the 1930s British scientist John Comrie of the British Nautical Almanac Office was using punch cards to determine the position of the moon, which gave Harvard University's E. W. Brown an idea: he returned from a 1937 trip to England determined to use punch card machines in scientific computation. At about the same time, Howard Hathaway Aiken, a physics researcher at Harvard, suggested building a large-scale digital calculator for the physics department. While he was looking for funding, a physics lab technician asked Aiken "why in the world I wanted to do anything like this in the Physics Laboratory, because we already had such a machine and nobody ever used it."[9] As it turned out, Babbage's son, Henry, had donated a fragment from Babbage's difference engine to Harvard in 1886. It sat in the attic of the Harvard Physics building, unbeknownst to Aiken and his colleagues for fifty years. Aiken, who had never heard of Babbage, picked up his torch.

Discovering that IBM held the Hollerith punch card patents that would fit Babbage's machine, Aiken sought funding from IBM for his "Automatic Sequence Controlled Calculator," and the company got on board. Better known as the Harvard Mark I, the first fully automatic programmable electromechanical computer was built between 1937 and 1944, with the help of engineers from IBM.[10] Harvard University's Grace Hopper programmed it using hole-punched paper tape loops resembling a string of connected IBM cards. Later machines would return to stacks of punch cards. Rather than merely counting and

tabulating like an adding machine or census taker, the Mark I could compute nonlinear equations, albeit slowly: three additions or subtractions took one second; a multiplication problem took six seconds; and a trigonometric function or logarithm took more than one minute. Although slow and limited to strict mathematical computations, the Mark I was the first fully electromechanical calculating machine that could execute long computations automatically, a milestone that was heralded at an inauguration event on August 7, 1944. What would have been a proud moment turned sour, however, when Aiken took full credit for the machine, neglecting to mention the engineers and funding of IBM. This slight sparked the competitive edge that would spawn the next generation of IBM computers.

Simultaneous with the drive to mechanize mathematical calculations came an interest in broader scientific applications of mechanical devices based on physical models. Since these models were physically analogous to the object of study, they are associated with the birth of so-called analog computing. In 1876 Lord Kelvin, of transatlantic cable fame, invented a tide-predicting machine whose springs, gears, and wires simulated the gravitational forces affecting the oceans, for example. By the 1920s scientists made analog models of the quickly growing U.S. power grid. According to computer historians, "These laboratory models consisted of circuits of resistors, capacitors, and inductors that emulated the electronic characteristics of the giant networks in the real world."[11] They could be quite large and complex: the AC Network Calculator built at MIT in 1930 occupied an entire twenty-foot-long room.

Vannevar Bush, an instructor in electrical engineering at MIT, made a breakthrough in general computing between 1928 and 1931. His differential analyzer addressed an entire class of engineering problems in which equations require calculating two or more variables—motions, pressures, temperatures, and so on. Differential analyzers were built in the 1930s at MIT, at General Electric's plant in Schenectady, New York, at Manchester University in England, at Oslo University in Norway, and at the Moore School of Electrical Engineering at the

243

University of Pennsylvania. With its differential analyzer, the Moore School computed firing tables for U.S. Ballistics Research in nearby Maryland, calculating the effects of wind, heat, and terrain on old and new weapons slated for the war effort, so that field soldiers could determine accurate firing angles for various conditions.

The Moore School's computational interests were not limited to weaponry, however. It was here that the first modern digital computer was invented. This benchmark machine, the Electronic Numerical Integrator and Computer (ENIAC), was built by John Mauchly and Presper Eckert in 1946.[12] ENIAC was very fast: it could perform 5,000 operations per second. Mauchly and Eckert's initial designs contained flaws, however, which became evident almost immediately. ENIAC had very limited storage in its oscillating electronic tubes. Worse, perhaps, it had to be hand-programmed for every problem set. Using a switchboard system of patch cords, it would take days or even weeks to reprogram for a new set of equations. John von Neumann, the youngest member of the Institute for Advanced Study at Princeton University and a colleague of Einstein's, solved both the storage and programming problems. A year before ENIAC came along, von Neumann had designed what became known as "stored program architecture," which dominates computer programming to this day. This architecture was introduced to the Electronic Discrete Variable Computer (EDVAC), the next generation of machine after ENIAC, and one that would finally launch the modern computer into full viability.

The key element of von Neumann's architecture is that both the program and the data can be stored and manipulated in a common memory, as historian Paul Ceruzzi describes: "The basic cycle of a von Neumann computer is to transfer an instruction from the store to the processor, decode that instruction, and execute it, using data retrieved from that same store or already present in the processor. Once the processor executed an instruction, it fetched, decoded, and executed another, from the very next position in memory unless directed elsewhere.... This concept, of fetching and then executing a

linear stream of instructions, is the most lasting [influence] of all."[13] Equally importantly, von Neumann understood that both numbers and programs could be stored as lists of binary code, an iteration of complex qualities that differentiates on the basis of patterns among just two terms. When we are watching a film from the *Matrix* series, which began in 1999, and we see a screen filled with a grid of equally spaced ones and zeroes, we are looking at von Neumann's architecture. The binary system had been introduced by Newton's rival, German mathematician Gottfried Wilhelm Leibniz, in his 1705 article "Explication of Binary Arithmetic." Applied by von Neumann to computing, the implications were vast.

Clearly, a grid principle is at work here: picture that *Matrix* screen, with its gridded network of code. The von Neumann architecture is a grid that forms the very core of modern information technology. As with the other grids described throughout this book, it is an organized set of modules that allows for manipulation and creativity, making new kinds of searching (data retrieval) and connection building (programming) possible. In the *Matrix,* it is as complex as reality; indeed, it is impossible to tell the difference. When anyone dismisses an idea as mere "binary logic," they have missed the point. Where binary thinking in the colloquial sense suggests reducing the complexity of the world to two terms, in fact the patterns of binary code are highly adaptive and no more *inherently* reductive than, say, alphabets, images, or a musical score. From the simple warp and weft of a mathematically conceived binary loom to the ones and zeros of computational code, any manner of unique patterns or forms can be woven.

By the late 1940s and 1950s, competition in the emerging computer industry was fierce and often well funded. In the United States at this time over thirty different companies vied for supremacy in this promising market. Eckert and Mauchly left the Moore School in 1946 to establish the Eckert-Mauchly Computer Corporation, which later merged with Remington Rand. After persuading the Bureau of the Census to buy a computer that they had not yet invented, they began work on the Universal Automatic Computer (UNIVAC), which

they completed in 1951. The UNIVAC system used vacuum tubes and magnetic tape for storage, rather than millions of punched cards. Its great advantage was in being a single, if large and expensive, system—an all-purpose machine rather than a collection of devices (hole-punching machines, cards, and readers). It was only a year before IBM responded with the 701, a similar stored-program computer it described as an "electronic data processing machine." A decade later, in 1962, IBM followed up with the 1401, the mature mainframe system that dominated the market (in various forms) until the late 1970s.

Computer memory through the 1960s was held for the most part on metal and plastic tape and rotating magnetic drums. Even though the data on these materials did not resemble a grid as much as the punched holes on cards, computer memory itself can be understood as a gridwork. Computer memory is made up of cells, each of which has an address, much as if it were located on a gridiron. These cells hold a number sequence of a predetermined amount and are therefore, like the cells of grids generally, of uniform size. A program might read, for example, "place the number 456 into cell number 7890" or "add the number in 7890 to the one found in 2345." The program directs the translation of these number-units back into a communicable form of text, number, or image. In most computers each cell of memory holds binary numbers in groups of eight bits (called a byte). These bytes each represent 256 different numbers. Computers today often hold trillions of bytes of memory and can search through them very quickly for the patterns contained in a given memory cell.

For human beings, however, creating the binary codes that make up the bytes is of course prohibitively painstaking. Computer pioneer Grace Hopper, the programmer of the Harvard Mark I, first suggested an automatic programming system that could translate human directions into binary code. Her suggestion led to three inventions: the Formula Translator (FORTRAN), by John Backus for the IBM 704 computer in 1957; the Common Business Oriented Language (COBOL), in which Hopper was instrumental in 1960; and the Beginner's All Purpose Symbolic Instruction Code (BASIC) in 1964. Heralded as the

first general-purpose high-level programming language, FORTRAN allowed nonprofessional users to program the computer automatically, using symbols that looked like regular algebra.

With programming in the hands of a range of individual users, applications for computers expanded dramatically. Single-purpose computers, an adding machine, say, were developed for a single task. General-purpose computing required that computer hardware be adaptable to multiple tasks. Thus along came sets of instructions we now call software, the development of which has progressed radically in the last forty years. FORTRAN made another important advance possible: with the help of a translating machine, it could work on any computer, so that organizations using different systems could communicate. It is this adaptability that makes the information networks associated with modern computing work. FORTRAN and its followers made the computer accessible to and functional for not just MIT mathematicians and specialized programmers, but everyone from administrators to artists.

New or unorthodox computer use would take time to emerge, of course—and some special promotional efforts. In the early 1960s, for example, despite the conventional association of mainframes with large-scale business, retail sales, government contracts, and the military, several companies developed relationships with artists in an effort to see how computers could be adapted to the visual and performing arts.[14] Among the best-known of the early experimenters was Billy Klüver, an employee of Bell Labs who collaborated with artists using new technologies and in 1966 founded the famous Experiments in Art and Technology (EAT) along with Robert Rauschenberg and others. As a resident composer at Bell Labs, James Tenney organized a casual workshop for artists in 1966 that was attended by the composer Steve Reich, Dick Higgins and Alison Knowles of Fluxus, and Nam June Paik, who would invent video art and the video synthesizer. Full disclosure: Knowles and Higgins are my parents. With this seminar, the new modeling of information in bytes and code was given over to a community of artists for the first time in the United States, though

247

there were parallel developments in Stuttgart and London. Despite their relative obscurity in the commercial art world, which places a premium on the sale of unique art objects, the experimental artists who took part in these early research and development programs are the founders of digital art.

Knowles's *House of Dust* was generated by computer in 1967—with the help of Tenney and FORTRAN. This early computerized process-poem consisted of four lists beginning with "a house of," followed by a material, a site or situation, a list of lighting options, and a list of potential inhabitants. The computer was instructed to list every possible combination as a quatrain. When the work first ran at the Brooklyn Polytechnic Institute, there were four hundred quatrains generated before a repetition occurred. Here are a few examples:

A house of dust
on open ground
lighted by natural light
inhabited by friends and enemies.

A house of wood,
under water,
using natural light,
inhabited by friends.

A house of leaves
in a metropolis
using all available lighting
inhabited by all races of men represented wearing predominantly
 red clothing.

A house of roots
in an overpopulated area
using electricity
inhabited by horses and birds.[15]

Writing about this poem, art historian Benjamin Buchloh has noted, "Knowles has succeeded in constructing an extreme opposition between the (involuntary?) poetics of her choices and the anonymous and aleatory, yet totally deterministic and controlling principles of their electronic permutations…. Every element redefines every other element as the result of a perpetually shifting set of mutual and modular relationships."[16] Subject to constant change, digital poetry diverts language from its association with the "choices" of a single speaker or narrative thread and makes it modular. Written text in the digital age has changed fundamentally; we now routinely parse language into modular elements—the emoticons that indicate happiness and sadness, for instance, or telephone texting phrases where letters stand for clusters of words such as "lol" for "laugh out loud." The *House of Dust* portended as much. This early example of digital poetry speaks to how computer languages have transformed written language, imposing qualities of modularity and manipulability that are, of course, central features of all grids.

As the programming of Knowles's poem by Tenney demonstrates, the universal language of FORTRAN was not universal in practice: it required a level of expertise beyond that of the general public. BASIC, however, was designed specifically for undergraduates and nonexperts and was, comparatively speaking, user-friendly. Regardless, programming time on mainframe computers was very expensive. This roadblock would be cleared as, over time, computers became smaller, cheaper, and faster, leading to the 1975 roll out of the Altair 8800, the first computer cheap enough to be purchased widely. Entrepreneurs followed, founding hundreds of startups developing hardware and software in the San Francisco outskirts now known as Silicon Valley. The most famous of these entrepreneurs, Bill Gates and Paul Allen, cofounded Micro-Soft (the hyphen was later dropped) in 1975. Stephen Wozniak and Steve Jobs founded Apple the same year.

By 1984 Apple's Macintosh had arrived, rendering all other personal computers instantly old-fashioned with its user-friendly graphic interface. The IBM compatible Microsoft Windows 95 program

adopted a similar graphic interface. The personal computer entered homes and classrooms in droves, where it would function from then on as a replacement for the typewriter, the calculator, and the board game. Ironically, perhaps, the user-friendly interface of clickable mice and prompts, paperclip characters, bold pop-ups, and absorptive 3-D "windows" obscures the information architecture of binary numbers and standardized byte-sizes that is the grid basis for the digital era. It is easy to forget that the desktop computer is an endpoint in a grid-based history that extends back through mainframes to von Neumann architecture to the Jacquard loom and to Babbage's calculating machines.

But of course the desktop computer was not *the* endpoint. Despite the noteworthy innovation of bringing word and data processing into the home, these early desktop computers were isolated. Linking computers—and their likeminded users—to one another in a global network would come next. (This is not to say that the idea of joining remote minds hadn't occurred to anyone before: the artist Ray Johnson, for example, conceived of his 1950s mail art as an "eternal network" of correspondent-collaborators.[17]) The seed of today's Internet can be found in a 1960 proposal by J. C. R. Licklider of the Advanced Research Project Agency (ARPA) for a geographically distributed network of computers. Titled "Man-Computer Symbiosis" Licklider's proposal prophetically reads: "It seems reasonable to envision, for a time ten or fifteen years hence, a 'thinking center' that will incorporate the functions of present-day libraries together with anticipated advances in information storage and retrieval.... The picture readily enlarges itself into a network of such centers, connected to one another by wide band communication lines and to individual users by leased-wire services."[18]

By 1970 Larry Roberts from ARPA and an anarchic team of graduate students from UCLA, UC Santa Barbara, the University of Utah, and the Stanford Research Institute had produced the first computer network—connecting just four nodes. A year later, twenty-three computer centers had joined the ARPA network, now known as ARPANET.

ARPA presented the project to the scientific community in 1972 at the first International Conference on Computer Communications (ICCC) in Washington. A thousand delegates from around the world could interact with distant databases at MIT, the University of California, and Paris using forty computers. Following the idea of a universal library, the emphasis was on research: databases, meteorological models, interactive graphics, and air traffic simulators were among the activities. By 1975 the number of nodes on the ARPANET system had grown to 111. By 1983 the Internet Protocol (IP) was developed to facilitate communications on the Internet using IP "addresses."

It was not research but electronic mail that would send the Internet into the public sphere. Although e-mail was never a major emphasis in the design of ARPANET, by 1991 there were 35,000 nodes and millions of subscribers to the Usenet e-mail spin-off of ARPANET. By the late 1980s whole documents could be exchanged this way, although this activity was, like e-mail, largely unanticipated. In 1990 the first search engine, Archie, was developed at McGill University. In 1989 and 1990 British computer scientist Tim Berners-Lee and Belgian collaborator Robert Cailliau married pattern-seeking hypertext, which creates links from one document to another through specific words, to the Internet. This allowed the delivery of hypertext documents over the Internet. They gave their project a grandiose, though ultimately not unwarranted, name: the World Wide Web.

The growth of the World Wide Web coincided with the invention of the Mosaic browser by an undergraduate, Marc Andreessen, at the National Center for Supercomputer Applications (NCSA) at the University of Illinois at Urbana-Champaign. Mosaic could be produced for PC, Macintosh, and Unix workstations and was very easily downloaded onto those previously isolated home computers. Like other browsers that would follow, it allowed individual users a unified visual experience when viewing Web pages. In 1994 Andreessen's Mosaic Communications Corporation was launched with venture capital from computer entrepreneur, Jim Clark. Changing the corporation's name to Netscape, Clark and Andreessen made the browser

251

10.3
Three-dimensional conceptualization
of Internet architecture, 2008.
Photo: Sebastian Kaulitzki/
www.shutterstock.com.

free to noncommercial users, grabbing the majority of the market share. Not to be outdone, Microsoft licensed the original software, which UIUC had leased to a company called Spyglass, renamed it Internet Explorer, and bundled it with Windows 95.

With the advent of browsers, the modules of binary code associated with von Neumann's stored program architecture could be transported across the world, building a global communications network. Perhaps this grounding in the terminology of architecture and programming addresses explains how this World Wide Web has been visualized: in popular representations it resembles nothing so much as an ethereal, boundary-free city of skyscrapers interconnected by planar forms that echo back to the orthogonals of perspective. The interconnectedness of these forms illustrates the emergent concept of grid computing: they appear completely open to one another.

Although browsers could connect individual users to external Web pages, they could not link the internal systems of individual computers to one another. This is where "grid computing" comes in. Grid computing enables distributed computers access to one another's data. Like electrical grids and railways, it requires an integrated, homogenized infrastructure. Toward this end, a group of programmers associated with the Global Grid Forum (GGF) developed Open Grid Services Architecture (OGSA) in 2002. As the name suggests, OGSA establishes a community standard of protocols that are ushering in the equivalent of a single, giant, global supercomputer existing within and through every individual home or office computer.

Shared virtual systems show enormous promise. They could bring entire industries into common communication, vastly increasing productivity. Cost-efficiency is also at stake: grid-based computers would be able to borrow or buy memory, power, and data on demand for the task at hand. Applications on the grid are being developed for a coordinated worldwide telescope, a biomedical informatics research network, a distributed network for earthquake engineering, numerous virtual universities and, of course, more multiplayer computer games.[19] Larry Smarr, the founding director of the National

Center for Supercomputing Applications at the University of Illinois at Urbana-Champaign, has argued that grid computing can provide a multidisciplinary research means for addressing environmental change: "Although society is becoming politically ready to deal with large-scale environmental problems such as ozone depletion, global warming and air and water pollution, researchers are lagging in creating trusted interactive knowledge bases that integrate all known science about these issues. Given the multidisciplinary nature of such problems, it is clear that to gather all the experts needed to study the problem, we will need the Grid.... Researchers should be able to work in a collaborative computational framework that links researchers and remote sensors with the Grid, allowing for the integration of much more detailed models of chemical, biological, and physical effects."[20]

By this account the emerging virtual organizations of the multi-computer grid system constitute a kind of intellectual public utility on a mass scale. Smarr emphasizes that individual relationships with the utility can be "small or large, short- or long-lived, single or multi-institutional, and homogeneous or heterogeneous." What's more, "resource sharing is often conditional: each resource owner makes resources available subject to constraints on when, where, and what can be done."[21] Assurances of conditional constraints take on another kind of urgency in the realm of personal information, however. In an era of eroding rights to privacy, the degree of global data integration might give one pause. In 2007 the *New York Times* reported that China Public Security Technology is producing security cards that will coordinate personal information (from landlord phone numbers to reproductive history) using global positioning systems and a range of conventional and real-time databases. It will be illegal not to carry one's card at all times, effecting an eery circumstance where personal contact and movement can be tracked and matched up against all existing databases. According to the *Times,* "Security experts describe China's plans as the world's largest effort to meld cutting-edge computer technology with police work to track the

activities of a population and fight crime." But, they acknowledge, the technology "can be used to violate civil rights."[22]

For better or for worse, grid computing constitutes a paradigm shift not only in the world of computers, but in everyday life, as Ian Foster and Carl Kesselman, the designated "fathers" of grid computing, note: "Coordinated resource sharing and problem solving in dynamic, multi-institutional virtual organizations … support our social structures and the way work gets done in our society."[23] In other words, like every grid form described in this book, grid computing is reconfiguring society in its own image. Grid computing coordinates complex and diverse information into a vast global knowledge network. How this network will affect our daily lives, how we work and play, and how we conduct research about ourselves and our environment, remains to be seen. It is clear, however, that the networking of information begun with the expansion of binary code constitutes an integrated view of society with vast, multidimensional applications. Ian Foster's definitive pronouncement suggests as much: "Grids are not flat."[24]

AFTERWORD
TOWARD FRACTIONAL DIMENSIONS

THE EXPERIENCE OF CHAOS AS CHAOS REQUIRES AN ORGANIZING PRINCIPLE, a frame of reference through which it is perceived as chaotic relative to something that is not. What's less chaotic than the standard, orderly, ordering grid? In contrast, that which is experienced as chaos could portend an emergent but not yet schematized grid, a decomposing grid, a twisted grid, the interaction of one grid with another, or a truly chaotic circumstance. My concluding remarks are concerned with nonquadrilateral, apparently chaotic grids embedded deep within nature. These grids are hidden inside Sir Isaac Newton's study of force vectors, for instance, and within the geometry of Albert Einstein's spacetime. Likewise, Benoit Mandelbrot's fractal geometry, an account of which ends our history of the grid, multiplies and complicates both what counts as a grid and the degree to which even the most seemingly pure grids can be reconceptualized—breaking open the one, two, three, and four dimensions we normally use to map our world.

We'll begin with Newton's force vector. In Leonardo da Vinci's drawing of a cannon firing, the smooth metal balls arc up, cross some ground, drop down, and hit the ground, followed by a low bounce. The next cannonball also bounces and perhaps hits other cannonballs,

which ricochet off in various directions. The drawing shows dozens of such cannonballs in action all at once—arcing, crashing, making little sparks, and bouncing off the ground and each other. Taken at face value, this is the very image of chaos. But the drawing doesn't show what the human eye cannot see: the underlying causes of this display—the combination of explosive and gravitational forces that are propelling the cannonballs in the first place. What our diagrammed tumble of cannon fire provides, in other words, is an image of the aftereffects of invisible energies acting in concert. These curve-inducing energies do not make up a grid. They are, however, measured and drawn using combinations of straight lines, called vectors, that *do* make up a grid—a grid that is fundamental to our basic understanding of the physical laws of the universe.

In geometry, a vector is a line that has both a direction, indicated by an arrow, and a magnitude, indicated by its length. Force vectors describe how a physical body moves from point *a* to point *b* at a given speed. Newton's discovery of force vectors, which were seemingly absolute in their predictive aspects, made it possible to measure and predict the movement not only of objects on Earth but of planetary orbits. This projection from the mathematics of force vectors into the heavens emerged gradually in the sixteenth and seventeenth

centuries, prompting the invention of classical mechanics as well as the geometric view of the solar system. In opposition to the long-held belief that the planets and stars were held in place by a series of nesting spheres, in *Mathematical Principles* (1687) Newton described a three-dimensional solar system as constant, enduring space coordinated by fixed points of length, breadth and depth that provided the geometric field in which force was measured or seen (see fig. 7.4).

It wasn't until 1919 that Albert Einstein would evoke his theory of relativity to counter Newton: "It is neither the point in space, nor the instant in time, at which something happens that has physical reality, but only the event itself."[1] With the advent of relativity, we could say, the Newtonian field of absolute space was reengineered on the model of time such that each event is made up of *momentarily* related pieces of reality. No longer could time be an independent coordinate that flows through static space.[2] Instead, the coordinated nature of each event occurring in a fixed spacetime interval is an occurrence in a new, combined structure of relative space and time, where both are affected by mass. Functionally, it is as if absolute space, the fixed cube of points that make up the measurable Newtonian universe, had become a large, three-dimensional rubber sheet that stretched space and time in accordance with the effect of mass. The coordinates of the grid still apply, but only relatively.[3]

259

11.2
Spacetime curvature, created by User: Johnstone using a 3D CAD software package and an image of planet Earth from NASA's *Galileo* spacecraft, n.d. (http://en.wikipedia .org/wiki/Image:Spacetime_ curvature.png).

Since human beings are fundamentally limited in our sensory perceptions by a sense of space and that benefits our physical survival, how might we imagine a spacetime universe? Is spacetime travel possible if the diachronic march of time through space is an illusion necessitated by our physical body's need to eat, sleep, and reproduce? Is it possible, if space can fold, for example, for some things to be in two places at one "time"—which appears to happen routinely at the subatomic scale? The mathematician Henri Poincaré described a way to visualize this four-dimensional universe in terms suggestive to those interested in visualizing this new world: "Imagine that the different perspectives of one and the same object succeed one another," he advised, as if cycling through four-dimensional slices of the universe.[4]

Clearly, spacetime throws into doubt all of our assumptions about the realism of the perspective screen, the reality of the orthogonal map, and the absolute space enclosed in the manufactured box. Since the advent of spacetime, one can no longer speak intelligently about either the realism of perspective or the absolute reality of the visible world which perspective made a pretense of representing. Neither can assumptions be made about the exclusively spatial or temporal nature of any artistic medium—as many proponents of modernism would attempt. In a spacetime world, one dimension, two, three, and four are merely relative, each knowable only in abstract terms through the dimension succeeding it. We use two dimensions (a plane or sheet of paper) to see one (a line), three dimensions (a cube) to draw the line and point, four dimensions (time) to understand three (as we move around a cube, a line, and a point) and a fifth (spacetime) to understand space and time.

The impact of the concept of spacetime on modern art, music, architecture, and poetry was profound.[5] To take one example: the French artist Marcel Duchamp applied Poincaré's logic to his watershed painting *Nude Descending a Staircase, No. 2* of 1912. The painting shows a cubist nude (offering different views of the same object) at carefully paced moments in her descent (offering different moments in time). The resulting multiplicity of spacetime intervals is perhaps

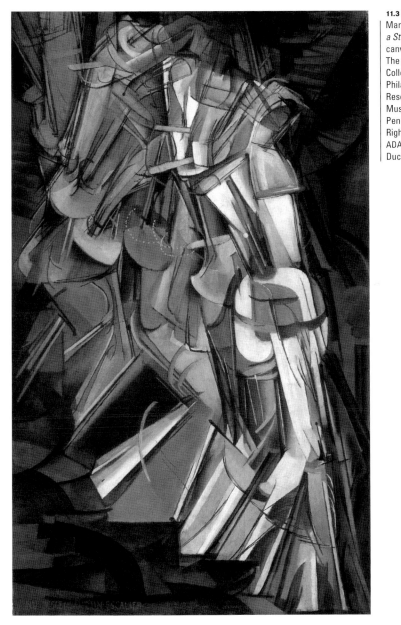

11.3
Marcel Duchamp, *Nude Descending
a Staircase, No. 2*, 1912. Oil on
canvas, 57⅛ × 35⅛" (148 × 89.2 cm).
The Louis and Walter Arensberg
Collection, 1950. Photo: The
Philadelphia Museum of Art/Art
Resource, New York. Philadelphia
Museum of Art, Philadelphia,
Pennsylvania, U.S.A. © 2009 Artists
Rights Society (ARS), New York/
ADAGP, Paris/Succession Marcel
Duchamp.

261

easiest to envision by using the full frontal figure as a reference point: we see a rotation from front at the upper left to profile moving diagonally across to the right and bottom of the image. That there is a clear geometric order to the image is beyond a doubt: the nude is made of regular shards that fill a rectilinear field adapted across the surface of the image to an underlying gridwork of expanding and shrinking spacetime intervals.

With the rise of Fascism in Europe in the period leading up to World War II, many of the major figures associated with ambitious culture in science and the arts in Europe, including both Albert Einstein and Marcel Duchamp, emigrated to the United States, along with artists and architects from the German Bauhaus school, which closed in 1933. Several figures associated with the Bauhaus, including the painter Josef Albers, converged on a small college outside of Asheville, North Carolina, Black Mountain College, where they conducted a series of artistic experiments during the summer programs between 1948 and 1952. Merce Cunningham, for example, first formed his dance company here, John Cage developed the basis for his musical form of "silence," Rauschenberg produced his all-white canvases, and the engineer and philosopher Buckminster Fuller built his first geodesic dome. Cunningham, Cage, Rauschenberg, and Fuller were all present at the summer program in 1948. All were friends.

Fuller had met Einstein in 1936 and was sufficiently comfortable with relativity theory to share it with his friends in the art world. Fuller's idea that the "universe of total man experience may not be simultaneously recollected and reconsidered, but may be subdivided into a plurality of locally tunable event foci or 'points'" is fundamentally consistent with the event interval view of the world theorized by relativity.[6] Rauschenberg's 1952 white painting, whose formal content consisted simply of the shadows that fell on it, could be described in similar terms—as "a plurality of locally tunable events." Indeed, in 1908 Einstein's teacher and subsequent collaborator, Hermann Minkovski, unpacked some of the most important implications of Einstein's special theory in a way that resonates with this painting.

"Henceforth space by itself, and time by itself," he wrote, "are doomed to fade away into mere shadows, and only a kind of union of the two will preserve an independent reality."[7] The white canvas, which at its most reductive could be seen as the closed box of modernist painting, is by this account more real than any image ever made: it makes a display of the "mere shadows" of things in the space of the physical world *as shadows,* while at the same time allowing for the reality of their constant transformation in spacetime.

Immediately following his experience with these paintings, Cage wrote his famous *4′ 33″* of silence. In his book *Silence,* Cage notes a fundamental similarity between the way in which the white paintings provide a context for the flow of shadows produced by their environment and the way in which *4′ 33″* provides a context for the sonic dimensions of everyday life. It would be a mistake to describe Cage's piece as pure time for the same reason that it is incorrect to describe the white paintings as pure space. Rather, each work addresses spacetime as a sensory-perceptual experience. As Cage has written, "There is no such thing as an empty space or an empty time. There is always something to see, something to hear. In fact, try as we may to make a silence, we cannot. Sounds occur whether intended or not."[8] If in Rauschenberg we see spacetime as space (a painting), Cage's piece might be an occasion for hearing spacetime as time (a piece of music). Rauschenberg's paintings and Cage's composition, in other words, create useful demonstrations in the well-established media of paint and music of a space-based perception of spacetime and time-based perception of spacetime.

When Cage offered a course in music composition at the New School for Social Research in New York in 1958, some of his students picked up on the implications of spacetime thinking. Among these, a young chemist in attendance, George Brecht, began writing performance scores called, appropriately for a spacetime artform, Events. These scores were published by Lithuanian cofounder of the Fluxus movement George Maciunas as an edition of about a hundred Event cards called *Water Yam,* in 1963. From an art-historical perspective,

the visually fractured form of the *Water Yam* cards, which range in size from a sugar packet to a large index card, would be seen in opposition to the unified field of flatness associated with the closed box of modernist painting. Events, however, should be understood not exclusively in relation to the Newtonian world of absolute space that they reject (as antiart), but for the spacetime intervals they instantiate. One particular event, *Two Durations,* is particularly well suited to the matter of spacetime. The score reads simply:

- Red
- Green

As colors, red and green vibrate at different frequencies. The "durations" of the title refers to physical properties viewed through the lens of time. Red and green are also the colors of traffic lights, of course, which choreograph the movement of cars through the urban fabric. Thus *Two Durations* effects a change in how the hitherto stable gridiron of cities appears in the mind of the observer. The entire city becomes animated by the pulse of light and the movement of traffic, effecting a dance of cars in syncopated streams of stopping and going.

Perhaps it comes as no surprise that a new vocabulary for describing spacetime arts would emerge alongside the formal concept of Event art. This terminology was developed by another student in the Cage class, my father, Fluxus artist Dick Higgins, who in 1966 coined the term *intermedia* to describe artwork that falls between media.[9] As he saw it, the separation between media was a product of the Renaissance and modern mechanics:

Much of the best work being produced today seems to fall between media. This is no accident. The concept of the separation between media arose in the renaissance [*sic*]. The idea that a painting is made of paint on canvas or that a sculpture should not be painted seems characteristic of [a] kind of social thought-categorizing and dividing society.... This essentially mechanistic approach continued to be

relevant throughout the first two industrial revolutions, just concluded, and into the present era of automation, which constitutes, in fact, a third industrial revolution.[10]

The concept of intermedia is based on the principle that conventional media extend structurally toward each other. To extend this extension to grids would require that the structures inherent to each of our grids (type, notation, screen, and box, for example) are translatable across their adjacent domains. That structured domains approach each other, however, creates logical problems for the two, three, and four dimensions normally used to define them. For example, whereas a standard illustrated poem consists of a complete text and a separate image (one can read the words or look at the picture), the intermedial composition closely attunes the visual format with the text/score, as in Brecht's Events. This, of course, stands in direct opposition to critical modernism's values of what we could call "whole number media": good painting, prints, and drawing corresponds to the purification of two dimensions, architecture and sculpture to three, music and text to four, and so on.

Where modernism preferred whole number media, it might be said that intermedia is fractional. A score like Brecht's *Two Durations* could be, for example, either a two-and-a-half- or a three-and-a-half-dimensional artwork located between the flat form of painted color and its vibrations (as colors), or between the gridiron and the movement in space and time that streetlights effect in the urban environment. Clearly, the point isn't to try to mechanically pinpoint exactly what the fractional dimension of a given artwork is, since some will experience the work as more or less close to a given dimension based on their own media expertise and proclivities. Rather, the principle of fractional dimensions itself demonstrates the fundamental absurdity of equating particular media categories wholesale with dimensional whole numbers.

Another way to address the issue of fractional dimensions and the movement of ideas between the grid structures associated with

conventional media is through the idea of scaling. At one scale, for instance, a Mondrian looks flat, whereas at another, it offers a bumpy and heavily worked surface full of the markings laid down over the duration of its making (see fig. 9.8). Up close, the surface pulsates, organizing the viewing time of the visitor to the image, whereas from a distance the image becomes flat, evoking a gridiron. The modernist painter Franz Klein, for example, has been celebrated both for painterly flatness and the architectural effects of his large black-barred paintings. Which effect we experience is largely a matter of scaling. Up close, the images feel architectural; from a distance they read as flat, calligraphic strokes. Scaling like this, however, makes for bad modernism, as a result of which the flatness of paintings like Klein's have tended to enjoy greater emphasis since flatness reflects modernism's critical preference. Working across these different experiences of these and similar paintings, however, indicates that the vast majority of artwork is perceptible in fractional dimensions. The "postmedia" art world of the present moment seems to suggest that this evolution is already well established.

Returning to the sequence of ten grids that makes up this book, however, we have seen as much fractioning far before the modern era. One account of the birth of the gridiron, for example, was rooted in the scribal formats of Egyptian record keepers, a scalar expansion of the grid from the tablet to the ground plan, which produced an urban plan consistent with both the bureaucratic nature of Egyptian society and with the scale of the well-established brick-wall grid. Depending on the scale, the gridiron is two-, three-, and four-dimensional as it moves from paper to block to pedestrian and automobile city. Similarly, a ledger projected into the third dimension and at a larger scale could be seen as foundational for the perspective screen and the television, moving it from two to three to four dimensions as well. The scaling of grids across dimensions, or more specifically across dimensions relative to specific scalar viewings, offers a perceptual mechanism for understanding the evolution of those grid forms even when they seem most rooted in whole number media: two, three, and

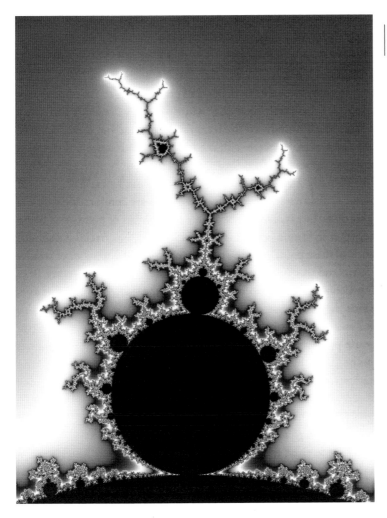

11.4
Classic Mandelbrot fractal, n.d.
Photo: Florin C/www.shutterstock
.com.

four dimensions being associated with painting, sculpture/architecture, and music, respectively, as experienced in the museum, plaza, church, theater, and musical score that establish the conventions of scalar experience.

Recent discoveries in the field of geometry offer a mechanism for exploring these fractional dimensions through the study of fractals. F. Hausdorff introduced the term *fractal* in 1919, but it only entered the cultural mainstream with the celebrated publication of the term and the famous "Mandelbrot Set" in 1975 by Benoit Mandelbrot. Significantly for grids, the term *fractal* comes from "fraction" and refers to fractional dimensions. Most of us are comfortable with the idea that a line is made up of an infinite number of points that blend together to form a "solid" line. However, from the fractal standpoint, each of these points actually consists of an infinite number of smaller points and spaces between them. Therefore, in fractal geometry, lines (by definition made up of points) have the characteristic of curves, since they are made up of the lumps and bumps of points. It also follows that all lines have the quality of being some parts point and some parts space; putting it another way, lines have both infinite points and infinite space. How then do we divide a line or plane into the regular forms that would make up a grid, how do we determine its edge or limit, and how do we assign a specific dimension to each grid as two, three, four, or more dimensional?

Wondering along these lines, Mandelbrot asked famously, "How long is the coast of Britain?" His answer? Infinitely long, because "the typical coastline is irregular and winding and there is no question it is much longer than the straight lines between its end points." Indeed, as the measurer gets closer and closer, he must account for the curved line of an inlet, then the edge of a rock, a piece of sand, and the individual molecule. In other words, "the observed tends to increase without limit."[11] Mandelbrot's object of inquiry, "real length," proves to be elusive. Length is a matter of scaling: it turns out to be a dual function of the distance relationship between the observer and the observed and the process of smoothing out curves to arrive at an

apparently straight line length. Fractal scaling means that the grid in general, like nature, is perceptible only as the result of a relationship between the object and the observer. When Buckminster Fuller writes that "size is not a generalized conceptual principle," this is basically what he means.[12]

Fractal scaling has immense implications for the grid. For example, the flat grid of the modernist box turns out to be highly textured at close proximity while the screen appears flat when reduced to a smaller scale. Though it is not inaccurate to say that a modernist painting is flat from the viewpoint of the typical viewer a few feet away from the image, its flatness should be seen as conditional. One acute analyst of modernism, Charles Harrison, notes as much when he writes that "the non-figurativeness of a painting is always relative."[13] In other words, every mark on the canvas is to varying degrees an act of spatial figuration. A fractal view of modernist painting would emphasize this fact. The flattened grid painting appears flat in comparison to the represented space of academic painting, which is seen at roughly the same scale. Artists, however, often speak of music or sculptural effects in relation to their seemingly flat works—a concern that clearly speaks of physical engagement through multidimensional touch or listening.

Another relationship between fractal and grid is the concept of approximate self-similarity, meaning the resemblance of parts to the whole of a thing. In a linear grid like those discussed in this book, the resemblance between a single square, the circumference of a geometric plane, and a face of the cube could be described as self-similar—each module resembles the whole. In nature, self-similarity would describe, for example, the resemblance between a head of broccoli, a single branch of the floret, and a single bud. Self-similarity is seen in the relationship between the edge of a rocky shoreline and a single rock, storm turbulence and the water vapor hovering over a morning cup of coffee, or a cluster of quartz and a single crystal. Fractals have also been used to describe boundary patterns between systems (coastlines, geological changes, and the exteriors of plants), as well

as branching systems (rivers, plants, and human blood-flow). As described by Nobel laureate physicist Murray Gell-Mann, "Nature apparently resembles itself at different levels."[14] In summary, through the fractal we find that something approximating grids actually exists in nature.

The geometry of this self-resembling is not, however, regular in the Euclidean sense. Mandelbrot wrote that "clouds are not spheres, mountains are not cones, coastlines are not circles, and bark is not smooth, nor does lightning travel in a straight line," a description that pits him against the geometric world view associated with the Euclidean standard of point to line to plane to cube.[15] Unlike spheres, cones, circles, and straight lines, fractals are complex geometric forms that structure much of nature in predictably random ways. In terms that seem to echo the chance elements in spacetime arts in general and especially Cage, Mandelbrot writes, "The most useful fractals involve chance and both their regularities and their irregularities are statistical."[16] Though not grids in the sense of parallel bar forms, in other words, fractals are gridlike in two key ways: (1) they are self-similar; and (2) the whole behaves according to a rule of assembly, albeit one that is regularly irregular, or predictably unpredictable.

There are many kinds of fractals. Here we'll focus on just one—the bubble-cluster variety—though virtually any would have the same astonishing result. Soap bubbles have long been used as models in solving complicated geometric problems because the sphere is the most efficient means of organizing surface tension around a point. If one bubble is introduced to another, the two will meet at the smallest possible surface area based on their size and pressure differences. This proclivity to efficiency creates geometric circumstances fundamental to the statistical irregularity characteristic of the fractal. Imagine you hold a handful of soap bubbles. There are only two possible ways for equal-size bubbles to cluster: three can meet on a smooth curve/line, or six can meet at a vertex. The angles created by the meeting of these equal bubbles will always be 120 degrees per bubble, which corresponds to the regular, six-sided hexagon. (We see this form in

the hexagonal grids of beehives, affording bees the most efficient means of clustering.) Here's the next step: even when the bubbles are of unequal size, and therefore unequal surface tension, their angles will always add up the same way because of the rule of efficiency in bringing the various circles together. Bubbles and beehives are thus two examples of the fractal geometric nature of the world we live in. Albeit distinct from the quadrilateral grids discussed in this book, it follows that fractal geometry has implications for grids and for how humans experience order in the natural world. Fractals may be one way to conceptualize the human predilection for grids and to theorize some fundamental way in which these grids form maps of the human mind.[17]

To wit, in 2005 University of Canterbury astrophysicist David Wiltshire began describing a "fractal bubble universe" that would do away with the idea of dark matter.[18] By his account, this would be a "model universe with only clumped matter at the present epoch, consistent with general relativity and inflation, ... based on a new solution to the problem of averaging lumpy geometries in cosmology." Instead of a universe mysteriously responding to invisible dark matter, he proposes gravitational wells of bubble fractal walls that are, ironically, not so far conceptually from the nested celestial spheres of days of yore. He continues: "The observed universe has an inhomogeneous structure of galaxy clusters on bubble walls surrounding voids. Despite being inhomogeneous, the growth of initial perturbations from primordial inflation provides a particular self-similar fractal structure to this inhomogeneity."[19]

The self-similar fractal structure and inhomogeneity of soap bubbles is nicely illustrated at the human scale in the work of British sculptor Antony Gormley, who has built sculptures that represent the imaginary contact lines of bubbles using small, welded rods.[20] *Ferment*, 2007, for example, consists of a bubble field, part of which makes up a human body that gestures with one arm out and a leg raised toward the back, as if stepping forward. In Gormley's works, the body seems to float in the bubble space that contains it, a union depicted in the

11.5
Antony Gormley, *Ferment,* 2007.
2mm square section stainless steel
bar, 267 × 215 × 116 cm, 42 kg.
Photograph taken by Steve White,
London. © Courtesy of the artist
and Jay Jopling/White Cube.

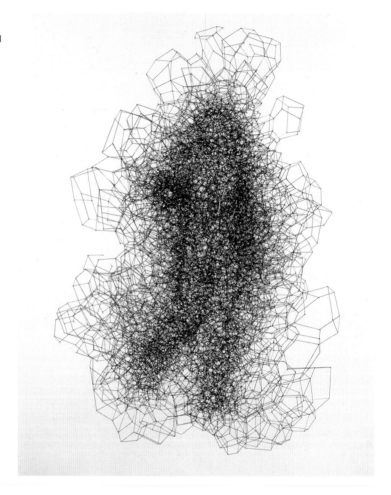

extension of the bubble form beyond the edges of the body and in the irregular surface of the sculpture. In looking at the piece, one is hard put to describe a specific geometric order—no grids here—yet at the same time the work does not feel truly chaotic. Some part of the sense of order is no doubt produced by the combination of bubble patterns with the organizing principle of the human body, a body with whose experience of space we can empathize. The geometrically quasi-regular, adaptive hexagonal grid of bubbles creates a form that is at once strange and familiar—a sort of geometric uncanny. W. J. T. Mitchell has described Gormley's work in similarly embodied terms, extending its primary mathematics to a larger scale. Instead of the boxed grid of clearly delineated inside and outside, he writes that Gormley "draws our bodies inside, physically into environments that invite our bodies to experience the sculptor's work from inside, as if we were pulled into sculpted, drawn, and constructed spaces.... And then it reverses this process by taking us outside."[21]

Among the mechanisms for this reversal of the viewing process is the sculpture's nonrounded outside edge. If the bubbles were performing naturally, there would be a surface made of completed bubble spheres. Rather, at the surface of the sculpture, the viewer is presented with angular meeting points, the lines and corners of invisible but adjacent cells. It is as if the bubble field were expanded to include the viewer. The very outside of the sculpture, in other words, denies its own limit, including the viewer in its bubble fractal geometry. Like the human body, which is both a boundary and a porous continuation of the space that surrounds it, the body–space relationship of *Ferment* is both an affirmation and negation of the boundary between self and other. In this work the fractal grid is revealed as a through-going structure that both permeates and renders distinct the boundaries of the human body.

As described by Mitchell, the work is transdisciplinary in terms that include the fractional dimensions associated with fractal geometry generally and spacetime arts in particular. By Mitchell's account, Gormley offers the viewer "architecture as sculpture as drawing," a

sliding across media that includes the scalar dimensions of each, and can also be seen as "ways of world making."[22] Attenuation among fractional dimensions (signaled by placing the various media on a continuum through the term *as*) is to some extent the result of scalar experience. The taut relationship of intermediate dimensions creates experiences with media that are necessarily permeable; using fractal vision, we see each medium through or as the next.

"Science never saw a ghost," wrote the poet Henry David Thoreau, "nor does it look for any, but it sees everywhere the traces, and it is itself the agent, of a Universal Intelligence."[23] From this one might conjecture that perception is an expression of this Universal Intelligence—one that is foundational to the human mind and that predetermines human experience of the world. Theoretical physicist and neuropsychologist David Bohm suggested as much, though from the perspective that the patterned world predisposes the mind to such systems: "Intelligence does not arise primarily out of thought.... the deep source of intelligence is the unknown and indefinable totality from which all perception originates."[24] Fuller made similar observations, embedding human experience in the translation between individual and external systems: "Life minimally described is 'awareness,' which is inherently plural, for at minimum it consists of the individual system which becomes aware and the first minimum 'otherness' of which it is aware, the otherness being either integrally internal or separately external to the observing system."[25] There are implications for the world of ideas and objects, our built environment, that result from such a transactional view of how art, mind, and nature are at times integrally internal or separately external from the observing system that is our collective environment.

Near the heart of the Chicago Fire of 1871 a working-class and immigrant neighborhood rose up that was, in 1969, reduced again to rubble to make way for the University of Illinois Chicago campus. Walking among the school's tightly organized modernist buildings within the expansive gridiron that is modern Chicago, I am surrounded by

brickwork set in an urban grid with a thick history that goes back to the beginning of this book. These buildings hold published books on all manner of subject. Rooms packed with computer screens are powered by a grid animated by electricity. In the dining and residency halls, music is piped in by a network of carefully calibrated radio stations that cater to student tastes. Food is packaged and sold in standard sizes in vending machines that offer the consumer a glass grid of snacks purveyed by module: press E5 for chips, J7 for a candy bar. Even academic performance is measured on a standard that can be articulated in a few marks as A, B, or C along a vertical axis demarcating each semester and course and printed out on a grid.

It is tempting to see in this world of interconnected grids a kind of authoritarianism of the form. The grid seems to flatten out the world, controlling virtually everything and diminishing the human and social worlds' natural variety. Whether the framework is a brick wall, a gridiron, musical notation, a screen, or a box, its grid is the result of spaced parallel bars broken by another system of spaced parallel bars at such regular intervals as to form a visual lattice and set of standard modules. A framework of spaced parallel bars—the grid seems the very picture of a jail cell! At the most superficial level, each grid described in this book could be said to conform to this association. By this account, the grid of my modern metropolis is a material expression of social control that includes educational, artistic, and penal system alike.

Though there is much to be said for this account as an image of the process of socialization, it often fails at the level of individual experience and adaptive use. Underneath this carefully planned university is a modern tell, a mound of broken buildings and urban substructures that reaches both historically and metaphorically beyond the working-class neighborhood that replaced old Chicago to the prairie pathways that lay beneath pre-fire Chicago. This disarticulated substructure is essential to how the city sees itself, as evidenced in the pastoral emphasis inherent in the O'Leary version of the Chicago Fire. At the university that sits on top of it all, music booms

over the quadrangle in keys and meters that suggest its notation, at the same time as the free harmony and compounded meters associated with the rhetorical-musical hybrid of hip-hop presses hard against standard notation. A radio or MP3 player nearby offers competition, resulting in sometimes cacophonic and occasionally interesting musical layers. Listening, walking, and looking, virtually every sense organ is employed cross-modally in a fractional system of grids. While many of the students I pass on a stroll across campus are eating boxed, packaged meals or food from vending machines, I also see all manner of food brought on their own, which they eat and share while networking, checking e-mail, or surfing the Web with their iPhones and Palm Pilots. How these various grid forms interact and to what purposes they can be put is as varied as human life itself. Indeed, it could be argued that the sheer number of experiences suggested here is to a great extent the result of the simultaneously modular and expansive aspect of how grids are used.

Grids, in other words, should not be seen merely in terms of the spaced, parallel bars with their attendant association with penal codes and social regulatory systems. Each grid has its own texture, uniqueness, individuating features, capacities for creative enactment, and relationship to other grids, as much as each person combines and utilizes a grid for him- or herself. As Ian Foster puts it, "Grids are not flat."[26] They are not physically flat, nor are they experientially flat, nor are they dimensionally pure.

As I hope this book makes clear, each grid has a weave of its own that can be put to the task of reinforcing existing social structures as well as bending them and breaking them apart. The brick wall is a grid surface warmed by palms that produces a sense of permanence as well as its opposite, rubble. Musical notation carries in its forms pieces of ancient rhetorical cues and various orders of time that aligned it with the communicative needs of the Catholic Church but also made possible the inscription of secular song. Even the most ethereal grids of information science and the World Wide Web take cues from ancient nets and networks, simultaneously connecting us

to many publics and demonstrating the impossibility of a universal human experience. All of this complex and multisensory history surrounds us. Grids are therefore as multifeatured as any instrumental component of human life: our rituals, habits, human needs, and sensations take form in the grid even as they deviate from it at the level of individual use. Put another way, each grid has its tell and exists in a constant state of making and unmaking, connecting to other grids and disconnecting from them, as determined by those who use them. That image, music, or text means something or nothing, something and nothing, or many different somethings, in other words, is a matter for the operative grid.

Like grids, human sensory and cognitive frameworks establish a relationship between order and disorder, which is why psychologist Howard Gardner has described human intelligences in the grid-based terminology of "frames" of mind.[27] These frames combine to form a total cognitive and sensory organism made of oriented and orienting systems. Each grid organizes the experience of a particular human sense, and each emergence was a watershed event in Western civilization. From proprioceptive gridirons to musical notation and visual screens, it is clear that virtually every sense organ has its intelligence and that every intelligence has its grid, at least in the West, if by grid we mean systematic, modular, communicable, and adaptable system. As Gardner puts it, "It is through symbols and symbol systems that our present framework, rooted in the psychology of intelligences, can be effectively linked with the concerns of culture…. Symbols pace the royal route from raw intelligences to finished cultures."[28] Far from static or flattened entities, finished cultures create established and emergent symbols and systems of knowledge production and sensation—all of it organized on the lively grid.

NOTES

INTRODUCING GRIDS
A MEDITATION ON MRS. O'LEARY

1 *Chicago Evening Post,* quoted in Robert Cromie, *The Great Chicago Fire* (New York: McGraw Hill, 1963), p. xiv.

2 *Chicago Evening Journal,* in Cromie, p. 24.

3 Rosalind E. Krauss, "Grids," in *The Originality of the Avant-Garde and Other Modernist Myths* (Cambridge, Mass.: MIT Press, 1999), p. 9.

4 Ibid.

5 Claude Lévi-Strauss, *Structural Anthropology,* trans. Claire Jacobson (New York: Basic Books, 1963), p. 224. Special thanks to Stephen Eisenman for reminding me of this reading.

6 Sigmund Freud, "Two Principles of Mental Functioning (1911)," in *The Standard Edition of the Complete Psychological Works of Sigmund Freud,* vol. 12, ed. James Strachey (London: The Hogarth Press and The Institute of Psychoanalysis, 1953–1974), pp. 215–226.

7 Michel Foucault, "The Analytic of Power," in *Power/Knowledge: Selected Interviews and Other Writings, 1972–1977,* ed. Colin Gordon (New York: Pantheon Books, 1980), p. 201.

8 Henri Focillon, *The Life of Forms in Art* (1934; Cambridge, Mass.: MIT Press/Zone Books, 1989).

9 Ibid., p. 149.

10 Ibid., p. 157.

1 BRICK 9000 BCE

1 Paul Good, *Time Sculpture* (Cologne: Walther Koenig Verlag, 2002), p. 92.

2 A comprehensive history of the brick, which served as a source for much of my own research, can be found in James W. P. Campbell and Will Pryce, *Brick: A World History* (London: Thames and Hudson, 2003).

3 See http://www.Çatalhöyük.com, 2004 Archive Report for details.

4 Quoted in Campbell and Pryce, *Brick*, p. 33.

5 See Lawrence Boadt, *Reading the Old Testament* (New York: Paulist Press, 1984), p. 129.

6 E. H. Huntley, *The Divine Proportion: A Study in Mathematical Beauty* (Mineola, N.Y.: Dover, 1999), p. 99.

7 The square base of the building represents the sacred on Earth, the *Kaaba* in Mecca, and the swelling grid of the dome's interior signifies the heavens. The building was also innovative for its solution to the engineering problem of placing an all-brick dome on a square base with the use of a four-arched system of support called *chortak* that was imitated widely in later Islamic monuments.

8 Campbell and Pryce, *Brick,* p. 208.

9 William Morris, "The Revival of Architecture," *Fortnightly Review,* 1888. Available online at http://www.marxists.org/archive/morris/works/1888/revival.htm.

10 William Morris, "The Influence of Building Materials on Architecture," reporter's notes from an undated lecture. Available online at http://www.marxists.org/archive/morris/works/1891/building.htm.

11 Ibid.

12 William Morris, "Ugly London," *Pall Mall Gazette,* September 4, 1888. Online at www.marxists.org/archive/morris/works/1888.

13 John Ruskin, "Part I," *Fiction, Fair and Foul,* June 1880. Available online from *London and Literature in the Nineteenth Century* at http://www.cardiff.ac.uk/encap/skilton/nonfic/ruskin01.html.

14 Charles Dickens, *Bleak House* (1898; New York: Bantam Books, 1992), p. 99.

15 Gabriel Orozco, interview with Benjamin Buchloh, in *Clinton Is Innocent* (Paris: Musée d'Art Moderne de la Ville de Paris, 1998), p. 69.

16 John Ronald Ruel Tolkien, *The Lord of the Rings, Part III: The Return of the King* (1854–1855; New York: Ballantine Books, 1973), pp. 349, 350, 348, 361, 373, 373.

17 Louis Kahn in *My Architect: A Son's Journey,* directed by Nathaniel Kahn (2003, New Yorker Films).

18 Ibid.

19 W. J. T. Mitchell, *What Do Pictures Want?* (Chicago: University of Chicago Press, 2005).

20 W. J. T. Mitchell, "Interview," Iconic Turn Lecture Series, Burda Academy of the Third Millennium, March 12, 2004. Available online at http://www.iconicturn.de/article.php?story=2004120710458297. My emphasis.

2 TABLET 3000 BCE 281

1 Jean-Jacques Rousseau, "The Essay on the Origin of Languages," cited in Jacques Derrida, *Of Grammatology* (1967; Baltimore, Maryland: Johns Hopkins University Press, 1997), p. 294.

2 Derrida, *Of Grammatology,* p. 290.

3 For details see David Markus, "Akkadian," in *Beyond Babel,* ed. John Kaltner and Steven L. McKenzie (Atlanta, Georgia: Society of Biblical Literature, 2002), pp. 22–23.

4 Clarisse Herrenschmidt, "Consonant Alphabets, the Greek Alphabet, and Old Persian Cuneiform," in *Ancestor of the West: Writing, Reasoning, and Religion in Mesopotamia, Elam and Greece,* trans. Teresa Lavendar Fagan (Chicago: University of Chicago Press, 2000), p. 95.

5 Derrida, *Of Grammatology,* p. 300.

6 "Hammurabi's Code of Laws," trans. L.W. King. Available online at http://www.fordham.edu/halsall/ancient/hamcode.html.

7 Ibid.

8 Ibid.

9 The relationship between events and when they were written down in Exodus and Deuteronomy can be found in Boadt, *Reading the Old Testament,* pp. 89–108.

10 Angel Sáenz-Badillos, *A History of the Hebrew Language* (Cambridge: Cambridge University Press, 1996), p. 76.

11 Plato, *Phaedrus,* in *The Collected Dialogues of Plato: Including the Letters,* ed. Edith Hamilton and Huntington Cairns (Princeton: Princeton University Press, 1961), pp. 475–525.

12 Jacques Derrida, "Freud and the Scene of Writing," in *Writing and Difference* (Chicago: University of Chicago Press, 1978), p. 217.

13 Plato, "Laws" (XII), in *The Collected Dialogues of Plato,* p. 1502. My emphasis.

14 For details see Jonathan P. Ribner, *Broken Tablets: The Cult of Law in French Art from David to Delacroix* (Berkeley: University of California Press, 1993).

3 GRIDIRON 2670 BCE

1 See Jack Williamson, "The Grid: History, Use and Meaning," *Design Issues* 3, no. 2 (fall 1986): 15.

2 Barry J. Kemp, *Ancient Egypt: Anatomy of a Civilization* (London: Routledge, 1989), p. 141. This book is the source of much of my research on ancient Egyptian cities.

3 Ibid., 138. See also Kemp, "The Early Development of Towns in Egypt," *Antiquity* 5 (1977): pp. 185–200.

4 Kemp, *Ancient Egypt,* p. 157.

5 After either flooding or following the destruction of Harrappan civilization by marauding Aryans in about 1750 BCE, this civilization abruptly came to an end and its cities fell into ruin.

6 Alan Waterhouse, *Boundaries of the City: The Architecture of Western Urbanism* (Toronto: University of Toronto Press, 1993), p. 102. The framing of this discussion can be found on pp. 102–105.

7 Ibid., p. 103.

8 Aristotle, section 1267 of "Politics," in *The Basic Works of Aristotle* (New York: The Modern Library, 2001), p. 1161.

9 Ibid.

10 Lewis Mumford, *The City in History: Its Origins, Its Transformations, and Its Prospects* (New York: MJF Books, 1961/1989), p. 193.

11 Ibid.

12 Waterhouse, *Boundaries of the City,* p. 103.

13 Ibid., p. 119.

14 Janet Abu-Lughod, "Contemporary Relevance of Islamic Urban Principles," quoted in Nezar AlSayyad, *Cities and Caliphs: On the Genesis of Arab Muslim Urbanism* (New York: Greenwood Press, 1991), p. 5.

15 AlSayyad, *Cities and Caliphs,* p. 96.

16 Ibid., 142.

17 A. E. J. Morris, *History of Urban Form: Before the Industrial Revolutions* (New York: John Wiley and Sons, 1979), p. 112. Morris cites his source here as E. A. Gutkind, *International History of Urban Development in Central Europe* (New York: Free Press of Glencoe, 1964).

18 See Marvin Trachtenberg, *Dominion of the Eye* (Cambridge: Cambridge University Press, 1997).

19 Leone Battista Alberti, *Ten Books on Architecture* (1452; London: Dover Press, 1987).

20 Mumford, *The City in History,* p. 424.

21 Morris, *History of Urban Form,* p. 255.

22 The best overview of this history is John Reps, *The Making of Urban America* (Princeton, N.J.: Princeton University Press, 1992).

23 Letter from William Penn to Thomas Holme, June 1682. Quoted in Morris, *History of Urban Form,* p. 265.

24 Morris, *History of Urban Form,* p. 266. From Samuel Hazard, *Annals of Pennsylvania, 1850.*

25 William W. Stowe, *Going Abroad: European Travel in Nineteenth-Century American Culture* (Princeton: Princeton University Press, 1994).

26 Mumford, *The City in History,* unpaginated note to "Hive or City," plate 64.

27 Ian McHarg, *Design with Nature* (Hoboken, N.J.: John Wiley and Sons, 1969/1995), p. 1.

28 See http://www.prairiecrossing.com for details.

29 Joel Garreau, *Edge City: Life on the New Frontier* (New York: Anchor Books, 1992), p. 6.

30 Ibid., p. 3.

31 Paul Davidson, "Off the grid or on: Solar and wind power gain, *USA Today,* April 12, 2006. http://www.usatoday.com/tech/news/ techinnovations/2006-04-12-off-the-grid_x.htm.

32 Ibid.

4 MAP 120 CE

1 Norman J. W. Thrower, *Maps and Civilization* (Chicago: University of Chicago Press, 1996), p. 6.

2 For a broad view on the map, see Thrower, *Maps and Civilization.*

3 For a political critique of the history of maps and mapmaking, see Denis Wood (with John Fels), *The Power of Maps* (New York: Guilford Press, 1991).

4 Thrower, *Maps and Civilization,* p. 21.

5 Ptolemy, "On the difference between world cartography and regional cartography," in *Geography,* ed. and trans. J. Lennart Berggren and Alexander Jones, in *Ptolemy's Geography: An Annotated Translation* (Princeton, N.J.: Princeton University Press, 2000), p. 57.

6 Ibid.

7 Ibid., p. 59.

8 Quoted in Evelyn Edson, *Mapping Time and Space: How Medieval Mapmakers Viewed Their World* (London: The British Library, 1997), p. 44.

9 Ibid., p. 45.

10 Ibid., p. 44.

11 Stephen Hall, *Mapping the Next Millennium: The Discovery of New Geographies* (New York: Random House, 1992), p. 380.

12 Michael Tobis, e-mail with the author, June 25, 2007.

13 An excellent survey of this material can be found in William H. Goetzmann, *Exploration and Empire: The Explorer and the Scientists in the Winning of the American West* (1966; Austin: Texas State Historical Association, 1996).

14 Jonathan Swift, "On Poetry," line i.117, quoted in Thrower, *Maps and Civilization,* p. 110.

15 Buckminster Fuller, "'Introduction' to *Omni-Directional Halo,*" from *No More Secondhand God* in *Buckminster Fuller: Anthology for the New Millennium,* ed. Thomas T. K. Zung (New York: Saint Martin's, 2001), p. 95.

16 Hall, *Mapping the Next Millennium,* p. 2.

17 Quoted in Miguel Helft, "With Tools on Web, Amateurs Reshape Mapmaking," *New York Times* (Technology), July 7, 2007.

18 Helft, "With Tools on Web...."

19 Wood, *The Power of Maps,* p. 184.

5 NOTATION 1025

1 John Dewey, *Art as Experience* (1934; New York: Perigee, 1980), p. 16.

2 Marco Livio, *The Golden Ratio* (New York: Broadway Books/Random House, 1992), p. 29.

3 The pitch of the Milky Way was determined by Leo Blitz, Evan Levine, and Carl Heiles at UC Berkeley, based on measurements combining the Leiden-Argentina-Bonn (LAB) Survey of Galactic HI with a survey from the Instituto Argentino de Radioastronomica. A nonspecialist explanation can be found in "Milky Way Galaxy Is Warped and Vibrating Like a Drum," ABC *Online Forum,* January 9, 2006. Available online at http://www.berkeley.edu/news/media/releases/2006/01/09_warp.shtml.

4 Plato, *Republic,* III: 399d, in *The Collected Dialogues of Plato,* p. 644.

5 My source for much of the following discussion of pitch is David E. Cohen, "Mapping Tonal Spaces," in *The Cambridge History of Western Music Theory* (Cambridge: Cambridge University Press, 2002), pp. 307–363.

6 See Albert Seay, *Music in the Medieval World* (Englewood Cliffs, N.J.: Prentice Hall, 1965), pp. 100–103.

7 See Anna Maria Busse Berger, "The Evolution of Rhythmic Notation," in *The Cambridge History of Western Music Theory,* pp. 628–656.

8 Seay, *Music in the Medieval World,* p. 107. My emphasis.

9 See Robert F. Hayburn, *Papal Legislation Concerning Music: 95 AD to 1977 AD* (Collegeville, Minn.: The Liturgical Press, 1979), pp. 20–21.

10 Joshua Selman, e-mail to the author, November 15, 2007. Special thanks to composer-artist Joshua Selman for helping me with this material.

11 Daniel K. L. Chua, *Absolute Music and the Construction of Meaning* (Cambridge: Cambridge University Press, 1999), pp. 51–61.

12 Vincenzo Galilei, 1581, quoted in Lydia Goehr, *The Imaginary Museum of Musical Works* (Oxford: Oxford University Press, 1992), p. 136.

13 Special thanks again to Joshua Selman for clarifying this.

14 Johann Adam Hiller, *Anweisung zum Muzikalisch-Zierlichen Gesange* (Leipzig: J. F. Junius, 1774), pp. 47–48. Quoted in George Houle,

Meter in Music, 1600–1800: Performance, Perception, and Notation (Bloomington: Indiana University Press, 2000), p. 84.

15 Mathis Lussy, quoted in William E. Caplin, "Theories of Musical Rhythm in the Eighteenth and Nineteenth Centuries," in *The Cambridge History of Western Music Theory,* p. 676.

16 Morton Feldman, *Give My Regards to Eighth Street* (Cambridge, Mass.: Exact Change Press, 2000), p. 147.

17 Brian O'Doherty quoted in Feldman, *Give My Regards,* p. 145.

18 Howard Gardner, *Frames of Mind: The Theory of Multiple Intelligences* (New York: Basic Books, 1983), p. 101.

19 Hoene Wronsky's definition of music is quoted in D. H. Cope, *New Directions in Music* (Dubuque, Iowa: Wm. C. Brown, 1978), p. 87. Cited in Gardner, *Frames of Mind,* p. 99.

6 LEDGER 1299

1 This misleading description of the hoard can be found in academic circles as well, as in A. C. Littleton, *Accounting Evolution to 1900* (1933; Tuscaloosa: University of Alabama Press, 1986), p. 15.

2 For details on Roman accounting history, see D. Rathbone, "Accounting on a Large Estate in Roman Egypt," in *Accounting History: Some British Contributions,* ed. R. H. Parker and B. S. Yamey (Oxford: Clarendon Press, 1994), pp. 13–87.

3 See W. T. Baxter, "Early Accounting: The Tally and the Checkerboard," in Parker and Yamey, *Accounting History,* pp. 197–238.

4 Ibid., p. 201.

5 Ibid., throughout.

6 Cited in Robert L. Heibroner, *The Worldly Philosophers* (New York: Simon and Schuster, 1999), p. 22. From a rudimentary French cash book, 1305.

7 Baxter, "Early Accounting," p. 225.

8 Ibid.

9 G. A. Lee, "The Oldest European Account Book: A Florentine Bank Ledger of 1211," in Parker and Yamey, *Accounting History,* p. 160.

10 The *Codex Aedilis 67* is located at the Biblioteca Mediciea-Laurenziana in Florence.

11 The simultaneity of legal and grammatical standards in languages has been described at some length by Jacques Derrida in *Of Grammatology*.

12 Luca Paciolo, "Account Keeping" from *Summa Arithmetica* (1494), translated in Littleton, *Accounting Evolution to 1900,* p. 63.

13 Ibid., p. 65.

14 Littleton, *Accounting Evolution to 1900,* p. 13.

15 Peter L. McMickle and Richard G. Vandermeersch, *The Origins of a Great Profession* (Memphis, Tenn.: The Academy of Accounting Historians, 1987), p. 1.

16 Ibid.

17 William Shakespeare, *2 Henry VI,* in *The Riverside Shakespeare,* ed. G. Blakemore Evans (Boston: Houghton Mifflin, 1974), act 5, scene 2, lines 33–37, p. 658.

18 James Aho, as cited in Parker and Yamey, *Accounting History,* p. 257.

19 Karl Marx specifically criticized this differentiation and associated all of the profits taken in trade with a usurpation of capital.

20 William Shakespeare, *The Merchant of Venice,* in *The Riverside Shakespeare,* act 1, scene 1, lines 40–44, p. 255.

21 Ibid., act 1, scene 1, lines 177–179, p. 255.

22 Ibid., act 1, scene 3, lines 43–50, p. 258.

23 Daniel Defoe, *Robinson Crusoe* (New York: Cosmopolitan Books, 1920), p. 83.

24 Ibid., pp. 85–86.

25 See Adam Smith, *The Wealth of Nations* (New York: Random House, 2000), p. 485.

26 "VisiCalc '79: Dan Bricklin and Bob Frankston," *Creative Computing* (November 1984), pp. 122, 124; available online at http://www .dssresources.com/history/sshistory.html.

7 SCREEN 1420

1 Michel Foucault, "What Is an Author?," in *Twentieth-Century Literary Theory,* ed. Vassilis Lambropoulos and David Neal Miller (Albany, N.Y.: State University Press of New York, 1987), pp. 124–142.

2 Painted in 1425, Masaccio's work was not the first example of perspective painting. There are paintings at Pompeii, for example, that utilize a highly developed sense of intuitive perspective, but these are not the same. In

classical and medieval intuitive perspective, things appear smaller as they are farther away and rise toward a horizon line, but being intuitively calculated, the rate of diminution is variable. What's more, in medieval works, as in medieval maps, the size of things or figures in an image often reflects relative importance, which is to say that symbolism trumps naturalism.

3 Erwin Panofsky, *Perspective as Symbolic Form* (1927; New York: Zone Books, 1997), p. 68.

4 Ptolemy, 7:6, "The mapping of the ringed globe with the *oikumenē*," in *Ptolemy's Geography: An Annotated Translation,* ed. and trans. J. Lennart Berggren and Alexander Jones (Princeton, N.J.: Princeton University Press, 2000), p. 112. My emphasis.

5 Euclid, *Optics,* quoted in A. Mark Smith, *Ptolemy and the Foundations of Ancient Mathematical Optics: A Source Based Guided Study* (Philadelphia, Penn.: American Philosophical Society, 1999), p. 51.

6 For details on this debate, see Fred Dibery and John Willats, *Perspective and Other Drawing Systems* (New York: Van Nostrand Reinhold, 1983), p. 60.

7 An architect for some of the most important architectural commissions in Florence from 1435 to the 1450s, Alberti would design the gridded facade of Santa Maria Novella as well as the Palazzo Rucellai—both expressions of Vitruvian classicism.

8 Leon Battista Alberti, *Della pittura,* translation quoted in William M. Ivins, Jr., *On the Rationalization of Sight: With an Examination of Three Renaissance Texts on Perspective* (New York: Da Capo Press, 1975), p. 22. Alberti's book on architecture, *De re aedificatoria* (1450), included significant parts of Vitruvius' *The Ten Books of Architecture,* the only extant book on architecture from the classical era.

9 Euclid, quoted in Ivins, *On the Rationalization of Sight,* p. 52.

10 See Hubert Damisch, *The Origin of Perspective* (Cambridge, Mass.: MIT Press, 1995).

11 See Michael Baxandall, *Painting and Experience in Fifteenth Century Italy* (Oxford: Oxford University Press, 1972).

12 Panofsky, *Perspective as Symbolic Form,* p. 44.

13 Paul Virilio, *The Vision Machine* (Bloomington: Indiana University Press, 1994), p. 6.

14 Ibid., p. 12.

15 René Descartes, *The Geometry of René Descartes: With a facsimile of the first edition,* trans. David Eugene Smith and Marcia L. Latham (New York: Dover, 1954), p. 240.

16 Abraham Bosse, *Le Pientre converti aux précis et universelles régles de son art,* Paris, 1637. Quoted in Damisch, *The Origin of Perspective,* p. 150.

17 Isaac Newton, *Principia,* trans. Andrew Mott (1687; Amherst, N.Y.: Prometheus Books, 1995), p. 15.

18 The phrase "background geometrical structure" is borrowed from Richard Hadden, *On the Shoulders of Merchants: Exchange and the Mathematical Conception of Nature in Early Modern Europe* (Albany, N.Y.: State University of New York, 1994).

19 Isaac Newton, *De gravitatione* (date unknown; sometime before 1685), in *Newton: Philosophical Writings,* ed. Andrew Janiak (Cambridge: Cambridge University Press, 2004), p. 22.

20 John Donne, "The Anatomy of the World: The First Anniversary" (1611), quoted in Steven Shapin, *The Scientific Revolution* (Chicago: University of Chicago Press, 1996), p. 28.

21 See Svetlana Alpers, *The Art of Describing: Dutch Art in the Seventeenth Century* (Chicago: University of Chicago Press, 1984).

22 Joel Snyder, "Picturing Vision," *Critical Inquiry* 6 (spring 1980): 502–511.

23 Gilles Deleuze, *Cinema I: The Movement-Image,* trans. Hugh Tomlinson and Barbara Habberjam (Minneapolis: University of Minnesota Press, 1986), p. 15.

24 Anne Friedberg, *The Virtual Window: From Alberti to Microsoft* (Cambridge, Mass.: MIT Press, 2006), p. 246.

8 TYPE 1454

1 Special thanks to Zachary Harris for alerting me to the sung creation.

2 A history of the evolution of the codex can be found in Norma Levarie, *The Art and History of Books* (New Castle and London: Oak Knoll Press and the British Library, 1995), p. 20.

3 There is scant evidence that woodblock-print codices predate the invention of mechanical printing by more than a decade or two, if at all. Levarie, *The Art and History of Books,* p. 71.

4 Claims to the invention of moveable type have also been made for France and Italy, and the basic technology had been used before

Gutenberg to emboss literary documents. It can be said with certainty that Gutenberg made the first die-cast letters in a bronze and lead alloy, as opposed to hand carving each one in wood. Thus exact typescripts could be mass-produced for letter presses beyond Gutenberg's own modest printing shop.

5 Philip B. Meggs, *A History of Graphic Design* (New York: Van Nostrand Reinhold, 1979), p. 70.

6 Guillaume Fichet, "Printing in France and Humanism, 1470–80," in *The Printed Word: Its Impact and Diffusion,* ed. Rudolf Hirsch (London: Variorum Reprints, 1978), p. 113.

7 Marshall McLuhan, *The Gutenberg Galaxy: The Making of Typographic Man* (1962; Toronto: The University of Toronto Press, 2002), p. 18.

8 Ibid.

9 See J. C. Carothers, "Psychiatry and the Printed Word," in *Psychiatry* (November, 1959): 308–312. Discussed in McLuhan, *The Gutenberg Galaxy,* pp. 18–20.

10 Michel Foucault, *Power/Knowledge: Selected Interviews and Writings 1972–1977,* ed. Colin Gordon (New York: Pantheon Books, 1980), p. 114.

11 See Elizabeth Eisenstein, *The Printing Press as an Agent of Change* (1979; Cambridge: Cambridge University Press, 1987), p. 132.

12 Ibid., p. 117.

13 McLuhan, *The Gutenberg Galaxy,* p. 199.

14 Johanna Drucker, *The Alphabetic Labyrinth* (London: Thames and Hudson, 1995), p. 102.

15 Ibid., p. 161.

16 Quoted in Eisenstein, *The Printing Press,* p. 304.

17 Quoted in Levarie, *The Art and History of Books,* p. 67.

18 See "Printed Reports on the Early Discoveries and Their Reception," in *First Images of America,* vol. 2, ed. Fredi Chiappelli, Michael J. B. Allen, and Robert L. Benson (Berkeley: University of California Press, 1976), pp. 537–562.

19 Eisenstein, *The Printing Press,* p. 587.

20 Michel Foucault, "What Is an Author?," pp. 124–142.

21 Drucker, *The Alphabetic Labyrinth,* p. 162.

22 McLuhan makes this point repeatedly in *The Gutenberg Galaxy.*

23 Drucker, *The Alphabetic Labyrinth,* p. 164.

24 Kevin Barnhurst, *Seeing the Newspaper* (New York: St. Martin's Press, 1994), p. 166.

25 Ibid., p. 162.

26 Howard Gardner, *Frames of Mind,* p. 77.

27 Ibid.

28 John Dewey, *Art as Experience* (1934; New York: Perigee, 1980), p. 168.

29 McLuhan, *The Gutenberg Galaxy,* p. 255.

9 BOX 181–7

1 Marc Levinson, *The Box: How the Shipping Container Made the World Smaller and the World Economy Bigger* (Princeton, N.J.: Princeton University Press, 2002), pp. 15–16. Much of the history and statistics of shipping in this chapter can be found in this watershed book, which generously uncovers the modern logic of the box.

2 See http://www.searsarchives.com for a full company timeline.

3 The exception that proves the rule is the new open-barrel model of high-end specialty supermarkets and health food stores, which serve an environmental function by reducing packaging landfill and a marketing function by offering a nostalgic shopping experience.

4 Levinson, *The Box,* p. 30.

5 Ibid., chapter 1: "The World the Box Made," pp. 1–16.

6 Edward L. Glaeser and Janet E. Kohlhase, quoted in Levinson, *The Box,* p. 8.

7 Levinson, *The Box,* p. 99.

8 Ibid., p. 264.

9 See Lisa M. Fine, "The Female Souls of the Skyscraper," in *The American Skyscraper,* ed. Roberta Moudry (Cambridge: Cambridge University Press, 2005), p. 65.

10 Louis Sullivan, "The Tall Office Building Artistically Considered," in *Lippincott's Magazine* (March 1896). Available online at http://ocw.mit .edu/OcwWeb/Civil-and-Environmental-Engineering/1-012Spring2002/ Readings/.

11 See Merrill Schleier, "The Skyscraper, Gender and Mental Life," in Moudry, ed., *The American Skyscraper,* pp. 234–254.

12 See Fine, in Moudry, ed., *The American Skyscraper,* pp. 63–84.

13 Thomas Bender, "Metropolitan Life and the Making of Public Culture," in *Power, Culture, and Place: Essays on New York City,* ed. John Mollenkopf, (New York: Russell Sage, 1988), pp. 262–264. Cited in Sarah Watts, "Built Language of Class," in Moudry, ed., *The American Skyscraper,* p. 195.

14 Jean Starobinski, *Jean-Jacques Rousseau: Transparency and Obstruction* (Chicago: University of Chicago Press, 1971).

15 Le Corbusier, *Towards a New Architecture* (1923; Mineola, N.Y.: Dover, 1986), p. 8.

16 Michel Foucault, *Discipline and Punish: The Birth of the Prison,* trans. Alan Sheridan (Paris: Gallimard, 1975).

17 Robert Bruegmann, *Sprawl: A Compact History* (Chicago: University of Chicago Press, 2005).

18 Schleier, "The Skyscraper …," p. 235.

19 Ibid., p. 240.

20 Robert Venturi, Denise Scott Brown, Steven Izenour, *Learning from Las Vegas: The Forgotten Symbolism of Architectural Form* (Cambridge, Mass.: MIT Press, 1972/1977), p. 87.

21 Ibid., p. 104.

22 Ken Yeang, *Reinventing the Skyscraper: A Vertical Theory of Urban Design* (Chichester: Wiley Academy, 2002), pp. 1–2.

23 Henri Bergson, *Creative Evolution* (1911; New York: Dover, 1998), p. 202.

24 The best scholarship on the relationship between ambitious mathematics and modern art is produced by Linda Dalrymple Henderson, whose books include *The Fourth Dimension and Non-Euclidean Geometry in Modern Art* (Princeton, N.J.: Princeton University Press, 1983) and *Duchamp in Context: Science and Technology in the Large Glass and Related Works* (Princeton, N.J.: Princeton University Press, 1998).

25 Clement Greenberg, "Abstract, Representational, and So Forth," Ryerson Lecture, School of Fine Arts, Yale University, May 12, 1954. Reprinted in *Art and Culture* (Boston: Beacon Press, 1961), p. 136.

26 Gotthold Ephraim Lessing, *Laocoön: An Essay on the Limits of Poetry and Painting* (1766; New York: Farrar, Straus and Giroux, 1969), p. 91. Special thanks to Tom Mitchell for working through this text with me in graduate school. It is a lesson I have never forgotten.

27 Rosalind Krauss, "Grids," in *The Originality of the Avant-Garde and Other Modernist Myths* (Cambridge, Mass.: MIT Press, 1999), p. 9.

28 Dewey, *Art as Experience,* p. 168.

29 Piet Mondrian, "Natural Reality and Abstract Reality, 1919," in Herschel P. Chipp, *Theories of Modern Art* (Berkeley: University of California Press, 1968), p. 323.

30 Jeanne Spielman Rubin, *Intimate Triangle: Architecture of Crystals, Frank Lloyd Wright, and the Froebel Kindergarten* (Huntsville, Alabama: Polycrystal Book Service, 2002).

31 Frank Lloyd Wright, *A Testament* (New York: Horizon Books, 1957), pp. 19–20.

32 My summary of Froebel's kindergarten curriculum is indebted to Rubin, *Intimate Triangle,* pp. 81–86.

33 Quoted in Lindsay Blair, *Joseph Cornell's Vision of Spiritual Order* (London: Reaktion Books, 1998), p. 32.

34 Blair, *Joseph Cornell's Vision,* p. 186.

35 Benjamin Buchloh, "Robert Watts: Animate Objects, Inanimate Subjects," in *Neo-Avant-Garde and Culture Industry: Essays on European and American Art from 1955 to 1975* (Cambridge, Mass.: MIT Press, 2000), p. 538.

36 Ibid.

37 Michael Fried, "Art and Objecthood," *Artforum* 5 (June 1967): 12–23.

38 Rosalind Krauss, "Sculpture Redrawn," *Artforum* (May 1972): 38.

39 Arthur Danto, *Beyond the Brillo Box: The Visual Arts in a Post-Historical Perspective* (New York: Farrar, Straus and Giroux, 1992).

40 For an account of pop art as an expression of consumer values, see Christin J. Mamiya, *Pop Art and Consumer Culture: American Super Market* (Austin: University of Texas Press, 1992).

10 NETWORK 1970

1 Quoted in Gina Kolata, "You, Your Friends, Your Friends of Friends," in the *New York Times,* August 5, 2007, section IV, p. 1.

2 Ibid.

3 Much of the following account of the history of textiles has been gathered from Mary Schoeser, *World Textiles: A Concise History* (London: Thames and Hudson, 2003).

4 See Jared Diamond, *Guns, Germs, and Steel: The Fates of Human Societies* (New York: W. W. Norton, 1999).

5 Cited in Martin Campbell Kelly and William Aspray, eds., *Computer: A History of the Information Machine* (Cambridge, Mass.: Westview Press/Perseus Books, 2004), pp. 6–7.

6 Ibid., p. 48.

7 Ibid., p. 18.

8 Ibid., p. 19.

9 Ibid., p. 61.

10 The Mark I, it should be noted, was not the first electromagnetic computer, nor was it the first programmable computer. Rather, the Mark I was the first programmable, fully automatic, electromechanical computer. The first electromechanical computers were made in Germany, Zuse Z3 of 1941, and at Bell Labs in the 1940s. These machines, however, used a cumbersome, floating point, physical software system, which slowed the machines down. For details, see Paul E. Ceruzzi, *A History of Modern Computing* (Cambridge, Mass.: MIT Press, 2003), p. 64. Similarly, the code-breaking Colossus of the Beltchley Park cryptography center in Beltchley Park, England, was the first programmable computer and was operational by 1943. This mechanical code-breaking information machine was, however, completely secret until the 1970s. For details, see Campbell-Kelly and Aspray, *Computer,* pp. 87–88.

11 Ibid., p. 53.

12 Recent accounts indicate that the ENIAC was in fact based on an existing, though little known, electronic computing machine invented by an acquaintance of Mauchly's, John Vincent Atanasoff, an Iowa State professor of mathematics, and his graduate student Clifford Berry, in 1939.

13 Ceruzzi, *A History of Modern Computing,* p. 24.

14 See Douglas Kahn and Hannah Higgins, eds., *Mainframe Experimentalism* (Berkeley: University of California Press, 2009).

15 Alison Knowles, *House of Dust* (Cologne: Kaspar König, 1969).

16 Benjamin Buchloh, "Book of the Future: Alison Knowles's 'House of Dust,'" in *Mainframe Experimentalism.*

17 John Wilcock, "The Village Square," *Village Voice* 1 (1), October 26, 1955, p. 3.

18 Quoted in Campbell-Kelly and Aspray, *Computer,* p. 260.

19 Chapters on each of these applications can be found in Ian Foster and Carl Kesselman, eds., *The Grid 2: Blueprint for a New Computing Infrastructure* (San Francisco: Morgan Kaufmann/Elsevier, 2004).

20 Larry Smarr, "The Environment Needs the Grid," in Foster and Kesselman, *The Grid 2,* p. 10.

21 Ibid., p. 41.

22 Keith Bradsher, "China Enacting High-Tech Plan to Track People," *New York Times,* August 12, 2007, p. 1.

23 Foster and Kesselman, *The Grid 2,* p. 38.

24 Ibid., p. 4.

AFTERWORD
TOWARD FRACTIONAL DIMENSIONS

1 A. Einstein, H. A. Lorentz, H. Weyl, and H. Minkowski, *The Principle of Relativity: A Collection of Original Memoirs* (1923; Mineola, N.Y.: Dover Publications, 1952/2000), p. 56.

2 The theory of special relativity speculates that relative to any moving objects, the speed of light is constant because *time is relative.* Objects have different orders of time as they move through space approaching the speed of light because as things speed up, time moves more slowly. Therefore, as something approaches the speed of light, time will have slowed sufficiently so that light will still move away from it at the same relative speed. For the observer approaching lightspeed, time will seem to pass as usual. Einstein's argument is clearly symmetrical: there is no movement in space that is not also a movement in time. This principle was illustrated in the 1978 Hollywood blockbuster *Superman,* when the superhero (played by Christopher Reeves) flies rapidly around the world against the direction of its spin and finally arrives in the past. We know he travels faster than light because the Earth appears as a spool entangled in light threads whose coexistence indicates faster-than-lightspeed.

3 Einstein's special relativity theory was based on the discoveries of Hendrik Lorentz (1853–1928), the Dutch physicist and mathematician who challenged classical mechanics by establishing mathematical convertibility between two different observers' measurements of space and time at speeds approaching the speed of light. These mathematical equations were called the Lorentz transformations by the French mathematician Henri Poincaré, who put them into a modern, symmetrical form in 1905.

4 Poincaré is quoted at length in Arthur I. Miller, *Einstein, Picasso: Space, Time, and the Beauty That Causes Havoc* (New York: Basic Books, 2001), p. 105.

5 See Linda Dalrymple Henderson, *The Fourth Dimension and Non-Euclidean Geometry in Modern Art.*

6 Buckminster Fuller, "'Introduction' to *Omni-Directional Halo,*" p. 95.

7 Quoted in J. B. Kennedy, *Space, Time, and Einstein: An Introduction* (Montreal and Kingston: McGill-Queen's University Press, 2003), p. 50.

8 John Cage, "Experimental Music," in *Silence: Lectures and Writings by John Cage* (Wesleyan, Conn.: Wesleyan University Press, 1961/1973), p. 8.

9 Dick Higgins was a founding member of Fluxus.

10 Dick Higgins, "Intermedia," *Something Else Newsletter* 1, no. 1 (1966). Reprinted in Dick Higgins, *Horizons: The Poetics and Theory of the Intermedia* (Carbondale: Southern Illinois University Press, 1984), pp. 18–28.

11 Benoit B. Mandelbrot, *The Fractal Geometry of Nature* (New York: W. H. Freeman, 1983), p. 25.

12 Buckminster Fuller, "'Introduction' to *Omnidirectional Halo,*" p. 92.

13 Charles Harrison, "Abstraction, Figuration, Representation," in *Primitivism, Cubism, Abstraction: The Early Twentieth Century,* ed. Charles Harrison, Francis Frascina, and Gill Perry (London and New Haven: Yale University Press and the Open University Press, 1993), p. 202.

14 Murray Gell-Mann, quoted in Horace Freeland Judson, *The Search for Solutions* (New York: Holt, Rinehart and Winston, 1980), p. 2.

15 Benoit B. Mandelbrot, *The Fractal Geometry of Nature,* p. 1.

16 Ibid.

17 This view developed in a conversation with art historian Jonathan Fineberg on December 12, 2007.

18 See http://www.phys.canterbury.ac.nz/seminars/2005.

19 Ibid.

20 Special thanks to Tom Mitchell for directing me to Gormley.

21 W. J. T. Mitchell, "Architecture as Sculpture as Drawing: Antony Gormley's *Paragone,*" in *Antony Gormley: Blind Light* (London: Hayward Gallery, 2007), pp. 112, 123.

22 Ibid., p. 112.

23 Henry David Thoreau, *Thoreau on Man and Nature,* compiled by Arthur G. Volkman (Mt. Vernon, N.Y.: Peter Pauper, 1960), p. 18, as quoted in William J. Jackson, *Heaven's Fractal Net* (Bloomington: Indiana University Press, 2004), p. 205.

24 David Bohm, *On Creativity,* ed. Lee Nichol (London: Routledge, 1998), p. 61, as quoted in Jackson, *Heaven's Fractal Net,* p. 205.

25 Buckminster Fuller, "'Prologue,' from *Tetrascroll ...*" in *Anthology,* p. 179.

26 Ian Foster and Carl Kesselman, "Concepts and Architecture," in *The Grid 2,* p. 38.

27 See Howard Gardner, *Frames of Mind.*

28 Ibid., p. 300.

ACKNOWLEDGMENTS

A BOOK AS UNWIELDY IN ITS SUBJECT MATTER AS THIS HAS AS MANY PEOPLE TO THANK AS THERE ARE SUBJECTS IN THE BOOK. Or maybe twice as many. First thanks go to Kristine Stiles, who insisted that this was a book when I thought it was an article, and to Roger Conover at the MIT Press, whose enthusiasm for the project moved it to the front of my too-long future project list and who stuck with me through a string of delays. I would not have pursued it without their insistence and interest. Special thanks also to my Dean at the University of Illinois at Chicago, Judith Kirshner, for understanding that a project like this takes more time than I could have imagined at the outset and who responded with the gift of time needed for its completion. Finally, this book is dedicated to my friend and mentor at the University of Chicago, Tom Mitchell, who is better known as WJT and whose interest and engagement with my life and work have brought me both inspiration and joy. His eagerness to take on topics beyond the scope of his apparent expertise and his commitment to visual-symbolic thought in the form of iconology have served as an inspiration for what follows.

Gratitude also goes to Jennifer Liese, my copy editor, who is an expert storysmith and fact checker. No doubt this would not

be readable without her invaluable input, as well as the input of my circle of manuscript readers, Stephen Eisenman, Peter Hales, Samuel Kramer, Joe Reinstein, Rebecca Schanberg, Maggie Scheyer, my mother Alison Knowles, and the careful, anonymous readers of MIT Press. With great humility, I thank Zachary Harris, my research assistant through most of the duration of this. Zach was the first reader of what follows and the gatherer of images and rights. He read bits and pieces of this when they were still in a state of utter chaos. I hope the experience was as useful to him as it was to me. What he couldn't finish in the way of copyrights was ably completed by his successor, Mirela Tanta. Through my research assistants I owe a debt of gratitude to the many artists, estates, and museums that have generously contributed images to the visual narrative shown here. I also owe a debt of gratitude to Helen Mirra, artist and poet, who directed me to Friedrich Froebel's kindergarten, transforming my view of the box, and to my brother-in-law Joshua Selman, composer and artist, who guided me through musical notation with admirable patience. I am also grateful to Mac Mackenzie, who first suggested a chapter on ledgers and to my other brother-in-law, Ernest Reinstein, who explained bookkeeping to me—twice.

In addition to my gratitude for the support of these fine readers and discussants, less tangible contributions were made by my family and friends. You know who you are. I am especially indebted to my mother-in-law, Laurie Reinstein, who filled in with childcare and who never judges my life choices though they differ markedly from her own, and to my husband, Joe Reinstein, who engaged enthusiastically with smart questions and the logistical process. To my sister Jessica, I remain grateful for your moral support. To my friend Maggie, also a reader, your friendship has in many ways made this possible through your steady confidence in the project, personal affection, support, and guidance in all things familial. To my daughters, Nathalie and Zoë, I have been inspired by your curiosity. I hope you stay as curious about the world as you are right now.

I'm sure I've forgotten someone. I hope you'll forgive me. I am no less grateful even if I've forgotten to write your name here.

ACKNOWLEDGMENTS